THE INCREDIBLE WORLD OF
SPY-Fi

P9-AGN-304

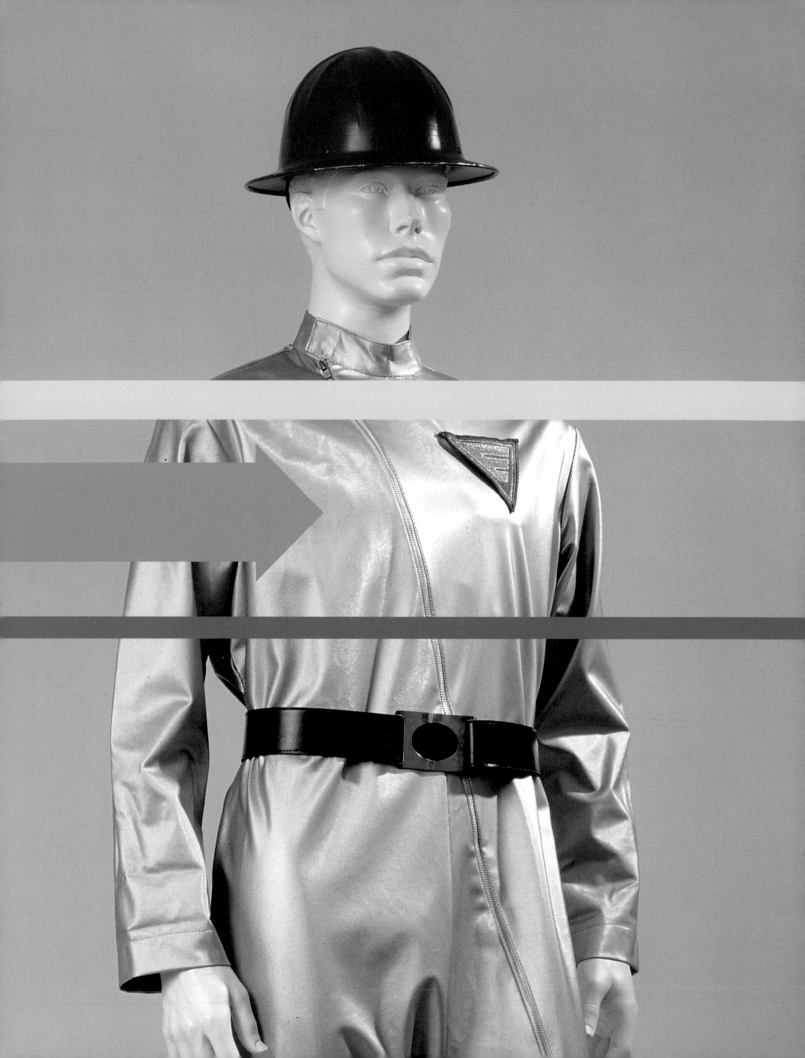

THE INCREDIBLE WORLD OF
SPY-Fi

WILD AND CRAZY SPY GADGETS, PROPS, AND ARTIFACTS FROM TV AND THE MOVIES

BY DANNY BIEDERMAN
PHOTOGRAPHS BY SUSAN EINSTEIN
FOREWORD BY ROBERT W. WALLACE, Former Director, CIA Technical Service

CHRONICLE BOOKS
SAN FRANCISCO

Copyright © 2004 by Danny Biederman. Artifact photographs copyright © 2004 by Danny Biederman. All rights reserved. No part of this book may be reproduced in any form without written permission from the publisher.

Library of Congress Cataloging-in-Publication Data:
Biederman, Danny.
The incredible world of spy-fi: wild and crazy spy gadgets, props, and artifacts from tv and the movies / by Danny Biederman.
 p. cm.
ISBN 0-8118-4224-X
1. Spy television programs—United States—History and criticism. 2. Spy television programs—United States—Miscellanea. 3. Spy films—United States—History and criticism. 4. Spy films—United States—Miscellanea. I. Title.
 PN1992.8.S67B54 2004
 791.45'615—dc22
 2004005561
The names Spy-Fi and Spy-Fi Archives are registered trademarks of Danny Biederman.

Manufactured in China

Designed by Jeremy Stout

Distributed in Canada by Raincoast Books
9050 Shaughnessy Street
Vancouver, British Columbia V6P 6E5

10 9 8 7 6 5 4 3 2 1

Chronicle Books LLC
85 Second Street
San Francisco, California 94105
www.chroniclebooks.com

Dedication

For my three wonderful children—
Moriah Flint, Bond, and Illya.

Acknowledgments

Thanks go to my parents Harry and Esther for being *the best;* my children for their great love and compassion, and their help in staging the Spy-Fi exhibits—my daughter Illya at the CIA, my daughter Moriah at the National Atomic Museum, and my son Bond at the Queen Mary; Tom Silberkleit for his invaluable friendship and unparalleled support for this book and so many other life endeavors; Lorin Biederman and Kristin Sabo, who have donated extensive amounts of their time to the Spy-Fi Archives; Paul Surratt, Scott Shea, Robert Short, Sue Kesler, and Peter Greenwood for their friendship and archival contributions.

A big thanks to my publisher, Chronicle Books, and my editors Jodi Davis and Sarah Malarkey, designer Jeremy Stout, and Chronicle's editorial and design teams. Thanks to Jim Buckley and his Shoreline Publishing group for envisioning this book, and for designing and pitching my proposal.

Special thanks to Bob Wallace for his friendship, his support of the Spy-Fi Archives, and for graciously writing the foreword to this book; and to Susan Einstein for her wonderful original photography of the artifacts that fill these pages.

For interviews, photographs, and archival materials I am thankful to my friends Norman Felton, Patrick Macnee, Leonard Stern, Hilda Rolfe, Jinny Geller, Reuben Klamer, Bill Bates, Ben Starr, Robert Justman, Naomi Heschong, Tom Hatten, Dick Gautier, and Fred Hollinger.

For their friendship and special interviews I thank Robert Vaughn, Barbara Feldon, Robert Conrad, Paul Playdon, Peter Lupus, Don Adams, Robert Culp, Tim Smyth, and Buck Henry. A special toast to five special people who sadly passed on: My dear uncle, Irving Wallace, who was my greatest creative inspiration and unparalleled advocate of achieving one's life dreams; Sam Rolfe, for his friendship, counsel, and creative invention that affected my life; Arnold Goode, Albert Heschong, and Greg Morris for their contributions and friendship.

I am indebted to the Central Intelligence Agency for debuting the Spy-Fi Exhibit and launching my collection onto the world stage. I am grateful to my friend Toni Hiley, CIA Museum curator, for inviting me to the Agency, staging the exhibit, and guiding me through the world of museums and artifact preservation. I am thankful to Carlos Davis, my opposite number in the real world of intelligence, for his unbridled enthusiasm and hard work in orchestrating the CIA event. Deep thanks to my friend Sirah Rahel Appel for coordinating the lectures and interviews. Added appreciation goes to CIA director George Tenet, Lloyd Salvetti, Edward Mickolus, Bill Harlow, Mike

Mansfield, Tom Crispell, Kurt, Carolyn Reams, Beth Bruins, Michael Stepp, Chase Brandon, Jennifer Stepp, Mike Barber, Anya Guilsher, plus members of the Office of Technical Service, the Center for the Study of Intelligence, the CIA Fine Arts Commission, the CIA Museum, the Office of Public Affairs, the Printing and Photography Group, the masterful Internet technicians, the store staff, and the CIA membership.

Thanks for support go to Jerry Biederman, Fred Libin, Patrick White, H. Keith Melton, Jerry Catt, George Keramidas, Bill Goss, Tony Mendez, Herb Agner and EMI, Emma Marriott and Boxtree/Pan MacMillan Ltd., Bob Silverstein and Quicksilver Books, Brian York, Steve Rubin, Peter Earnest, Frank Lieberman, George Lehr, Gregg Heschong, Linda Brevelle, Scott Hettrick, Ray Tuley, Beth Rosen, Mike Wetherell, Craig Piligian, Joel Rogers, the late Herb Klynn, Michael I. Silberkleit, Lisa Lesniak, Wesley Britton, Jim Ackelson, Mark Peltz, Doug Stoneman, and Tom Pennock. Hats off to George Donnell and Section Four of U.N.C.L.E. for providing File 40 research documents.

Additional thanks to Michael Wilson, Barbara Broccoli, David Pope, Keith Snelgrove and Danjaq; James Walther, Tom Salazar, Merri Lewis, and the National Atomic Museum; Sean Connery; Guy Hamilton; Pierce O'Donnell, Ann Marie Mortimer, Tim Toohey, Sherill Soliz, and the rest of the team at O'Donnell & Shaeffer; Matt Sherman and SpyFest; Melissa D. Harling of ABC; Barbara Van Sickle, Jason Sarrafian, Ivy Kwong, Gary Teetzel, and MGM Studios; Gilbert Emralino of Sony Archives; Duke Blackwood, John Langellier, Faith Bilyeu, Mary Brown, Melissa Giller, and the Ronald Reagan Presidential Library and Museum; Paramount Television, 20th Century Fox, Columbia Pictures, Sony Pictures, NBC-TV, CBS Television, ABC-TV, Turner Entertainment Co., Universal Television, Warner Brothers, and Viacom.

This book would not have been possible without the incredible vision, talent, and creative work generated by the hundreds of writers, art directors, prop masters, special effects artists, costumers, producers, directors, performers, graphic artists, composers, and crafts people who collaborated to produce the TV series and motion pictures represented in this book.

Finally, a nod of appreciation to all those intelligence operatives and soldiers in the field for their daily struggles and sacrifices that help keep the Free World free, and for continuing to serve as the inspiration for our dashing spy heroes of the silver screen.

—*Danny Biederman*

TABLE OF CONTENTS

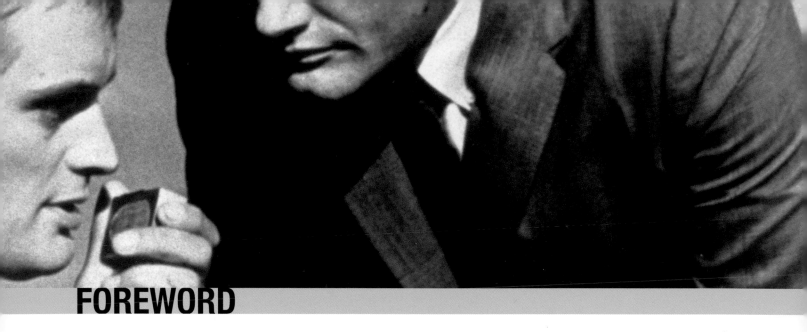

FOREWORD

From early on, spies have been with us, the mystery and power of intelligence operations capturing our imaginations. Their world is rarely visible, though, spinning on a secretive axis of clandestine intrigue. One of the first examples is an Old Testament account of a twelve-man, forty-day spy mission into the land of Canaan run at the behest of Moses.

Throughout the ages, we've been following spies through literature, drama, and news stories. But after World War II, real and imagined exploits of spies operating in America, Europe, Russia, the Middle East, and Asia created intense public interest in the "second oldest profession." The emergence of television and movies added the dimensions of picture, color, and movement to written descriptions of spy-craft. These new media, available to a universal audience, created a captivating espionage world filled with dramatic images—clear missions, unambiguous enemies, virtuous endings, cool gadgets, and beautiful people—that true-life intelligence officers often found amusing, fanciful, and compelling.

So compelling, in fact, were the film renditions of Ian Fleming's tales that officers of the Central Intelligence Agency, after watching each successive Bond movie, commonly asked three questions:

"Why wasn't Bond required to prepare an expense report and account for all the equipment he lost, broke, or destroyed?"

"Why haven't my assignments involved such handsome men and beautiful women?"

"Why don't we have all those neat toys and technical gadgets that Q makes for Bond?"

That spy movies and television programs are ardently viewed, even studied, by professional intelligence officers is a phenomenon not far different from technologists' attraction to science fiction. The imagination of the scriptwriters and the creativity of the prop and scene makers inspire a new level of thinking about what might be possible. Amazingly, the comic spy Maxwell Smart gave 1960s audiences an early glimpse of a world connected by instant messaging and universal dialing with his wireless, always accessible, albeit not entirely user-friendly, shoe phone.

Within the U.S. intelligence organizations, the CIA's Office of Technical Service (OTS) has had, since 1951, the principal mission of providing spy gear to America's operations officers and foreign agents. So it's not surprising that the CIA sponsored an exhibit from August 2000 through January 2001 featuring several hundred items from Danny Biederman's *Spy-Fi* collection of memorabilia and props from spy movies and television programs. This "private" *Spy-Fi* exhibition, coupled with a three-day festival of TV spy shows in September, delighted its select audience.

As CIA officers viewed the displays and films, the distinction between spy-fi and real-life operations blurred. For example, in an episode of *Get Smart,* Maxwell Smart enters the Cone of Silence to deny Kaos access to his conversations with the Chief. How different, really, are today's specially designed shielded rooms that protect our government's sensitive military, diplomatic, and intelligence discussions?

Napoleon Solo pulls out his fountain pen, opens Channel D and securely communicates with U.N.C.L.E. headquarters. How different, really, are today's low-power, low-probability-of-intercept, miniaturized and concealed voice transmitters? And in *The Wild Wild West,* Artemus Gordon unexpectedly appears disguised as a renowned foreign medical specialist at the sanatorium of the

dastardly Dr. Miguelito Loveless just in time to rescue James West from a lobotomy. How different, really, are today's OTS true-to-life disguises that convincingly transform a spy's size, gender, age, and facial features?

During my tenure as director of OTS (1998–2002), I encouraged OTS officers to see the new spy movies, particularly for the totally unreal technical and equipment scenes. OTS employs incredibly innovative, technically adept engineers who, when seized with new ideas, regardless of their improbability, seem able to alter the known laws of physics to construct real spy gear that would amaze even Q.

Over the fifty years of OTS's history, only boundaries of imagination seem to limit what its technical officers can accomplish; spy-fi entertainment, however, frequently obliterates those boundaries of the mind. (In contrast to CIA's field operatives, James Bond evidences little technical acumen, understanding, or appreciation for what Q provides. If Bond has ever thanked Q for the inventions that repeatedly save his life, that dialogue has occurred off camera. Yet the real-world intelligence environment is characterized by closeness, rather than distance, of the technical officer to the operations officer.)

Walt Disney said, "It's kind of fun to do the impossible." Through spy-fi the impossible becomes the imaginable. In the pages that follow, a history of "incredible" spy adventures and equipment will remind us of delightful episodes that have entertained and amused us since CBS's original dramatization of *Casino Royale* in 1954. But remember the disclaimer that appears after Agent Hero again has rescued the world from forces of evil and destruction: "The characters and incidents portrayed and the names used herein are fictitious and any similarity to the name, character, or history of any person is entirely coincidental and unintentional." Read those words again: "The characters and incidents portrayed are fictitious." Really?

Next time you settle in on a dark and stormy night for a good old spy movie or a *Mission: Impossible* festival, look closely at those spy-fi props. They may no longer be just fiction.

Arthur C. Clarke once observed, "Any sufficiently advanced technology is indistinguishable from magic." He could have added "and spy-fi" after "magic." I know— I've seen both sides.

—*Robert W. Wallace*
Former Director of the CIA's Office of Technical Service

INTRODUCTION

"I know where I am. I was right the first time. I did fall down a rabbit hole. And this is a mad, mad tea party."

—*Kay Lorrison, an innocent person who stumbles into a world of spies in* The Man from U.N.C.L.E.

My mission for the CIA was to transport four hundred pieces of espionage gear across the United States. After months of planning, I loaded the haul aboard a high-security, satellite-tracked vehicle. As it crossed the continent, I headed for Los Angeles International Airport, my black attaché case packed with twenty spy devices, each wrapped in white tissue paper. In the event of a catastrophe with the ground mission, these crucial items would survive.

As fate would have it, the catastrophe occurred at the airport. Just like the cliff-hanger before a commercial break, the contents of my case flashed across the X-ray monitor, triggering security personnel to move in. I was hustled over to a corner, the case apprehended and opened.

The twenty white packets glared out of the black case like hot white stars against the night sky. "That one!" demanded an official, her finger poking at the largest packet. "Open it." There was no point in resisting. Contacting Washington would have been fruitless. I had heard the line hundreds of times: *"Should you be caught or killed, the secretary will disavow any knowledge of your actions."*

I unwrapped the item: an old leather shoe. The security guard eyed it suspiciously. I removed the fake sole, revealing the shoe's hidden communications components. The guard stared at it blankly. I said, "It's a shoe phone." There was a moment of silence. "Oh," she said finally. "Okay. You can go."

In my mind, I could hear a Lalo Schifrin score kick in as I calmly walked to my waiting flight, just having averted a crisis. Had security checked the other nineteen packets, they'd have found a pen that was a high-powered transmitter, a cigarette case housing a communicator, a throwing star used by Japanese ninjas, a secret sleeve-gun device, and the blueprints for "The Hawk," a powerful new missile launcher.

I'm neither an international arms dealer nor a secret agent. I'm a screenwriter, filmmaker, and expert in the field of spy fiction. I also own the world's largest collection of props, wardrobe, artwork, and set pieces from a half-century of spy movies and TV shows. To my astonishment, in the summer of 2000, the CIA invited me to bring it to their headquarters so that I could stage the world's very first *Spy-Fi* Exhibit.

How did this bizarre scenario come about? Flash back to September 29, 1964, when my mother introduced me to a new TV series, *The Man from U.N.C.L.E.* The hero was a dashing secret agent who gained entry to his hidden headquarters through a tailor shop. When he turned the coat hook on the wall and stepped to the other side of the secret door, I went with him. *The Man from U.N.C.L.E.* transported me to another world, one akin to the "land of shadow and substance" inside the *Twilight Zone,* or to *The Outer Limits,* where the control of our TV set has been snatched away. It's that place over the rainbow, where you never grow up, where no man has gone before.

In this marvelous universe of intrigue, I found not only *U.N.C.L.E.* but also James Bond and hundreds of other cool spy thrillers, from *Mission: Impossible* and *The Avengers* to *Our Man Flint, I Spy,* and *The Wild Wild West.* This world was filled with spies, gadgets, adventure, and beautiful women—everything that a ten-year-old boy could possibly want. And I was not alone. These fictional adventures had grabbed the imagination of the entire world, triggering a "spy craze," a pop-culture phenomenon as identifiable of the 1960s as is the Beatles.

Why was the public so enamored with escapist espi-

OPPOSITE:
Action! Danny Biederman stars as a secret agent who infiltrates the motion-picture industry headquarters on a mission to preserve the memory of fictional intelligence agents. *The Celluloid Spies: An Undercover Documentary* was written and directed by Biederman at age sixteen.

BELOW:
Speaking to Bond. The author interviewed Sean Connery during production of the James Bond movie *Diamonds Are Forever* (1971). Biederman was on the set to produce his behind-the-scenes documentary, *A Spy for All Seasons.*

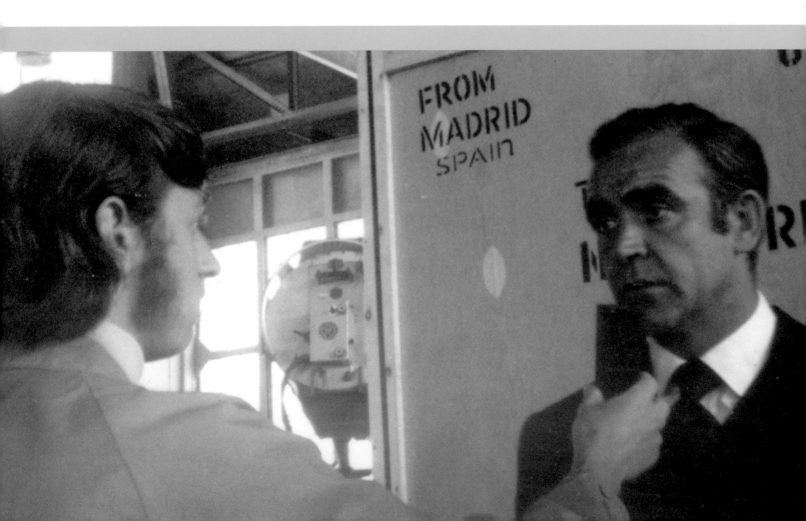

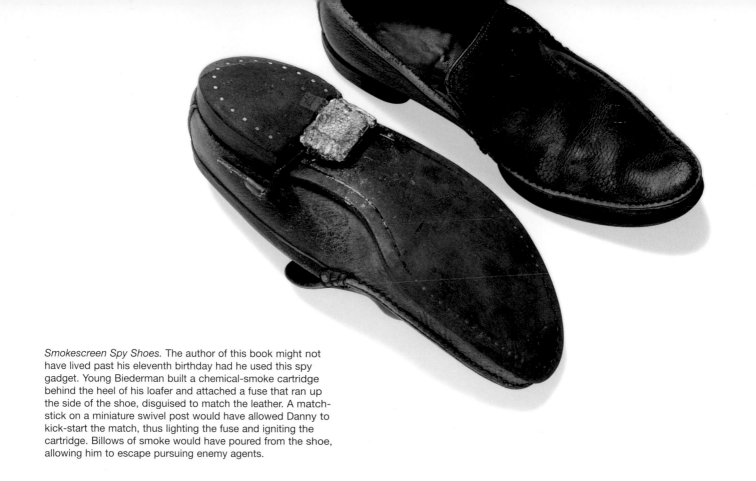

Smokescreen Spy Shoes. The author of this book might not have lived past his eleventh birthday had he used this spy gadget. Young Biederman built a chemical-smoke cartridge behind the heel of his loafer and attached a fuse that ran up the side of the shoe, disguised to match the leather. A matchstick on a miniature swivel post would have allowed Danny to kick-start the match, thus lighting the fuse and igniting the cartridge. Billows of smoke would have poured from the shoe, allowing him to escape pursuing enemy agents.

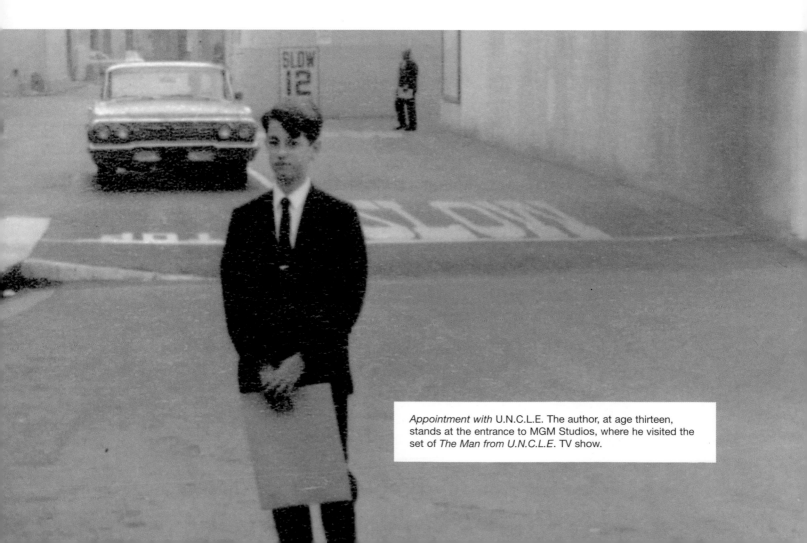

Appointment with U.N.C.L.E. The author, at age thirteen, stands at the entrance to MGM Studios, where he visited the set of *The Man from U.N.C.L.E.* TV show.

onage? In the United States, we were reeling from the assassination of our president and living in fear of possible war with Russia. The threat of nuclear holocaust was brought into terrifying focus by the Cuban Missile Crisis; diving under one's desk to survive the expected bombs became a dark ritual for American schoolchildren. Haunted by a powerful, faceless enemy, we found solace and escape in these fictional heroes who could, confidently and single-handedly, locate and destroy the enemy. That it was accomplished with a high degree of entertainment value made it all the better. Bond and the Beatles were the perfect antidote for a nation in trauma.

While most little boys played cowboy, I played spy, creating my own intelligence unit, C.O.U.S.I.N. *(Counterespionage Organization United Secret Intelligence Network).* This entailed transforming my neighborhood into a "spy zone," with my friends recruited as agents and undercover operations conducted in the shadows of family carpools and PTA meetings. I designed a security system for my bedroom, which protected the lab where I built my own spy gadgets—an arrangement that might have earned an endorsement from Q himself.

This homemade gear was joined by spy merchandise that I bought at the local toy store. In the 1970s, I added original production items I acquired from Hollywood studios. My hunt for TV and movie spy props continues to this very day.

On my thirteenth birthday, my uncle, novelist Irving Wallace, gave me the gift of a visit to the set of *U.N.C.L.E.* My father drove me to MGM, where we spent the day watching my favorite TV show being filmed. It was shortly after this remarkable experience that I began making movies. Inspired by these spy thrillers, I wrote and directed over fifty featurettes and won forty international awards during my teenage years. Some were spy adventures, including a James Bond documentary that included an interview I conducted with Sean Connery.

Having earned a reputation as a specialist in "spy fiction," I have found myself recruited by film studios, music companies, and publishers to write network TV shows, specials, books, and articles about spies. Producers hire me to serve as an expert consultant on their spy projects, including the James Bond folks at MGM.

It was during my work on a 007 legal case, in 1999, that my life took the ultimate *Twilight Zone* twist: I received a phone call from *the CIA.* At first, I was concerned. Did the intensity of my activities in the world of spy *fiction* somehow set off alarms in the *real* spy world? Is there a tiny office, buried somewhere deep inside the CIA, probably referred to as OFM—Office of Fictional Management—that keeps track of people like me? (People like me are few in

number, hence the limited size of the OFM operation.)

The Central Intelligence Agency sent two of its operatives to my home in the suburbs of Los Angeles, where they spent several days examining, photographing, and sketching my extensive arsenal of prop spy gear. The next thing I knew, I was formally invited to stage a major exhibit of my collection inside CIA headquarters in Langley, Virginia.

In organizing this exhibit, I was amazed to discover that I had, since 1964, collected more than four thousand artifacts, making the five-month exhibit a big hit with the CIA's employees and VIP visitors. For me, it was an amazing experience. Behind the mysterious image of America's secret agency, I discovered an organization filled with dedicated professionals—good, hardworking people devoted to the safety and security of our nation.

The worldwide media attention that my *Spy-Fi* Exhibit received has triggered international interest from museums and other organizations. Drawing record crowds at California's Ronald Reagan Presidential Library, New Mexico's National Atomic Museum, and elsewhere, *Spy-Fi*'s world tour has only just begun.

What is it that makes these pieces of fictional espionage so intriguing? I submit that it is *magic.* To see these items up close—in your hand or in a display case—gives you a sense that the artifacts have crossed over from another dimension. These props transcend the wood, paint, plastic, and glue that give them their physical form. Each artifact carries with it a story and, in many cases, an emotional connection to a fictional character or situation. The secret knife from 007's attaché case elicits the intensity of Bond's fight to the death with a vicious assassin in *From Russia with Love.* The sleeve-gun rig from *The Wild Wild West* recalls the thrilling moments when Jim West's hidden Derringer ejected into his hand just in time to save him from a certain death. And John Steed's bowler brings forth the heartwarming image of Patrick Macnee offering one of his charming smiles to Diana Rigg in *The Avengers.*

For the first time ever, these images and many more pop-culture treasures, each drawn from my private collection, are presented in a book. In the "otherworldly" spirit of these spy adventures, I have spun each spy-fi tale to make you, the reader, an active participant.

Whether stepping through a looking glass, falling down a rabbit hole, or passing through the secret doorway of an ordinary tailor shop, I invite you now to cross that magical line that separates reality from dreams and imagination.

Turn the page . . . and enter *The Incredible World of Spy-Fi!*

—*Danny Biederman*

JAMES BOND

CHAPTER 00:01

FROM RUSSIA WITH LOVE POSTER

Russian Kisses. This foreign poster for *From Russia with Love* was signed by Oscar-winning Bond special-effects supervisor John Stears and Martine Beswick, who played Zora, the gypsy girl. The movie is arguably the best entry in the long-running series.

No fictional secret agent has been as enduring or influential to modern-day popular culture as James Bond, Secret Agent 007 of the British Secret Service. James Bond was born in Jamaica in 1952 at the typewriter of Ian Lancaster Fleming, a former British Naval Intelligence officer during World War II. This dashing hero, Bond—who would provide millions of readers and filmgoers with high doses of escapism for many years to come—in fact owes his very existence to Fleming's own desire to "escape."

"I was going to get married, which is a very dangerous thing to do," recalled Fleming in 1963. "I created Bond to sort of insulate myself against the shock [of matrimony]." So began the writing of *Casino Royale,* a thriller whose protagonist would be provided with the "dullest name" Fleming could muster. In fact, Fleming took the name from a real person, an American ornithologist whose byline graced the cover of a book in Fleming's collection: *Birds of the West Indies* by James Bond.

Fleming had devised numerous schemes to help win the war during his years in British Naval Intelligence, but his desire to execute these plans in the field fell victim to his own success behind the desk. Consequently, it was through Bond that Fleming vicariously saved England and much of the free world from the postwar plottings of villainous masterminds, many of whom were agents of SMERSH, the real-life secret Soviet assassination unit.

James Bond, of course, did much more than provide Fleming with a "Walter Mitty" escape from his premarital jitters. He brought Fleming success. Over the course of twelve novels and two collections of short stories (published between 1953 and 1966), Fleming's Bond achieved a worldwide following and, inevitably, attracted interest from TV and movie producers.

Of the various people who attempted to bring Fleming's thrillers to the big screen, it was Albert R. Broccoli and Harry Saltzman who succeeded. Their debut production, *Dr. No,* was created for United Artists in 1962 on a modest budget of $1 million. A relatively faithful adaptation of Fleming's sixth novel, the movie focused on Bond's investigation, in Jamaica, of a missing British agent. Starring little-known Scottish actor Sean Connery as Agent 007, the well-crafted adventure film was a box-office hit. It also caused a stir over its cavalier blending of dry humor with scenes of cold-blooded violence and casual sex.

A follow-up movie, *From Russia with Love* (1963), left no doubt that this team of moviemakers was on to something extraordinary. Directed by Terence Young, these first two films established a bold, new style of filmmaking that would serve as the backbone for future entries in the U.A. series and influence generations of motion pictures produced from the 1960s on.

Goldfinger, released in 1964, solidified the elements introduced in the two previous films, establishing a formula that would guide the series for decades: exotic locations, beautiful women, adventure and intrigue, the supervillain and his evil plot, an amazing array of gadgets, and, of course, the handsome, cool, and ever-resourceful James Bond 007.

The need to keep the films current with the times—both socially and politically—meant relying less and less on Fleming's narratives. Also, by 1987, all of Fleming's titles had been adapted for the movies. So, from that point on, the producers created new titles to headline their original Bond stories.

From the sabotaging of American rocket launches in *Dr. No*, to a scheme to hold the world hostage with two atomic bombs in *Thunderball,* to Soviet efforts to acquire a submarine missile launcher in *For Your Eyes Only,* to Bond's mission of revenge against an international drug lord in *Licence to Kill,* and to a superweapon unleashed on Korea in *Die Another Day*, the 007 thrillers have never failed to leave audiences shaken and stirred.

The 007 phenomenon has endured into the twenty-first century, braving cinematic competition, changes in cast and creative approach, technological revolution, and upheavals in the social and political landscape in which James Bond and his world took root half a century ago. Under the watchful eye of producers Michael G. Wilson and Barbara Broccoli, the Bond movies maintain blockbuster status around the globe as the most successful film series of all time, with no end in sight.

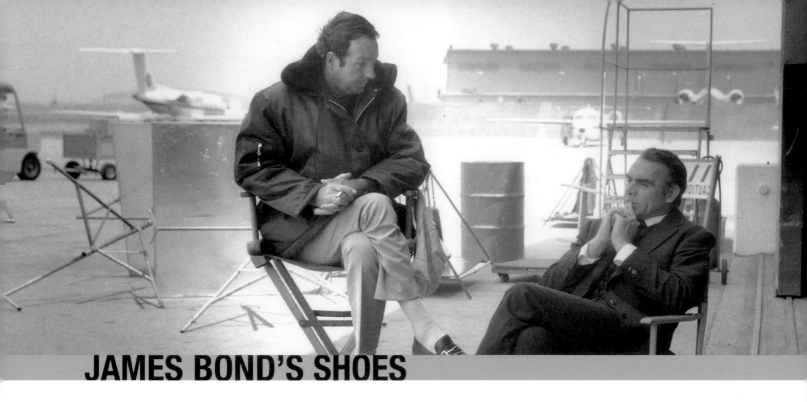

JAMES BOND'S SHOES

Who can fill the shoes of James Bond?

Fleming's Agent 007 is described as having "grey-blue eyes . . . and [a] short lock of black hair which would never stay in place . . . to form a thick comma above his right eyebrow." SMERSH's dossier details "a dark, clean-cut face, with a three-inch scar showing whitely down the sunburned skin of the right cheek." Vesper Lynd, the first "Bond girl" to appear in the novels, found Bond "very good-looking," yet "cold and ruthless."

Fleming originally envisioned David Niven in the part. But producers Broccoli and Saltzman opted for a relatively unknown actor, Sean Connery. Although Fleming was hesitant about the choice, on seeing Connery's performance in *Dr. No,* he said, "Sean has been absolutely tremendous." Connery's cool, suave interpretation of

Bond, complete with a dry, ironic wit and animal magnetism, won over filmgoers in short order. Between 1962 and 1967, Connery appeared in five 007 thrillers for United Artists, each an international box-office hit. He successfully reprised the role in 1971 and 1983.

Six other actors have also stepped into 007's shoes: George Lazenby, Roger Moore, Timothy Dalton, Pierce Brosnan, and, in two productions outside the MGM/U.A. series, Barry Nelson and David Niven. Which actor best fills James Bond's shoes? Everyone has his or her own favorite; but for many of us, there will always be a special place in our hearts for the original—the man whose cat-like walk and charismatic on-screen presence brought on goose bumps and helped make James Bond the phenomenon that it is today.

ABOVE:
A Break for Bond. Sean Connery takes a break from filming on the Bond set to chat with *Goldfinger* director Guy Hamilton.

RIGHT:
Dressed to Kill. These dress shoes were worn by cinema's first 007, Sean Connery, while portraying James Bond in the *Thunderball* remake, *Never Say Never Again* (1983).

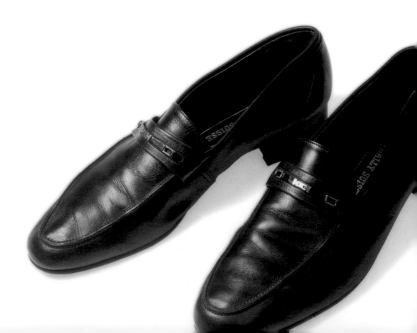

"BOND PROPS DEPT." STUDIO PRODUCTION SIGN

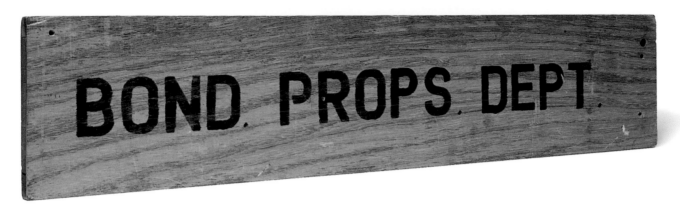

Q Shops Here. This painted wooden sign hung on the wall of the prop shop at Pinewood Studios in England, where the James Bond gadgets are built.

THE ADMIRAL GODFREY ENVELOPE

We will probably never know the contents of the letter that was inside this envelope. What we do know is that it was mailed to Rear Admiral John H. Godfrey, director of Naval Intelligence in England during World War II. His personal liaison within the British intelligence network was Commander Ian Fleming. Years later, when it came time for Fleming to create the character for James Bond's superior—M—in *Casino Royale,* he used Admiral Godfrey as his model.

In the first eleven Bond films, M is portrayed by Bernard Lee, a fitting choice for Fleming's crusty, clear-eyed admiral with the "weather-beaten face." The role has subsequently been played by Robert Brown and Judi Dench.

What did the real "M" find when he tore open this envelope? Could it have been a hastily scribbled message from one of his agents in the field? Or an urgent dispatch from one of his operatives, alerting him to the discovery of an insidious plot? Perhaps it was a note that Godfrey had passed into the hands of his most trusted aide, who, knowing that he would one day "write the spy story to end all spy stories," filed its contents away in his memory for use many years later in a James Bond adventure.

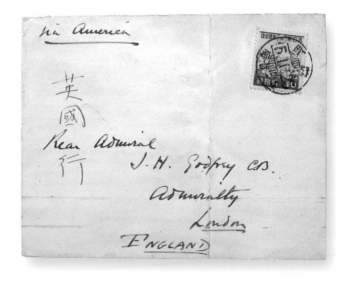

Message to M. This envelope was mailed during World War II to British intelligence chief John H. Godfrey—Ian Fleming's onetime superior and the model for James Bond's boss, known as "M."

007'S WALTHER PPK

Blofeld: "Do you know what gun this is?"

Osato: "A Walther PPK."

Blofeld: "Only one person we know uses this sort of gun. James Bond."

—You Only Live Twice, *1967*

"Why do you always wear that thing?" This question is put to Bond by a beautiful cabaret dancer in *Goldfinger* after his holstered gun pokes her in the breast during their kiss. Bond hesitates and then replies, "I have a slight inferiority complex."

It is indeed rare to find the licensed-to-kill 007 without his sidearm, which, throughout forty years of film adventures, has remained a Walther. In the early novels, however, the .25 Beretta was Bond's weapon of choice . . . until the closing scene of *From Russia with Love,* when the Beretta gets caught in the lining of Bond's jacket as he attempts to draw it on SMERSH's Rosa Klebb, nearly resulting in Bond's death.

It was around the time of that novel's publication that Fleming was contacted by Geoffrey Boothroyd, a British gun enthusiast who felt strongly that the Beretta was not the kind of weapon that an agent of 007's caliber should be using. He sent the author a Walther PPK, explaining

that it would be preferable to the Beretta, which he said was better suited for a female.

In Fleming's next novel, *Dr. No,* M takes Bond to task for the near-fatal mishap and orders him to submit to a lesson in weaponry from MI6 armorer Major Boothroyd. Bond surrenders his Beretta, and Boothroyd, in the film adaptation, weighs the piece in the palm of his hand, remarking, "Nice and light . . . in a lady's handbag. No stopping power."

Bond protests but is quickly overruled as Boothroyd presents him with a replacement weapon. "Walther PPK 7.65 mm," he says, "with a delivery like a brick through a plate-glass window. Takes a Brausch silencer with very little reduction in muzzle velocity. The American CIA swear by them."

For M, the decision is final: "You'll carry the Walther."

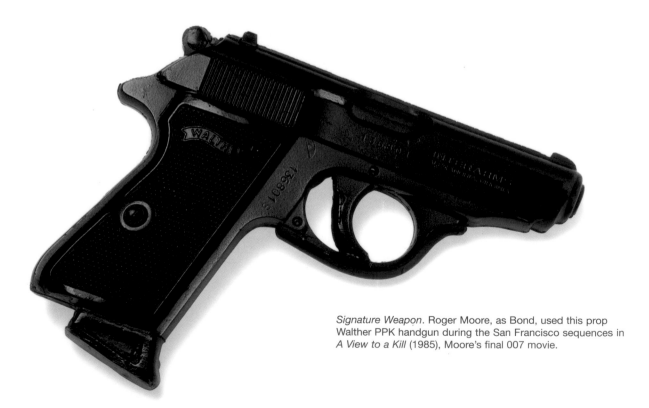

Signature Weapon. Roger Moore, as Bond, used this prop Walther PPK handgun during the San Francisco sequences in *A View to a Kill* (1985), Moore's final 007 movie.

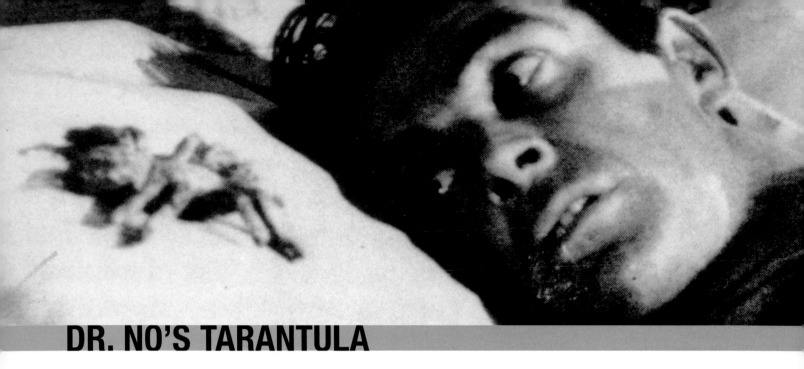

DR. NO'S TARANTULA

One of the most memorable Bond movie scenes is the one in which Sean Connery, as 007, awakens in bed to find a tarantula crawling up his arm. (In Fleming's novel, it was a centipede that had been placed in Bond's bed, but for the movie it was felt that a tarantula would be more visually terrifying.) Arranged by the villainous Dr. No, the deadly trap fails when Bond manages to smash the tarantula to death with his shoe.

While a real tarantula was used for the filmed sequence, an identical prop version was also employed during production. Between takes, the living tarantula—undoubtedly weary from shooting that grueling bed scene—left the set to take five, while his stand-in took over to help set up the next shot and appear in publicity photos with Sean Connery.

After filming wrapped, the tarantula headed straight for the British mod scene, where he spent the next decade hanging out on the wall of a London disco. But even swingin' spiders find that, as the years roll by, there comes a time to move on. Bidding adieu to his London bar mates, Sean Connery's onetime scene-stealer retired to Southern California. Enjoying the attention given to stars of classic movies, Dr. No's killer arachnid visited CIA headquarters as part of the *Spy-Fi* Exhibit. While there, he appeared live on NBC's *Today Show* with a film clip of his famous 007 movie scene.

Word has it that the tarantula's phone is ringing again. An on-screen reunion with Mr. Connery? Only if Sean keeps his shoes off the set, says the bug's agent. As a matter of fact, the tarantula agreed to be in this book on one condition: that Sean Connery's James Bond shoes appear on a *different* page.

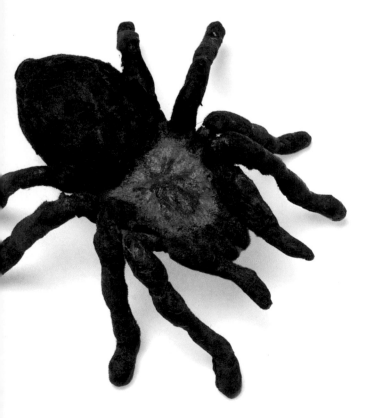

ABOVE:
Trouble! Sean Connery posed with the prop tarantula for this publicity shot. In the movie, creative editing kept the real spider a healthy distance away.

LEFT:
Bed Bug. This prop tarantula was used for shot setup and publicity photography during production of the first James Bond movie, *Dr. No,* in 1962.

OPPOSITE:
Executive Meeting. Blofeld's desk is the centerpiece of this meeting of SPECTRE's top brass.

BLOFELD'S DESK

If a man's home is his castle, then his desk is the royal throne from which he commands his personal kingdom. And it is unlikely that any other executive desk in the fictional world has stood silent witness to the kinds of hushed utterances that carry the weight of global consequence, as has the desk of Ernst Stavro Blofeld, chief executive of the international criminal organization, SPECTRE.

Few fictional movie villains have wielded as much power over their subjects as Blofeld has. Whether heading up a gathering of his top executives in a high-tech suite hidden off a boulevard in Paris or plotting from the high-rise casino lair of a missing Las Vegas billionaire, Blofeld commands SPECTRE's worldwide operations with an iron fist.

SPECTRE (SPecial Executive for Counterintelligence, Terrorism, Revenge, and Extortion) was invented by Ian Fleming as a replacement for SMERSH, the Soviet murder apparatus that served him so well as Bond's sworn enemy in four novels. Anticipating that the Cold War might soon thaw out, leaving Russia less practical as a

villain in his stories, Fleming decided, in 1959, to create this fictional criminal society composed of former members of the Gestapo, SMERSH, the Mafia, the Union Corse, and others.

The leader of an organization of twenty executives, Blofeld—in the novel *Thunderball*—is described as a shrewd, highly educated, power-hungry, asexual cipher of Polish-Greek descent. He has doll-like eyes set within a large, white face, crew-cut black hair, and pointed hands extending from his 280-pound frame. In the movies, however, he is not depicted like this; in fact, the character is initially kept in the shadows, shrouded in mystery.

We first meet the SPECTRE leader in an early scene of the second Bond movie, *From Russia with Love* (1963). He is seated at his expansive desk in a plush office on his yacht in Venice, Italy. We never see his face, only his hands stroking the white Persian cat resting in his lap.

From this desk, Blofeld meets with his director of planning, Kronsteen, and his head of operations, Rosa Klebb,

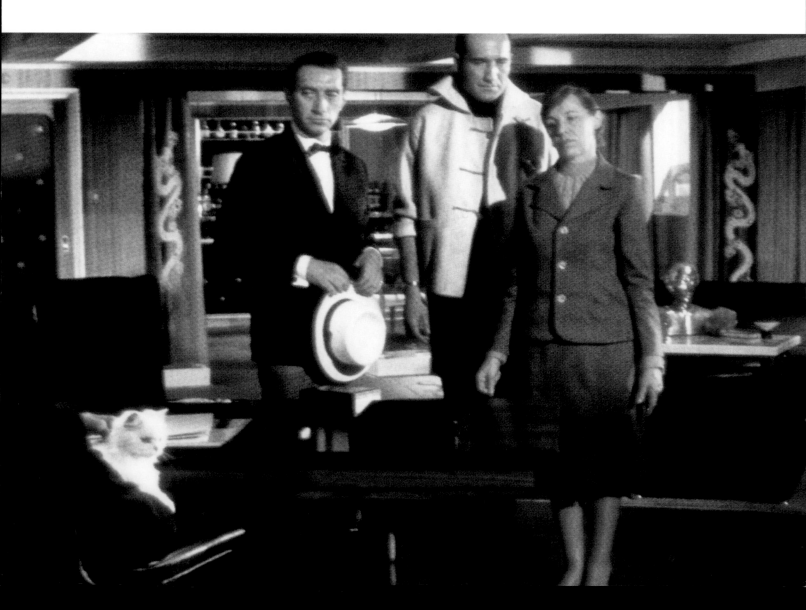

to orchestrate an insidious scheme to extort money from Russia, embarrass the British government, fan the flames of war between Russia and the West, and, as a bonus, effect the assassination of James Bond. When Blofeld learns, much later in the movie, that Bond has foiled the plan, he confronts Kronsteen and Klebb. Standing before their superior at his desk, the two blame each other for the failure. Blofeld appears to side with Kronsteen. "We do not tolerate failure," Blofeld says to Klebb. Then,

pressing a button on his desk, Blofeld summons an aide, who approaches, silently triggers a poisoned blade from his boot, and kicks not Klebb but Kronsteen in the leg with it. Looking at Blofeld in shock and disbelief, Kronsteen staggers, grabs onto Blofeld's desk for support, and then falls to the ground dead. Calmly stroking the white cat from behind his desk, Blofeld remarks, "Twelve seconds. One day we must invent a faster-working venom."

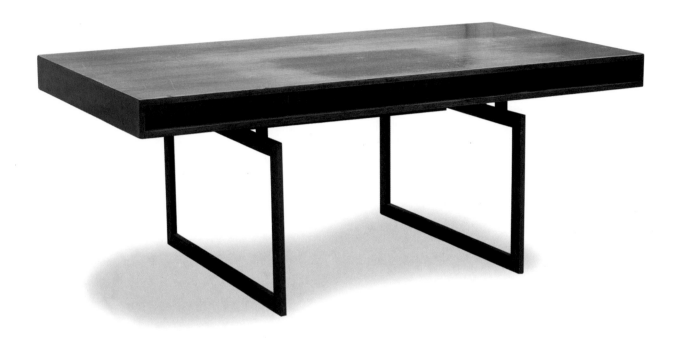

Command Center. SPECTRE leader Blofeld, with his fluffy white cat, sat behind this desk to devise his evil plans against James Bond in the second 007 movie, *From Russia with Love* (1963).

HOW TO FURNISH THE OFFICE OF A CRIMINAL MASTERMIND

Setting out to furnish the set that would be Blofeld's office, the set decorators of *From Russia with Love* spotted a desirable desk and chair at the offices of Oscar Woollens in London. The furniture had just been sold to the Hertford Handbag Company, but they were willing to loan it to the production.

After their use by the director of SPECTRE, the desk and chair were delivered to the managing director of Hertford

Handbag, Donald E. Smith. "The desk was a valued piece of furniture in my office until my retirement," recalled Smith. "The chair, unfortunately, was beyond repair and destroyed." After Woollens, Blofeld, and Smith used the desk, it fell into the possession of a fourth managing director, the head of the Spy-Fi Archives.

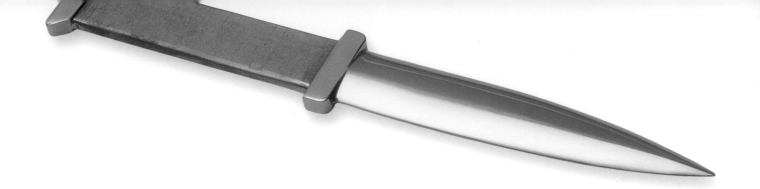

THE PROTOTYPE KNIFE
FROM 007'S ATTACHÉ CASE

"In the side here, a flat throwing knife. Press that button there, out she comes."

—*Major Boothroyd to 007,* From Russia with Love

The knife would be James Bond's ace in the hole if he found himself in imminent danger, trapped and unarmed. It was part of a survival kit—"an ordinary black leather case"—supplied to him by Q Section's Major Boothroyd for his mission in *From Russia with Love*. 007 doesn't want it at first—"I shouldn't think I'll need it on this assignment, sir," he says to M. "Nevertheless, take it with you," M counters. Bond does. And days later, the knife saves his life.

The events leading up to this begin when MI6 learns that a Russian cipher clerk, Tatiana Romanova, is offering to smuggle one of Russia's top-secret Lektor decoding machines out of its embassy in Istanbul . . . *if* James Bond will take her along as well. Sensing a trap, M nonetheless decides to bite. He summons 007 and calls in Boothroyd to equip him.

The smart-looking attaché case—inspired by a similar piece of luggage in Fleming's novel—contained an AR-7 folding sniper's rifle, hidden ammunition, and straps of gold coins, plus a booby-trap mechanism that would trigger a disguised tear-gas canister to explode if anyone other than Bond attempted to gain entry. Finally, a button on the corner of the case, when pressed, would eject a flat throwing knife from a secret sheath.* Demonstrating, Boothroyd activates it and Bond, intrigued, lifts out the knife. Bond sums up the gadget in one apt phrase: "a nasty little Christmas present."

Days later, having escaped Istanbul with both Tatiana and the Lektor, Bond finds himself trapped in a train compartment, the prisoner of SPECTRE assassin Red Grant. The sadistic Grant is about to kill Bond, who has been disarmed and is on his knees. But with the lure of the hidden gold sovereigns, Grant is tricked into opening the attaché case, thereby exploding the gas canister and giving Bond the chance to strike. A vicious fight ensues, and the powerful Grant gets the upper hand,

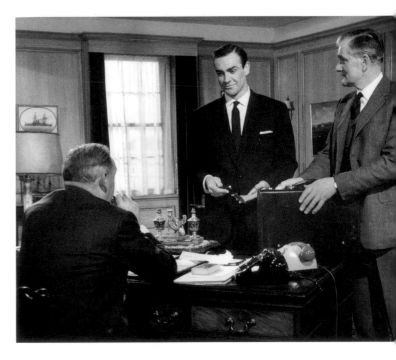

TOP:
Nasty Little Christmas Present. This is the prototype model for the flat throwing knife that popped out of James Bond's gadget-filled attaché case—a gift from Q in *From Russia with Love*.

ABOVE:
Session with Q Branch. In M's office, Major Boothroyd demonstrates the attaché case for Agent 007. Sean Connery, as Bond, holds the prop knife that comes in handy during his mission in Istanbul.

* In the novel, the Swaine and Adeney case contained "in each of the innocent sides . . . a flat throwing knife, built by Wilkinson's, the sword makers, and the tops of their handles were concealed cleverly by the stitching at the corners."

strangling Bond with a garrote wire pulled from his watch. Bond, however, manages to reach the black case and press the eject button for the secret knife. He grabs it and plunges the dagger deep into Grant's shoulder, giving 007 enough of an edge to kill Grant with his own strangle wire.

The secret knife and the multifunctional case that housed it are significant elements in the movie: They represent the debut of this type of clever espionage gadgetry, which became thereafter a permanent fixture in both the Bond film series and the spy genre itself.

And the "nasty little Christmas present" turned out to be just that. Shortly after the release of *From Russia with Love*, Multiple Products manufactured the "James Bond 007 Attaché Case," an elaborate toy for kids that undoubtedly found its way, that Christmas, into the homes of families across the United States. Just like the prop in the movie, the toy version contained a sniper's rifle, a row of ammunition, an exploding booby-trap mechanism, and the hidden knife . . . made of hard plastic, of course.

OSATO CHEMICAL STATIONERY

A letter arrives in the mail. You check the return address. It is from Osato Chemical Engineering Co., Tokyo, Japan. The ordinary letterhead of an ordinary company?

In the world of spy-fi circa 1967 *(You Only Live Twice),* Osato Chemical is a major Japanese corporation, owned and operated by a short, middle-aged businessman, Mr. Osato. The new managing director of Empire Chemicals, Mr. Fisher, meets with Mr. Osato to negotiate a typical agreement at Osato's office. After their business is concluded, Osato bids Fisher good-bye and then turns to his personal secretary, Helga Brandt, with her next secretarial assignment: "Kill him."

Later that day, Fisher is taken prisoner and delivered to Miss Brandt, who threatens to torture him to death with a surgical instrument. Fisher confesses to being an industrial spy and offers to make Helga his partner in the sale of stolen formulas. But later, after making love to Fisher, she tries to kill him anyway. Business as usual in the cutthroat world of big business and high finance?

The truth is that Osato Chemical is in fact a front for SPECTRE, and both Miss Brandt and Mr. Osato are agents of that terrorist group, reporting directly to Blofeld, himself. As for "Mr. Fisher," he is, in reality, James Bond. For their failure to kill Bond, Mr. Osato is shot dead by Blofeld, and Miss Brandt is fed to a pool of man-eating piranha. As for Bond, his investigation of Osato Chemical eventually leads him to Blofeld. The SPECTRE chief manages to escape, but Bond succeeds in foiling his plot to trigger World War III.

So . . . the next time you get a letter in the mail, remember that even an ordinary piece of stationery may have an extraordinary tale to tell.

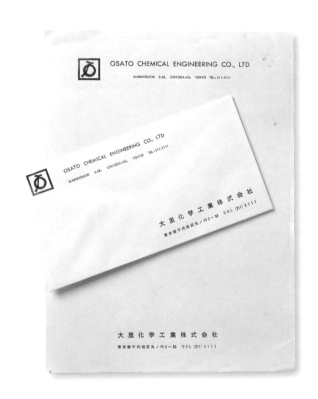

Take a Letter, Miss Brandt. This prop stationery was used on the set of Osato headquarters during production of the fifth Bond movie, *You Only Live Twice* (1967).

NINJA THROWING STAR

The life of James Bond was once saved by this small weapon—a ninja throwing star. At the climax of *You Only Live Twice,* SPECTRE chief Blofeld is about to "inaugurate a little war" from his secret lair inside a Japanese volcano. Supported by a team of modern-day ninjas, Bond invades the complex but eventually finds himself cornered by his nemesis. His white cat cradled

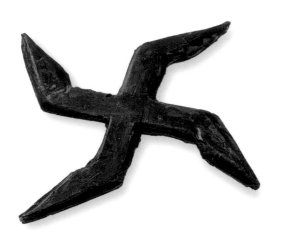

to his chest, Blofeld points a gun at Bond and says with an air of triumph and finality, "Good-bye, Mr. Bond!" Suddenly, a small, metallic, razor-sharp "star," seemingly from nowhere, flies through the air and buries itself in Blofeld's arm, causing him to drop the gun just as he is about to fire it. Blofeld escapes and Bond learns who his savior is: Tiger Tanaka, head of the Japanese Secret Service and commander of the ninja assault squad.

The movie's Secret Service ninjas are a modern-day version of the ancient Japanese warriors who used stealth and concealment to carry out sabotage and assassination. (Notably, the CIA has reported that Saudi Arabia currently recruits thousands of ninjas to perform bodyguard and internal security services.) As for the throwing star, it has, for more than a thousand years, been used by ninjas as a means of distraction, deterrence, and—when dipped in poison—death.

Silent and Deadly. This prop throwing-star weapon, constructed of hard rubber, was used by Sean Connery as James Bond in *You Only Live Twice.*

BRAIN-CONTROL DEVICE

James Bond may have thought a meal was in order after making love to Fatima Blush, but he never imagined the meal would be *him.* Taking a swim in the ocean after their coupling aboard Fatima's boat, the beautiful SPECTRE assassin secretly attaches an electronic homing device to Bond's aqualung, which sends a signal to a receiver implanted on the skull of a shark, triggering its brainwaves to track Bond. It is a game of cat and mouse as 007 tries to evade the deadly shark, until he finally detects the homer and escapes.

The scene was satirized years later in *Austin Powers,* when Dr. Evil complains about not having any radio-controlled sharks. In the second sequel, he finally gets them as a gift from his son, Scott.

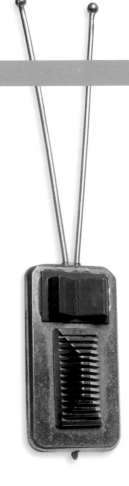

Don't Give It Another Thought. This prop mind-control unit was used by SPECTRE to make a killer shark go after Bond in *Never Say Never Again.*

007 WALLPAPER

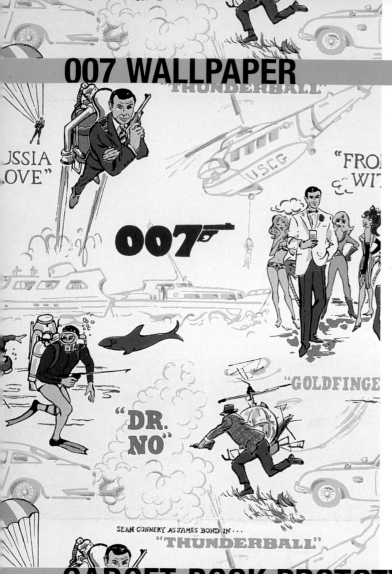

My mid-'60s childhood bedroom was filled with spy toys, books, records, and posters. Although I had fashioned this room into a world of spydom, a day arrived when I felt that perhaps that world was not enough. Why? Because my mother told me she'd heard that a wallpaper store in Reseda, California, was selling a new pattern: *James Bond wallpaper!* It would certainly be the ultimate cool to have all four walls plastered with images from the 007 films, to be surrounded by Bond even as I slept.

My parents, for reasons unclear, chose not to indulge me. It may have been the cost, or simply that, with perfectly good wallpaper already in place, this would be taking my passion for Bond one step too far. My disappointment, however, proved to be short-lived. The owner of the store, learning of my tremendous interest in Bond, sliced off a large section of the wallpaper and gave it to my mother as a gift for me.

In the decades since, I've heard of no one else growing up with James Bond wallpaper. But I'm proud to say that, thanks to my mother and the shop owner I never met, I was fortunate to have been given a sample of it. As with all the spy memorabilia I saved as a kid, that sheet has remained in my collection to this very day.

GADGET-BOOK PROTOTYPE AND ARTWORK

The phenomenal box-office success of the James Bond movies in the 1960s spawned an equally successful merchandising program. American Character was one of the companies granted a license to manufacture a line of James Bond action toys. Possibly inspired by a gadget in the movie *Thunderball*—a hollowed-out book fitted with a secret tape recorder—the company created the prototype for a mock book that would hold a variety of spy devices. "At the time, I thought it was a novel idea to hide all the components in a book," recalled the toy's designer, Fred Hollinger. "We went from sketch to handmade coverings to actual preproduction cardboard, hot-stamped prototype, with a flocked molded plastic insert to hold the products in place."

The prototype devices included a shooting pen, code ring, self-destructing notepaper, message missiles, and an ID bracelet with a secret compartment. "I used painted plastic tube for the projectiles," explained Hollinger. "The pen was not a working model, and the bracelet was just a regular men's bracelet with the 007 logo written on adhesive tape and stuck on." For the mock book, Hollinger

used rub-on letters, color markers, and an original sketch of a "Bond-like" character. Of course, the "phony" book needed a title. "What would be a catchier name than *Effective Pest Control?*" said the designer.

This toy would certainly have been every little boy's dream. "Unfortunately," said Hollinger, "the bean counters saw that this concept would be too expensive to produce, not enough profit margin to keep in line with a certain retail price." But all was not lost. Young Bond fans across the United States were already in 007th heaven with the merchandising onslaught of records, model kits, toy cars, beach towels, and action figures. And then American Character decided to produce the gadgets *inside* the book as separate toys, without the book as its secret carrying case.

Fortunately, Hollinger's spy-book prototype and sketches survived, leaving Bond fans, film historians, and toy aficionados with evidence of one very clever '60s-era James Bond toy that might have been.

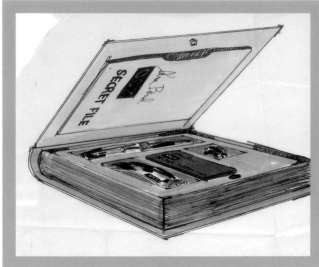

OPPOSITE:

Off the Wall. This section of rare James Bond wallpaper was a 1966 gift from a San Fernando Valley, California, wallpaper store.

LEFT:

Novel Idea. This is the original artist's concept of the James Bond toy spy book, 1966.

BELOW:

Never Judge a Book . . . This is the prototype for the never-manufactured Bond spy book. While it looks like an ordinary book, behind the title page lies an assortment of clever gadgets.

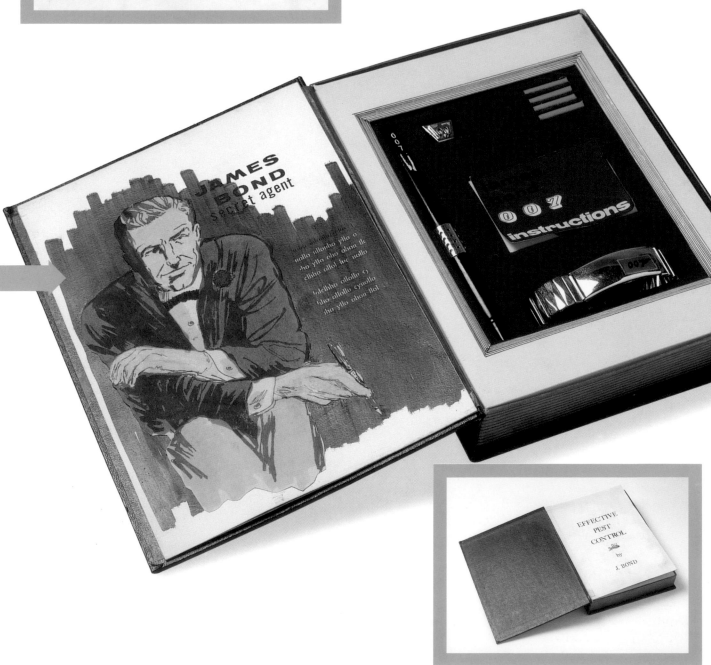

DRACO'S CALENDAR

It was 1969. *Apollo* landed on the moon. Yasser Arafat took control of the PLO. An antiwar march descended upon Washington, D.C. The Woodstock Music Festival drew three hundred thousand fans. And last, but not least, the world as we know it nearly came to an end when a bacteriological terrorist plot was set into motion by SPECTRE. No one knew this, of course, except for British intelligence, whose agent, James Bond, foiled the plan in Switzerland while *On Her Majesty's Secret Service.*

Bond's success was due in part to a chance meeting with Tracy di Vicenzo, a haunting, beautiful woman whom Bond meets on a beach in France. Bond ends up spending the night with Tracy, only to find himself kidnapped the following morning and taken to a strange house at knife-point. Bond overcomes his captors, secures their knife, and finds himself in a plush study across the room from a distinguished man who identifies himself as Count Marc-Ange Draco, head of the Union Corse crime syndicate.

Bond flips the knife in his hand and throws it with precision toward the fellow who, Bond surmises, arranged his abduction. The knife whisks through the air, flying directly toward Bond's host, and then, as planned, shoots past him and into a calendar on the wall. Draco looks at his calendar, the knife firmly imbedded in the page, *September 1969.*

As Draco turns back to Bond, he does a double take, putting on his eyeglasses to get a better look at the calendar. Bond's knife has found its mark on September 14.

"But today is the thirteenth, commander," admonishes Draco. "I'm superstitious," says Bond.

Draco, Bond learns, is Tracy's father. Although on opposite sides of the law, the men quickly develop a friendship—one that leads Bond to a private allergy clinic in the Swiss Alps, where he uncovers and destroys Blofeld's insidious new operation.

Such were the events of September 1969—the date on a mob chief's calendar, pierced by the knife of a British agent in love with his daughter.

How Time Flies. In Fleming's novel *On Her Majesty's Secret Service,* James Bond throws a knife at a wall calendar, aiming for September 16 but hitting 15. In the movie adaptation, the knife hits this prop calendar page on 14.

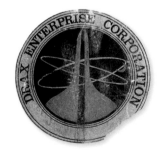
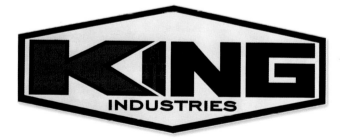

BOND VILLAIN CORPORATE LOGOS

Three Faces of Evil. These are prop insignias of three fictional corporations from the Bond movies—Stromberg Shipping Lines, Drax Enterprise Corp., and King Industries—each run by a criminal mastermind with designs on the world.

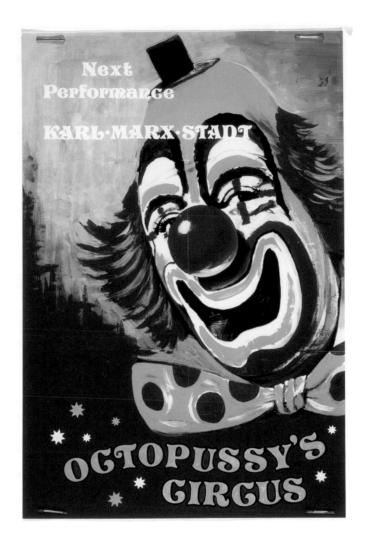

OCTOPUSSY'S CIRCUS PROGRAM

Come one! Come all! It's Octopussy's traveling circus! Clowns . . . elephants . . . acrobats . . . a human cannonball!

What could be more delightful than spending a day at the circus? Surrounded by throngs of excited people, you and your family approach the entrance of the giant circus tent and are handed an official program. The pamphlet cover features a painting of a happy clown. "This is going to be a real treat!" you assure your family.

Clutching the souvenir program, you find seats in the bleachers that encircle the center ring. You open the program and flip through the pages, smiling in anticipation of all the entertaining acts promised for the afternoon.

Unfortunately, things are not always as they seem. Do you see that red-nosed clown bouncing around the circus ring? Doesn't he seem a bit nervous? There is a deep concern in his eyes that cannot be masked by all that makeup.

A shot rings out and the cannon breaks open. The clown rushes toward it, but security guards stop him. The clown reveals that his name is Bond and that there is a bomb in the cannon set to explode any second. A sudden hush falls under the circus tent as Bond moves toward the device and attempts to disarm it. You sit quietly, look down at your circus program, and have faith that James Bond will once again save the day.

Come One, Come All! This prop program was distributed at Octopussy's traveling circus show, front for an international smuggling operation in *Octopussy* (1983).

KAMAL KHAN'S CHECK AND CURRENCY

One thing every supervillain needs to launch a master plan for world domination is money. *Lots* of money. Goldfinger had his hordes of smuggled gold. Mr. Big had his poppy fields, and Sanchez had his heroin lab. Elektra King had her oil reserves, and Gustav Graves had his diamond mines.

Kamal Khan, 007's nemesis in *Octopussy,* earned his wealth from the international smuggling operations he and his partner conducted under the cover of a traveling circus. Outwitted by Bond in Khan's fixed backgammon game, Kamal is forced to pay his opponent 200,000 rupees. Khan whips out his checkbook, but Bond wisely insists on cash. "Spend it quickly,

Mr. Bond," Khan says threateningly. "I intend to," Bond assures him. Later, chased through the busy city streets by Khan's henchmen, Bond hurls the cash into the air to attract the crowds, creating a frenzied roadblock against his pursuers.

This prop check came directly out of Khan's checkbook, and the Indian currency is part of Khan's payoff that Bond used for his escape.

Illicit Funds. This prop business check and Indian currency are from the private account of Bond nemesis Kamal Khan in *Octopussy.*

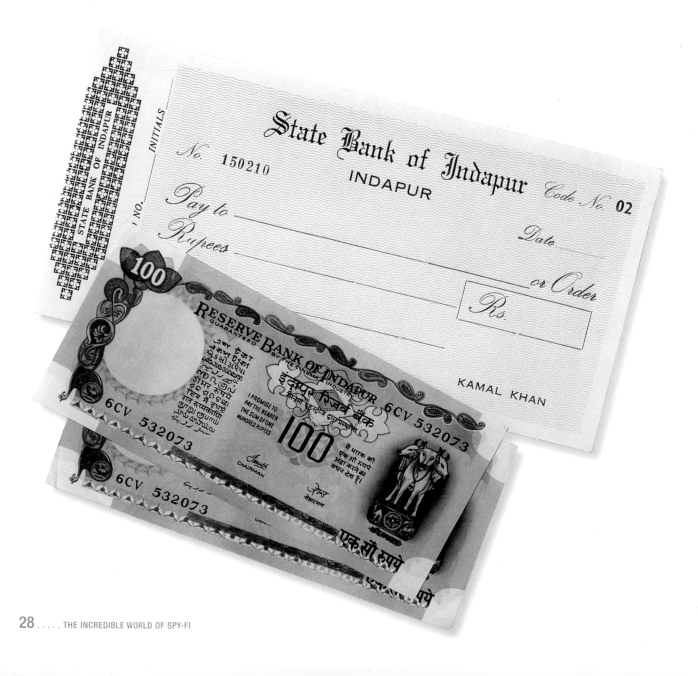

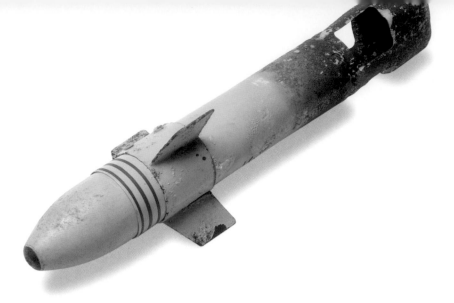

ASTON MARTIN MISSILE

This yellow missile represents one of the most famous gadgets in the 007 film series: James Bond's Aston Martin. Bearing the blackened scars of being fired from the secret launch well beneath the car's headlights, the explosive foot-long heat seeker was used by Bond to blast through a military roadblock in Czechoslovakia during a 1987 mission.

Agent 007 was first issued an Aston Martin DB3 in Fleming's 1959 thriller, *Goldfinger*. The car, which Bond chose over a Jaguar 3.4, was provided as part of his cover—"a well-to-do, rather adventurous young man with a taste for the good, the fast things of life." Bond selected the Aston because of its "extras": steel bumpers, headlight and taillight modifiers, a homing-device receiver, and secret compartments, one of which concealed a Colt .45.

In the 1964 film adaptation of that novel, Bond finds that his beloved Bentley has been retired in favor of an Aston Martin DB5, whose special modifications have been updated from those in the book. Q gives Bond a rundown of the machine guns, oil-slick and smoke-screen releases, homing tracker (as in the novel), and—no joke, Q insists—an ejector seat. It all comes in handy when Bond heads to Switzerland to investigate the gold-smuggling activities of Auric Goldfinger.

The Aston resurfaces in six subsequent adventures, but it is in *The Living Daylights* (1987) that this particular missile is employed. Attempting to outrun the state police in his Aston Martin V8, Timothy Dalton, as Bond, activates the Aston's new "optional extras," including two heat-seeking missiles secreted behind the V8's fog lights. Taking aim with the help of a targeting display that appears on the car's windshield, 007 presses the missile buttons on a concealed weapons console. The fog lights flip open and the missiles are fired, blowing up the opposition on the road ahead.

TOP:

Optional Extra. This prop missile was fired from 007's Aston Martin at an enemy roadblock in Timothy Dalton's debut Bond thriller, *The Living Daylights* (1987). Recovered from the scene after filming, it still shows the burn marks from the blast that sent it flying.

ABOVE:

Deadly Car. The missile was fired out the front of this Aston Martin in *The Living Daylights*.

The Carver Media Group requests your presence at the party of the year: the launch of media mogul Elliot Carver's global communications network. A word of caution, though, as you enter the building. When you move through the crowd, rubbing shoulders with the hundreds of VIPs, jet-setters, and members of the world press, be aware that hidden cameras are recording your every move. In fact, Carver himself occasionally views the surveillance tapes, particularly if it happens to be a video of his wife, Paris, making small talk with an ex-lover. "Tell me, James," Carver will hear his wife say, "do you still sleep with a gun under your pillow?"

You also should avoid wandering too far from the main party area. You might open the wrong door and stumble into a back room where one of the guests is being beaten up by two of Carver's bodyguards. "What sort of a party is this?" you might ask yourself. You look again at the man being attacked. He strikes you as familiar. Of course. It's the man in the video with Carver's wife. *James.* That's it. *James Bond.* This is not a man who will stand for this kind of treatment. Before your eyes, he turns the tables on Carver's thugs, leaving both unconscious on the floor.

Elliott Carver, Bond will soon discover, has launched a devious plan to put China and England at war and, in the process, acquire for himself exclusive media rights in China. Once again, Agent 007 will have his mission—to stop another megalomaniac from implementing his evil plans.

But we're getting ahead of ourselves. This should be of no concern to you. In your hand is an invitation to a party. By all means, phone in your RSVP to Mr. Carver. Tell him you'd be delighted to attend. . . . Wouldn't miss it for the world! As for your host, Elliot Carver, you can be sure that he'll be keeping a sharp eye out for you.

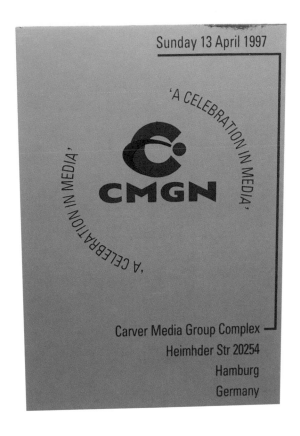

Sunday 13 April 1997

'A CELEBRATION IN MEDIA'

CMGN

'A CELEBRATION IN MEDIA'

Carver Media Group Complex
Heimhder Str 20254
Hamburg
Germany

ABOVE:
Invitation from a Villain. This prop invitation was used during the Elliot Carver party in the eighteenth Bond movie, *Tomorrow Never Dies* (1997).

OPPOSITE, TOP:
End of an Era. This is the cover of the booklet that was distributed to family and friends of Ian Fleming at his memorial service, September 15, 1964, at St. Bartholomew The Great, in England.

OPPOSITE, BOTTOM LEFT:
***ARCHIE* COMIC BOOK**

Ubiquitous Bond. James Bond seemed to be everywhere in the 1960s, including on the cover of this *Archie* comic book in November 1965.

OPPOSITE, BOTTOM RIGHT:
JAMES BOND ID CARD

Card-Carrying Bond Fan. This identification card was used by the author at age ten.

IAN FLEMING

28th May 1908

12th August 1964

EXCERPT FROM
THE IAN FLEMING MEMORIAL BOOKLET

"Isn't it possible that Bond and his adventures became world-famous . . . because they constitute a thoroughly romantic myth, a series of vivid fairy-tales, which seems to fulfil a persistent need? Isn't it perhaps the simple, age-old need to escape from dullness by identifying oneself with a dragon-slaying and maiden-rescuing hero, who wins battle after battle against devilish forces of destruction, and yet continues indestructible himself? What a feat to have re-created, in a new idiom, a myth of such universal appeal!"

—William Plomer, a close friend of Fleming, September 15, 1964

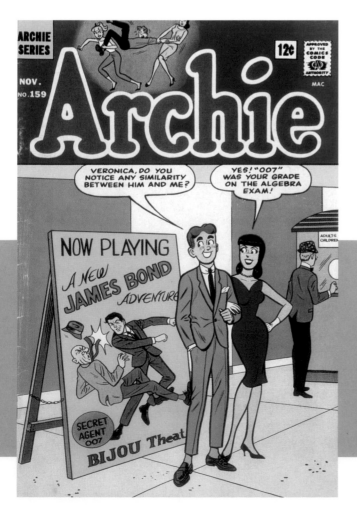

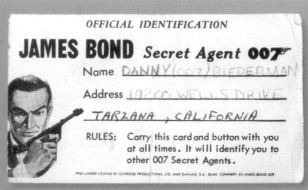

THE MAN FROM U.N.C.L.E. 2

CHAPTER 00:02

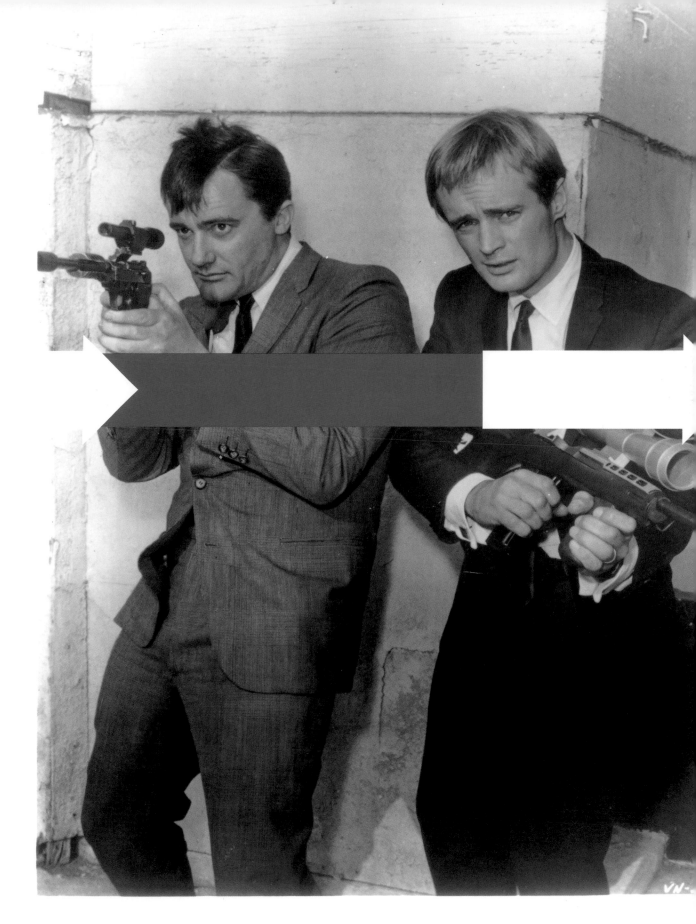

Solo and Illya on the Scene. Robert Vaughn and David
McCallum took the world by storm in *The Man from
U.N.C.L.E.*

"The question of why *U.N.C.L.E.* was an international hit has been posed many times. The Bond films were enormous successes, so the audience was ready For an hour or two, it pulled the American populace away from the cares and woes of the world."

—*Robert Vaughn*

The Man from U.N.C.L.E. is, arguably, the most popular TV spy series of all time. This tongue-in-cheek espionage thriller was such a worldwide hit in 1965 that its two stars—Robert Vaughn and David McCallum—were mobbed by teenage fans wherever they appeared. Even the Beatles asked to meet Vaughn during their visit to Hollywood.

The seeds of this show took root in 1963, when Norman Felton—executive producer of *Dr. Kildare* and *The Eleventh Hour*—was brainstorming ideas for a new TV program. He thought viewers were tired of the serious social dramas that had long dominated the networks' schedules. "I wanted a change of pace, a reaction the other way," recalled Felton, "so I decided to do an adventure, because I'd never done one." Suspecting that a Bond-like espionage concept might work, Felton pitched his agent an idea about a brilliant yet mysterious man who, working out of a secret office at the United Nations, helps to solve international crises. Felton invited Ian Fleming to help create the show but found that the 007 author's hastily jotted story lines were not substantial enough. Felton did, however, like Fleming's proposal for the name of the hero—Solo—which Fleming had lifted from his novel *Goldfinger*. In the book, Solo is one of the mobsters that Goldfinger recruits for his planned raid on Fort Knox.

Titling his new show *Mr. Solo,* Felton recruited writer-producer Sam Rolfe (cocreator of TV's *Have Gun—Will Travel*) to develop a workable series. Rolfe did that and more; he manufactured an entire universe. Behind "an ordinary tailor shop" in New York City, claimed Rolfe, there exists a secret organization called U.N.C.L.E., which stands for "United Network Command for Law and Enforcement." "The problems that confront . . . U.N.C.L.E. are enormous in range [and] international in significance," announced NBC in early 1964. "Any destructive political, criminal, or natural force that may affect large masses of people . . . comes within their area of responsibility."

In each hour-long episode, an innocent person would get swept up into a surreal world of spies and intrigue. Although U.N.C.L.E.'s global operations would be handled by its five international branches, the weekly adventures (the title of each ending in "Affair") would focus on the globe-trotting adventures of two agents working out of U.N.C.L.E.'s Manhattan headquarters: the Canadian-born Napoleon Solo and Illya Kuryakin, a Russian. In the midst of the Cold War, it was a bold idea to team a Westerner and a Russian as heroes against a common evil, the embodiment of which was given the name Thrush, a secret group of conspirators out to control the world.

The fact that the members of U.N.C.L.E. were multi-national appealed to Felton. "It bothered me to perpetuate the notion that Americans seem to solve everybody's problems," he said. "I didn't like entertainment that said, 'Any problems? Uncle Sam will send someone.' I said, I'll do an adventure with good men and bad men—Americans, Germans, French, Russians, anybody. Good and bad on both sides, because that's the way things are."

NBC liked the *Solo* pilot enough to order a series for its fall 1964 lineup. But with the third Bond movie, *Goldfinger,* premiering that Christmas, United Artists didn't want Fleming's name, or that of the Bond villain Mr. Solo, associated with a concurrent espionage vehicle. Felton was told to disassociate his project from Fleming

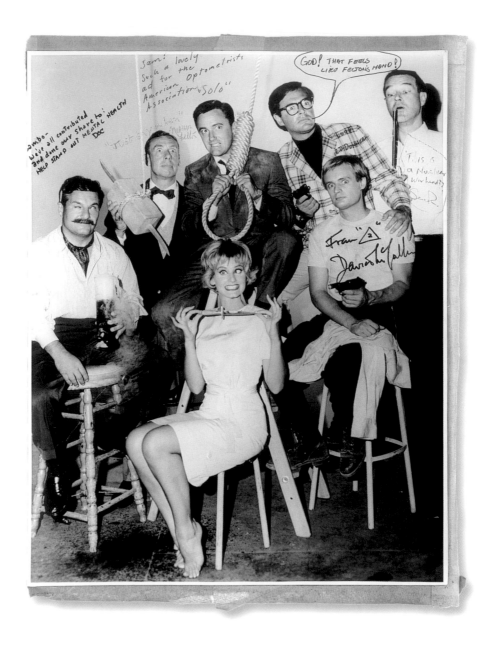

and to change the name of his series. He complied, paying Fleming an agreed-upon $1 for his services and changing the title of the TV show to *The Man from U.N.C.L.E.*

Starring Robert Vaughn as Solo, David McCallum as Illya, and Leo G. Carroll as U.N.C.L.E. chief Alexander Waverly, the tongue-in-cheek *Man from U.N.C.L.E.* took several months to find its audience. But once it did, the series quickly turned into an international sensation. McCallum's attire—the "Illya look"—had a huge impact on fashion, putting black turtleneck sweaters in vogue across the globe. The series also became popular for its clever espionage gadgetry, which resulted in merchandising spin-offs, industry honors, and extensive magazine layouts.

The Man from U.N.C.L.E. ran for nearly four years on NBC, inspiring a seemingly endless array of spoofs and imitators. A pop-culture phenomenon of the '60s, *U.N.C.L.E.*'s imaginative approach to escapist espionage altered the landscape of prime-time television. Its influence can be seen even in today's TV and movie spy thrillers.

The U.N.C.L.E. *Team.* This rare behind-the-scenes portrait of the series' creators is signed by each to writer-producer Sam Rolfe. Pictured are (clockwise from top left) story editor Joseph "Doc" Calvelli, executive producer Norman Felton, star Robert Vaughn, director Richard Donner, Sam Rolfe, co-star David McCallum, and guest star Jill Ireland.

IAN FLEMING'S COPY OF *SOLO*

When Sam Rolfe completed his seventy-five-page *Solo* series prospectus, Norman Felton sent this copy of it to Ian Fleming, inviting his comments. A notation on the cover says "Ian's Copy," followed by the numbers 8 and 9, referring to the page numbers on which Fleming made suggestions in pen. On page 8, Fleming altered the description of how a Thrush assassin ignites a thermite-manganese solution designed to burn through a steel door leading to the office of the U.N.C.L.E. chief. Instead of "striking a match he lights the fuse," Fleming wrote: "He bunches the soft metal." On page 9, where we first meet Mr. Solo, Fleming changes his gun from a Walther P-38 to a Smith & Wesson (one of the guns that Geoffrey Boothroyd once told Fleming that James Bond should use). When the scene described on page 9 was actually filmed, Solo used a German Luger.

RIGHT:

Licensed to Quill. Ian Fleming's copy of Sam Rolfe's *Solo* prospectus includes several handwritten notations made by Fleming at the invitation of Norman Felton.

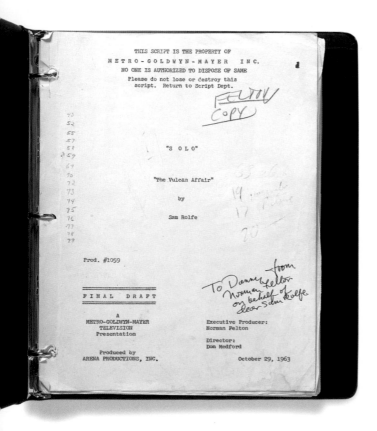

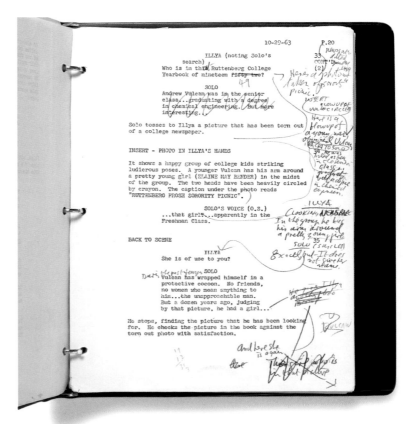

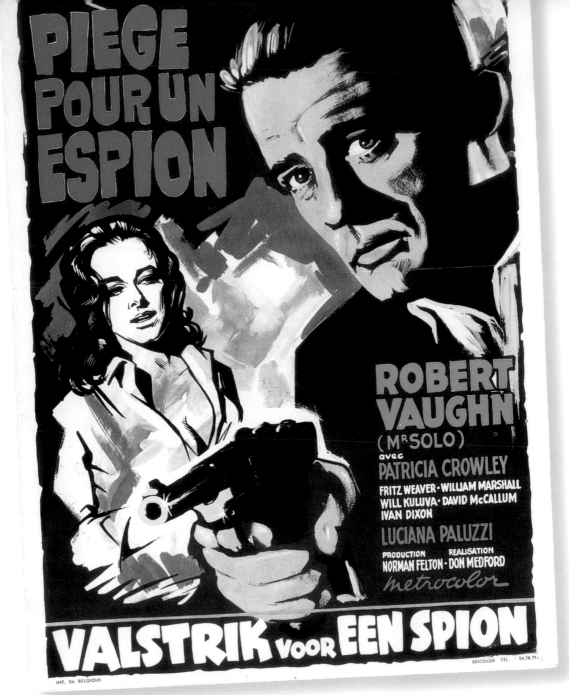

ABOVE:
BELGIAN *SOLO* MOVIE POSTER

To Trap a Spy. An extended version of the *U.N.C.L.E.* pilot was released around the world as a theatrical motion picture. This is the Belgian poster advertising that movie.

OPPOSITE, BOTTOM:
***SOLO* PILOT SCRIPT**

The Beginning. This is Norman Felton's master copy of Sam Rolfe's pilot script for the *Solo* series, titled "The Vulcan Affair." The draft contains numerous notes, in Felton's handwriting, suggesting changes in dialogue and action.

RIGHT:
NBC PRESENTATION BOOKLET

Welcome to U.N.C.L.E. This in-house presentation book describes the new TV series.

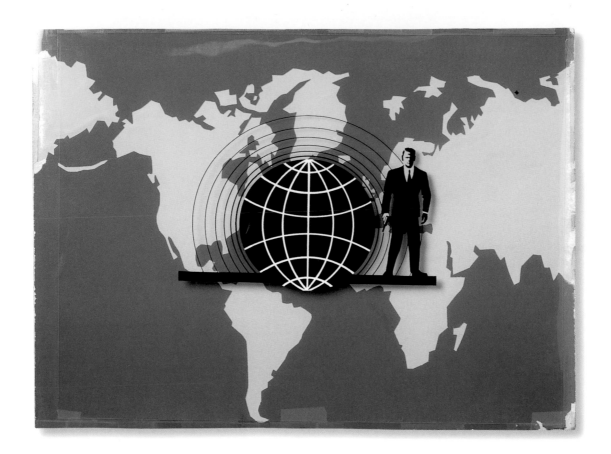

U.N.C.L.E. LOGO CEL AND WORLD MAP

The dynamic opening title sequence in the *U.N.C.L.E.* series features a stylized blue-and-yellow map of the world, against which forms the silhouette of a man in a suit, holding a gun and standing beside a globe, as its protector. A series of semicircles echoes outward from Earth. Beneath this image are the letters *U.N.C.L.E.* As the globe gives way to shots of the starring performers, the exciting *Man from U.N.C.L.E.* theme music, composed by Jerry Goldsmith, accompanies the visuals.

The man-and-globe insignia was, at the series' outset, adapted as the official logo of the U.N.C.L.E. organization and used on props such as files and documents. A highly identifiable '60s pop-culture image, the U.N.C.L.E. logo was used regularly in advertising and merchandising for the series.

Zip-pan forward to sixteen years after *U.N.C.L.E.*'s cancellation. The powers that be at MGM—the Culver City, California, studio where the show was produced—decide to do some housecleaning, and an order is issued to destroy the enormous amount of stored paraphernalia that accumulated during decades of film production. The contents of drawers, shelves, and filing cabinets are suddenly

and unceremoniously dumped. A studio employee working on Michael Landon's *Highway to Heaven* series watches as studio personnel trash, among other things, all the negatives and prints from Elvis Presley's movies, including photos of his wedding. Alarmed, but helpless to halt the mass destruction, the employee spontaneously wanders into one of the targeted rooms, reaches toward a shelf, and grabs a large envelope without the destruction crew noticing. Taking the envelope home and opening it, he discovers what he—on a moment's impulse—has saved from oblivion: the logo animation cels, world-map art, and end-credit photos used to create the title sequences of *The Man from U.N.C.L.E.*

ABOVE:
Famous TV Title. This is the original artwork used to create the dynamic opening titles of *The Man from U.N.C.L.E.*

OPPOSITE, BOTTOM:
Promo Prop. This ID card signed by Napoleon Solo was used on a TV commercial by Robert Vaughn, urging viewers to watch the show.

NAPOLEON SOLO'S BUSINESS CARD

Secret agents must be discreet at all times, and Napoleon Solo is no exception. His personal business card says simply "Napoleon Solo—New York, N.Y."

This original prop card was used by Robert Vaughn in the role of Solo. In one episode, "The Nowhere Affair," Napoleon swallows an amnesia-inducing capsule when he knows that his capture by Thrush is imminent. Later, as Thrush's prisoner, Solo goes through his wallet and finds this business card—a piece of the puzzle to his identity.

Napoleon Solo
New York, N. Y.

Meet Mr. Solo. This prop business card was used in the series by Napoleon Solo.

SOLO'S TV PROMO ID CARD

Signed by Napoleon Solo himself, this U.N.C.L.E. identification card was shown to TV viewers in close-up on a commercial promoting the new series. The camera pulled back from the card, revealing that it was being held by Robert Vaughn. Identifying himself as "the man from U.N.C.L.E.," he asked the audience, "Are you ready to give up your life for U.N.C.L.E.? Well, a lot of folks are. . . . Why don't you tune in?"

This prop card was never again seen on TV, but its use as a promotional tool had only just begun. In a brilliant marketing move, MGM printed millions of these cards during the course of the series, mailing 70,000 per month to the hordes of viewers who inundated the studio and network with fan mail. The membership cards stated that the bearer was an active agent of the U.N.C.L.E. organization and noted that official U.N.C.L.E. "operations" could be viewed weekly by tuning in to the show on NBC.

These cards had the effect of furthering the notion among viewers that U.N.C.L.E. was a real organization. At the end of each episode, an official-looking on-screen credit thanks the U.N.C.L.E. organization for making the program possible. Consequently, the United Nations and the FBI were overwhelmed by applications from people who wanted to work for U.N.C.L.E. FBI Director J. Edgar Hoover fired off harshly worded responses that said: "For your information, the television series entitled *The Man from U.N.C.L.E.* is fictitious. There is no government agency which performs the functions portrayed in this program. This type of activity must be left to authorized, competent and highly trained police officers."

The widespread public belief in U.N.C.L.E.'s existence caused U.S. Congressman John V. Tunney, in 1966, to conduct his own investigation. "The pointed question,"

Tunney told the *Washington Post,* "was if the U.S. Government had any organization that had the same functions as U.N.C.L.E." Tunney's digging culminated in a surprise visit to his office from an operative of the CIA, who gave him "a personal briefing." Praising "tenacious" U.S. intelligence investigators for responding to his "valid question[s]," Tunney concluded there was no evidence to prove that U.N.C.L.E. was real.

But even a congressional investigation didn't put the matter to rest. Attempts to enlist in U.N.C.L.E. soon extended to the U.S. Secret Service. While traveling with the vice president of the United States, Hubert H. Humphrey, Robert Vaughn was approached by one of Humphrey's Secret Service bodyguards, who asked if he could get one of the ID cards. "After I gave him one," recalled Vaughn, "it went through the agents' communication system. Moments later I had a request from a half-dozen or more of these guys, wanting to be members of the U.N.C.L.E. organization."

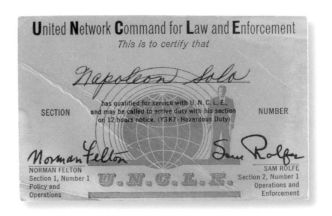

ARTIST'S RENDERING OF CITY BLOCK FACADE HIDING U.N.C.L.E. HQ

"There is a row of buildings in New York City, on First Avenue . . . a few blocks from the United Nations Building. This row consists of . . . a multi-storied Public Parking Garage pasted against the first of four dilapidated brownstone buildings. . . .

The first . . . is occupied by a few lower income families living above the decrepit tailor shop (Giovanni's) at the street level. The next two brownstones are boarded up and condemned. The last appears to be used as a warehouse by a company named 'Akron Paper Products'

If it were possible to peel away the outer, decaying, brownstone skin of the four buildings . . . a surprising edifice would be revealed. For behind the walls is one large building consisting of three floors of a modern, complex office building . . . a maze of corridors and suites . . . [and] complex masses of modern machinery . . .

This is the heart, brain, and body of the organization named U.N.C.L.E."

—*Sam Rolfe, writer-producer of* Solo

This artist's rendering of U.N.C.L.E.'s Manhattan façade is included in Ian Fleming's copy of Rolfe's *Solo* prospectus. While the public garage entrance was only briefly utilized in the series, the tailor shop was designated as the gateway to U.N.C.L.E. headquarters. In the drawing, the tailor shop is called Giovanni's, Rolfe's original name for it. In the pilot draft he created on October 29, 1963, Rolfe changed the name to Del Floria's.

Somewhere in Manhattan. This is the preproduction drawing of the city block that secretly houses U.N.C.L.E. headquarters.

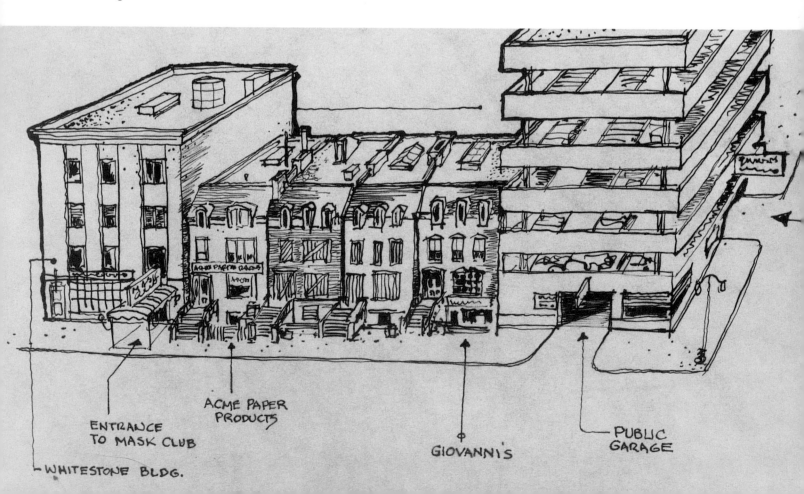

ENTRANCE TO MASK CLUB

ACME PAPER PRODUCTS

WHITESTONE BLDG.

GIOVANNI'S

PUBLIC GARAGE

THE COAT HOOK
FROM DEL FLORIA'S TAILOR SHOP

"In New York City on a street in the east 40s, there is an ordinary tailor shop. Or is it ordinary? We enter through the agents' entrance . . . and we are now inside U.N.C.L.E. headquarters."

—Narrator's introduction that opens the early episodes

This coat hook is the magical key—used by those in the know—that allowed entrance into U.N.C.L.E. headquarters. With a quarter turn to the left of this ordinary-looking wall hook, one made the transition from ho-hum, everyday life on the Manhattan streets to the shiny, computerized, "chrome-and-gun-metal" complex called U.N.C.L.E.

Our heroes would enter the tailor shop, give a knowing nod to the little old man behind the counter—Del Floria—pop inside the dressing cubicle at the rear of the shop, and shut the curtain. Del Floria would trigger some steam from the pressing machine on the counter, releasing the lock on the coat hook. On hearing this, the agents inside the cubicle would turn the coat hook and push on the large wooden wall, allowing them entrance to another world.

When the tailor-shop set at MGM was permanently dismantled in late 1967, a member of the production staff grabbed the coat hook before it could be tossed. He presented it to producer Felton as a memento.

Magical Key. This metal coat hook is a functional prop that was built into the moveable wall in the dressing room. The door knob and extended rod were never seen on screen; they were housed inside the wall, allowing the ornamental hook to swivel when the actor turned it.

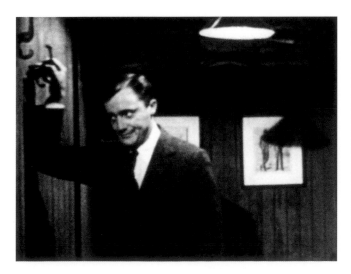

Secret Door. Inside the tailor shop dressing cubicle, Napoleon Solo turns the coat hook to enter headquarters.

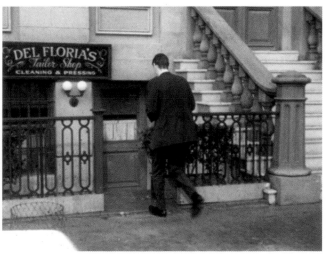

An Ordinary Tailor Shop. On a street in New York's east 40s is the entrance to U.N.C.L.E.

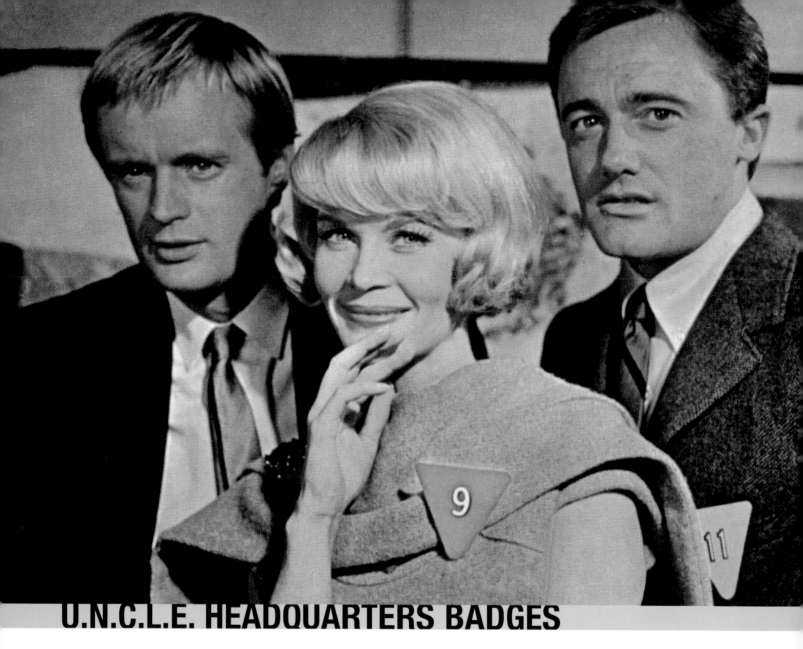

U.N.C.L.E. HEADQUARTERS BADGES

Once an agent passes through Del Floria's into the U.N.C.L.E. reception area, an attractive young woman—the "admissions clerk"—pins a triangular, numbered badge onto the agent's lapel. Visitors and lower-level personnel are given a green badge, while those cleared for all levels of the complex get a yellow badge. The badges are an important tool in U.N.C.L.E.'s security system, since they trigger sensors inside the building that cause doors to slide open as the wearer approaches. No badge, no access through corridors.

In the event that an enemy agent infiltrates the head-quarters, it is unlikely he'll get very far. He may know to don a badge at the entrance, but it's extremely unlikely he would know about an additional security measure used by U.N.C.L.E.: The receptionist has a special chemical on her fingers that transfers onto each badge. Without that chemical, sensors respond by sealing the complex and sounding alarms.

In reality, of course, these prop badges had no such power. During filming, crew members hidden behind walls on the set slid the doors open and closed as the actors approached. Unable to see the actors from their hiding spots, the stagehands occasionally missed their cue. "We always had problems with that," laughed Vaughn. "They'd close the doors too quickly and we'd be caught. If David and I weren't walking directly next to each other, one of us, whoever was in the rear, usually got hit by the door on the shoulder or the head. We eventually worked it out."

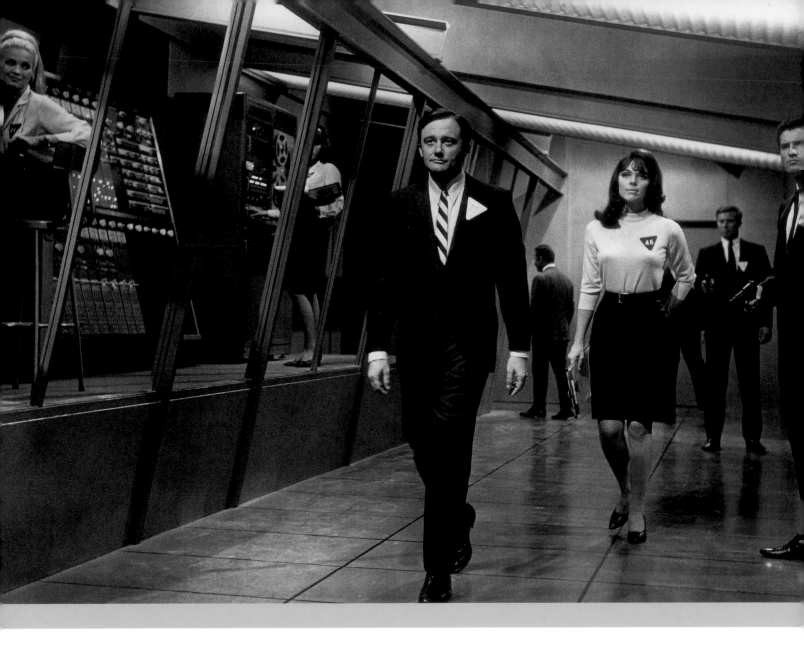

OPPOSITE:

Number 9. The green No. 9 badge is worn by Dorothy Provine in one episode. Solo, as always, wears the yellow No. 11 badge.

ABOVE:

Inside U.N.C.L.E. Personnel can move freely throughout headquarters, provided they wear triangular security badges.

LEFT:

Door Openers. These two prop badges were worn by actors on the set of U.N.C.L.E. headquarters. In the series, they activate security doors throughout the futuristic complex.

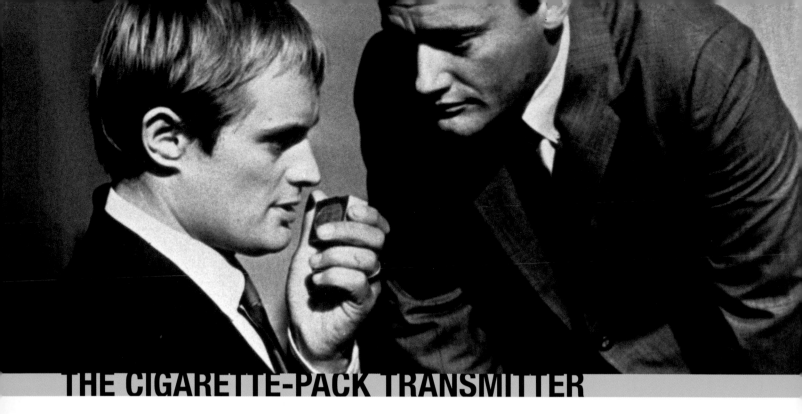

THE CIGARETTE-PACK TRANSMITTER

"Open Channel D. Overseas Relay."

—Napoleon Solo making an international call to U.N.C.L.E. HQ on his cigarette-case transmitter.

When I first watched *The Man from U.N.C.L.E.* in 1964, I saw Robert Vaughn as Napoleon Solo take out a cigarette case, flip open the lid, and slide out what appeared to be a pack of cigarettes. To my utter fascination, it turned out to be in fact a miniature transmitter, disguised on top by cigarette-pack foil and several dummy cigarettes. Solo adjusted the dial and spoke into the radio, "Open Channel D," which immediately put him in voice contact with a beautiful young woman in the Communications section of U.N.C.L.E. "Channel D is open, Mr. Solo," she said, connecting him to Mr. Waverly.

This was the first spy gadget I ever saw, and it had me hooked. Emitting a futuristic two-tone signal that put the dashing men from U.N.C.L.E. in contact with each other from anywhere in the world, the radio was used regularly during the show's first season. I made sketches of it and built a crude model, and the Cragston Company manufactured a toy version. But none of these was as cool as the actual prop used on the show. Built by prop master Bob Murdock, the transmitter—according to Arnold Goode—had been "cut out of balsa wood" and dressed up with "color tape and whatever dial we could get."

When MGM held its studio auction in 1970, I pored over its inventory, but the prop didn't turn up. As years passed, I had dreams in which I walked into an antique store or auction house and found the transmitter on a shelf. Its significance to my childhood, combined with the mystery of its whereabouts, gave the device a magical aura. This wondrous TV prop had become my personal Holy Grail. It

was the stuff of dreams and, I suspected, probably would never be found, if indeed it still existed. Several decades after *U.N.C.L.E.*'s debut, however, a Hollywood special-effects technician—learning of my hunt for spy memorabilia—casually remarked that an associate of his might have the item I was seeking. I phoned his friend, a prop master, who told me he did have an old prop radio that fit inside a cigarette pack. I couldn't believe my ears. Had I found it at last?

The morning of my visit to his warehouse, I tried to remain calm. We chatted in his office for a good hour or so, sharing our experiences in Hollywood. Finally, I asked if I could see the prop radio. "You know what?" he said. "I completely forgot; I threw that thing out six months ago." It was the sort of offhand remark made by a normal person who, indeed, had just remembered he'd thrown out something that wasn't all that important. For me, it was as if someone had just severed the cable that had been holding the Earth on its delicate axis. The sensation I felt—the thing that anyone else would have merely called "disappointment"—was an earthquake that registered deep inside me, which I made a point of concealing beneath a veneer of matter-of-fact calm. "Oh, no!" probably came out of my mouth. "Really? Are you sure?" He was sure.

"I remember thinking that it was so old and antiquated," he said. As someone who rents out props to new Hollywood productions, he knew that "today, they only want things that are high tech. No one would want to use

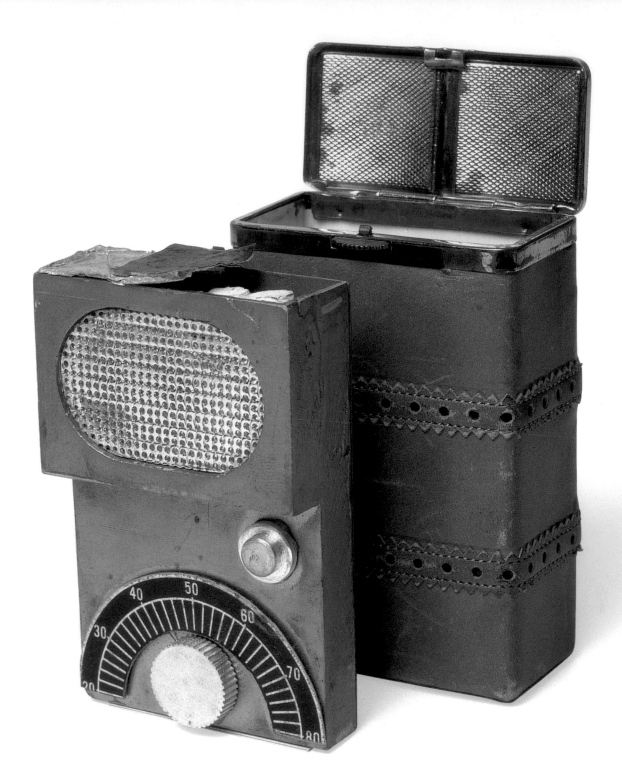

ABOVE:

Holy Grail. This is the TV spy prop that started it all: the *U.N.C.L.E.* cigarette-pack transmitter. The famous 1964 gadget—used by Napoleon and Illya for two seasons—was believed to have been destroyed.

OPPOSITE:

Tuned In. As Napoleon looks on, Illya Kuryakin uses the cigarette-pack transmitter in a scene from the show.

LEFT:

CONCEPT DRAWING OF CIGARETTE PACK

Concept Art. This artist's sketch of the cigarette pack was created by Reuben Klamer, whose designs turned many *U.N.C.L.E.* props into a successful line of children's toys.

something this dated. So I threw it out." After all these years, I had finally found the prop, only to learn that I really hadn't. If I'd located this fellow six months *and one day ago,* I could have saved it—not only for me, but for history.

I accepted my host's invitation to tour his warehouse. Wandering through the mammoth, two-story building, I saw thousands of props, from soda machines, bicycles, and books to guns, signs, and purses. In the midst of all this, I passed a small trash cart. I glanced down at it for only a moment, its top shelf a foot-high mishmash headed for the garbage dump. My gaze briefly passed over a dark void in the pile, where jagged edges of stray items gave way to a tunnel of darkness leading to more abandoned stuff.

In that split second, my eye froze on the void. Like a laser beam honing in on a distant, unseen target, it locked onto a quarter inch corner of gold. That shade of color and its texture immediately registered in my mind as the lower back corner of the prop transmitter. Certain that this was not possible, I nonetheless reached my hand into the black void, took hold of what felt like a three-by-two-inch block, and pulled it out of the heap. Turning the item around in my hand, I found myself staring at the little gold radio through which, decades earlier, Napoleon Solo had spoken to U.N.C.L.E. on "Channel D."

"Oh, here it is," I calmly said to the prop man, who was several yards ahead. He turned and saw the radio in my hand. "What do you know," he said, shaking his head, surprised. "I thought I threw that out." We went upstairs, where I perused hundreds of period cigarette cases. Within a few moments, I found the brown leather case that David McCallum, as Illya, had used to house the transmitter. This completed the gadget.

Understanding my longtime quest for this piece, the prop master—who had originally acquired it as part of a production package from a retiring MGM craftsman—passed the U.N.C.L.E. cigarette pack and transmitter to me. Given the roller-coaster ride I had been on, culminating in that miraculous find, this prop earned its place as the prize piece in my collection.

Little did I imagine—as a ten-year-old *U.N.C.L.E.* fan watching my hero use the world-famous gadget on TV— that, one day, I would find the missing prop and rescue it from the garbage. Nor could I have fathomed that, decades later, I would be demonstrating it on national television—live from CIA headquarters, on the *Today Show*—broadcast on the very same network that had aired *The Man from U.N.C.L.E.* thirty-six years earlier— NBC.

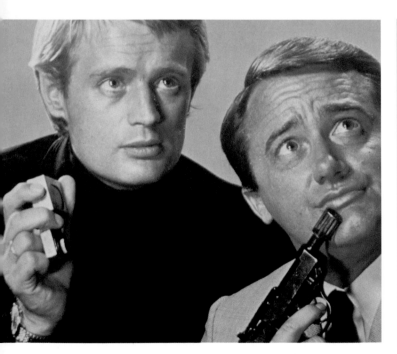

Primed for Adventure. David McCallum holds the cigarette-pack transmitter while posing with Robert Vaughn for a publicity shot.

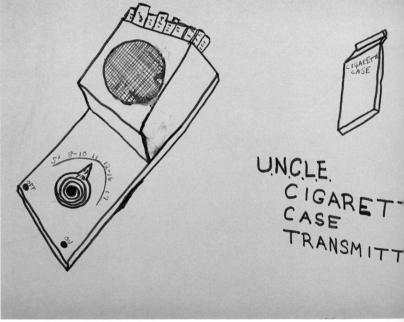

CHILDHOOD SKETCH OF TRANSMITTER

The Stuff of Dreams. This sketch was drawn by the author, at age ten, of the U.N.C.L.E. gadget that captured his imagination. Decades of hunting for the actual prop led to a surprising finale.

EMMY NOMINATION PLAQUE FOR "UNUSUAL PROPS"

Numerous awards and honors were bestowed upon *The Man from U.N.C.L.E.*, including a 1966 Emmy nomination for "creation of unusual props." Those honored props—displayed in this chapter—were so popular that *TV Guide* and *Popular Science* magazines featured them in special photo spreads.

"Half the things we made on the show were from silver tape, balsa wood, cigar holders, and lipstick tubes," revealed Arnold Goode, a prop master who got his start working on Laurel & Hardy films. "We built up whatever prop was needed that day, out of the air, because the rewrites came so fast."

The groundwork for Goode's *U.N.C.L.E.* devices came from his experience in designing the espionage props for a 1950s TV spy show called *The Case of the Dangerous Robin,* which Goode described as a forerunner to both the Bond films and *U.N.C.L.E.*

Goode credited producer-writer Rolfe for inventing the gadgets during the series' first season. "Many of those ideas came from Sam Rolfe," he noted. "He would meet with us, talk to us, tell us how he'd like it. Sam was in a class by himself, a very wonderful man." Rolfe left the show after the first year, leaving Goode's team on its own. "The scripts never gave a description of the props," he said. "We'd have to spontaneously make it up."

A member of the series who seemed to appreciate this, according to Goode, was David McCallum. Between scenes of playing Illya, McCallum would spend time examining the gadgets. "If we didn't watch him," recalled Goode, "he'd tear everything apart to see how it worked." Robert Vaughn, however, was never a concern. "Bob was different," smiled Goode. "He was never interested in props. After he used it [on camera], he just put it down; he was through with it."

One person who was extremely interested in the *U.N.C.L.E.* props was a U.S. Army brigadier general based in Chicago. He sent a letter to MGM Studios requesting blueprints and working models of the spy gadgets so that the Army could test them "in the interest of national security."

The Emmy plaque pictured here was awarded to Goode and his two *U.N.C.L.E.* associates, Bill Graham and Bob Murdock. "No property master had ever gotten one before," said Goode. "It was quite an honor."

Industry Honor. This Emmy Awards plaque was presented to the MGM prop masters for creating all the "unusual" spy guns and gadgets for *U.N.C.L.E.*

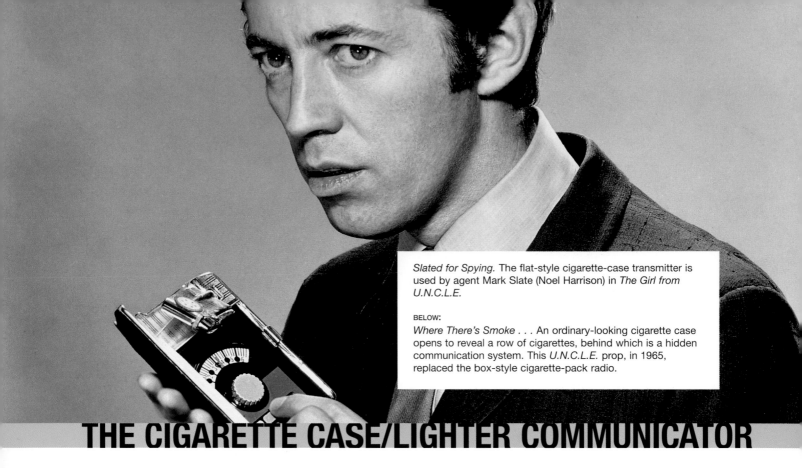

Slated for Spying. The flat-style cigarette-case transmitter is used by agent Mark Slate (Noel Harrison) in *The Girl from U.N.C.L.E.*

BELOW:

Where There's Smoke . . . An ordinary-looking cigarette case opens to reveal a row of cigarettes, behind which is a hidden communication system. This *U.N.C.L.E.* prop, in 1965, replaced the box-style cigarette-pack radio.

THE CIGARETTE CASE/LIGHTER COMMUNICATOR

"When I saw the *U.N.C.L.E.* spy gadgets I was really quite impressed with their sophistication. They were incredibly constructed, as if they'd been sent off to factories to actually be made."

– Actress Barbara Feldon, who played an U.N.C.L.E. operative in "The Never-Never Affair," 1964

At the outset of its second season, the *U.N.C.L.E.* producers decided that the original cigarette-pack transmitter was too bulky, so they replaced it with this sleeker design. The flat, leather-bound case opens like a book to reveal a row of phony cigarettes, which serves as a façade to the miniature communications center within. The lighter converts into a microphone, and a central dial activates the transmitter.

A standout piece of craftsmanship, this cigarette case—like its 1964 predecessor—shows the ingenuity of the *U.N.C.L.E.* prop designers. "The cigarette cases that we used as communicators were made quickly in a matter of days on a very limited budget," noted Robert Vaughn. "They became one of the aspects of the show that people still talk about today." Although this one-of-a-kind prop was used in only a handful of episodes, it inspired a popular replica from Ideal Toys.

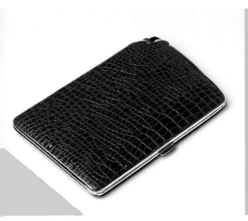
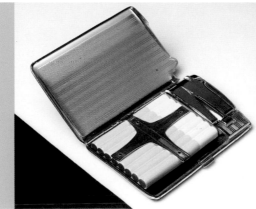
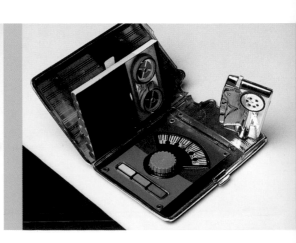

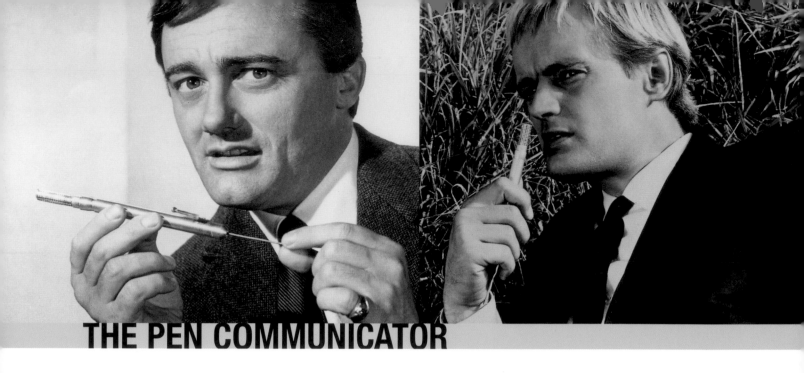

THE PEN COMMUNICATOR

"That's a marvelous-looking device. We would have been delighted to have had something like this, with the range of going all the way to Washington."

—*Peter Earnest, former senior CIA operations officer*

The silver pen that converts into a communication device, the pen communicator, is one of the most memorable spy gadgets on any TV espionage show. It was used for several years by the stars of both *The Man from U.N.C.L.E.* and *The Girl from U.N.C.L.E.*

The shows' heroes would remove the pen's end piece, flip it around, and reconnect it, exposing a gold microphone grid. They would then extract a hidden antenna from the other end, which, when turned, would activate the unit. In addition to voice transmission, the pen functioned as an amnesia inducer and electronic scanner.

The gadget was conceived when producer Felton expressed concern that the cigarette-case transmitters might encourage smoking among his show's young fans. This, plus the fact that it would be smaller and easier to work with, resulted in the pen radio becoming a permanent replacement for the cigarette packs.

"The pen is the thing that's most remembered from the show," insisted Vaughn. "People still come up to me, talk into their thumb, and say, 'Open Channel D.'"

ABOVE:
"Come in, Napoleon . . ." Solo and Illya maintain contact via the U.N.C.L.E. pen communicator.

BELOW:
Pen Pal. U.N.C.L.E. agents never leave home without it. This prop "pen communicator" is the most-remembered gadget from the TV series. "Open Channel D. . . . "

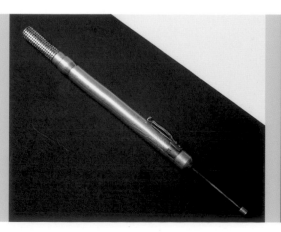

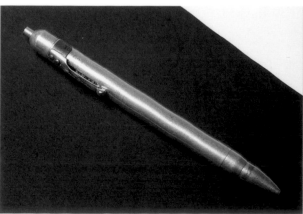

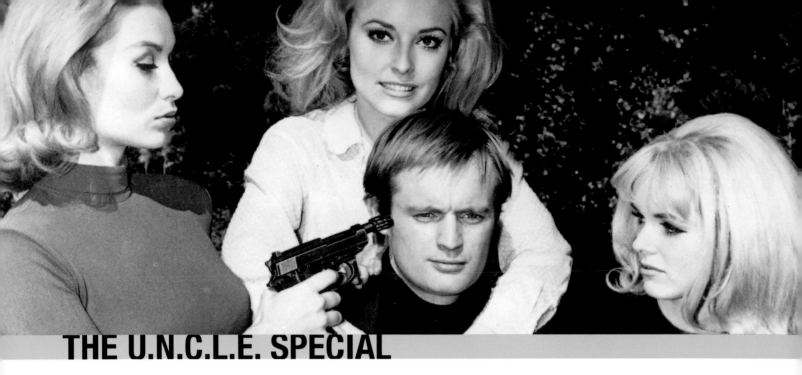

THE U.N.C.L.E. SPECIAL

One of the most famous movie guns created for the screen is the U.N.C.L.E. Special. "I wanted one gun that could convert to a long-range rifle," explained Sam Rolfe in 1965, "capable of shooting sleep-inducing darts [or] bullets . . . single shots or rapid fire." So the series' prop masters created an exotic weapon utilizing a German Walther P-38, which they modified to accept a variety of attachments. For handgun use, a stylish "flash arrestor" was added to the shortened barrel. On-screen, it produced a unique silenced report, akin to the sound of a truncated air blast. When facing particularly formidable opposition, U.N.C.L.E. agents converted the Walther to carbine mode by attaching a barrel-silencer extension, telescopic sight, shoulder stock, and extended magazine clip.

"It was a gun that was supposed to be assembled very quickly by me, or whoever was using it," recalled Vaughn. "I guess it could be done in five or ten seconds. Maybe I could have done it even faster if I had worked at it. But they cut away to another shot, and when they came back it was already assembled."

Arnold Goode explained that the weapon came into being when he and his prop team "took our ideas into the machine shop, where we would discuss what we wanted on the gun. We made the gun in pieces, while we were shooting. It wasn't built all at once." A German Mauser had originally been used, but it proved to be a disaster. "That Mickey Mouse thing wouldn't even shoot," laughed Goode. Faced with a crisis on the set, he ran over to a World War II series being filmed on the lot, *Combat,* and borrowed some of their wartime P-38s. "I whittled a few scopes and so on from balsa wood and foam," explained Goode, taping the makeshift attachments to the handguns "just to get us through the episode."

The U.N.C.L.E. Special became so popular among viewers that the studio received up to five hundred letters a week about this specific prop, many of them addressed to "The Gun." A toy version, Ideal's Napoleon Solo Gun, became a top seller in the United States. To this day, the U.N.C.L.E. Special continues to serve as the model for movie guns and children's action toys around the world.

ABOVE:
All Work and No Play. His gun in the hands of the enemy leaves Illya at the mercy of three deadly blondes.

LEFT:
Cool TV Spy Gun. The U.N.C.L.E. pistol is a real Walther P-38 with modifications. Of the few that were created for the show, this is one of the earliest.

OPPOSITE, TOP:
Off-Camera Chitchat. Leo G. Carroll, Barbara Moore, and Robert Vaughn discuss the U.N.C.L.E. Special between takes on the set.

OPPOSITE, BOTTOM:
Taking Aim. A cameraman films Robert Vaughn using the U.N.C.L.E. handgun in a 1966 episode.

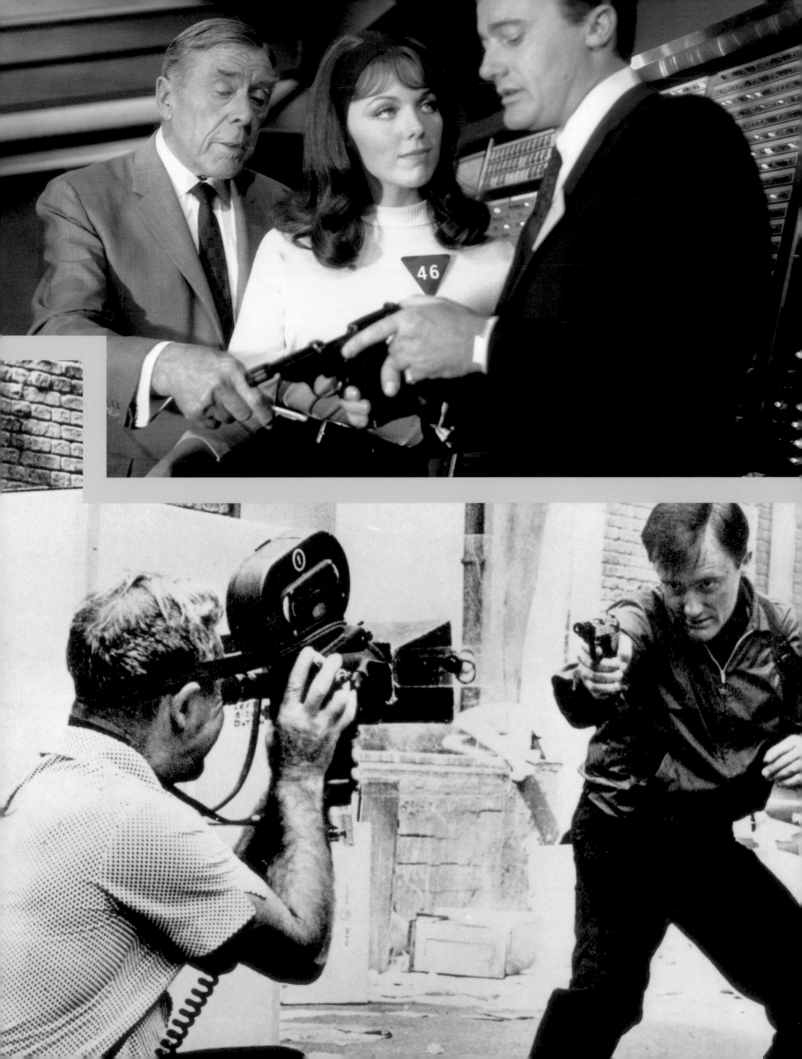

TOP:
Taking a Stand. Napoleon and Illya use their U.N.C.L.E. carbines to fend off an attack from enemy forces.

MIDDLE:
Ready for Action! The fully assembled U.N.C.L.E. Special became a star in its own right, receiving five hundred fan letters per week.

BOTTOM:
Carbine in Hand. U.N.C.L.E. Special at the ready, Illya investigates the destruction of a village by the deadly thermal prism.

"THE TREASURY AGENTS AFFAIR"

"The studio prop chief called me into his office one day. There were two gentlemen there, very well dressed. He introduced them to me by name, nothing more. These guys asked me all kinds of questions about the *U.N.C.L.E.* guns. I sensed I should be very careful. I said, 'First of all, who are *you?*' They said, 'We're from the Treasury Department, and you're manufacturing guns without a license.' Turns out they had gathered up all the guns from *U.N.C.L.E.* to take away as evidence, so we couldn't shoot. Fortunately, these Treasury men were movie crazy! I whispered to my boss, 'It's just about lunchtime. Why don't we call the commissary and reserve a table in the good section? If we don't, we're in trouble.' We went up to the dining room and I introduced them to a lot of stars, gave them 'the great polish job.' Finally, they were so impressed by meeting all these people, they said they would instead only take two guns and fine the studio $2,000. The two agents later returned the guns because they wanted another studio tour. That time they brought a friend with them."

—*Arnold Goode,* U.N.C.L.E. *prop master*

Men in Arms. The men from *U.N.C.L.E.* pose with the series' two famous carbines.

U.N.C.L.E. FEATURE FILM COMIC-BOOK ART

This original artwork is from the comic-book adaptation of *The Man from U.N.C.L.E. –The Feature Film,* a movie developed for MGM in 1979, in which Vaughn and McCallum both agreed to reprise their famous roles. As shown in this illustration, the U.N.C.L.E. security badges played an important part in the proposed movie. The project never went into production, however, because MGM executives felt the James Bond franchise had too strong a grip on the espionage market for a competing spy thriller to succeed.

Back in Action! Solo and Illya battle to stop Thrush from destroying U.N.C.L.E.'s worldwide network in a proposed motion picture written by Danny Biederman and Robert Short. This comic-book art depicts scenes from the script created for MGM.

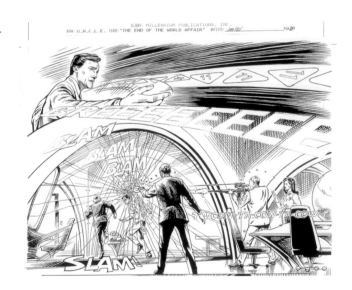

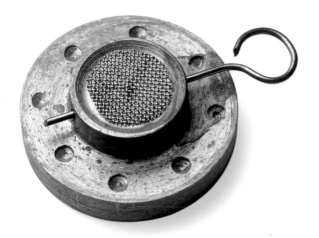

HOMING GRENADE

Big Bang Theory. Big bangs sometimes come in small bombs. This inch-wide prop served as a miniature grenade issued to trainees at U.N.C.L.E.'s island-based Survival School. The grenade contains a homing control that allows it to seek out incoming explosives. During obstacle-course maneuvers, the student pulls the pin and throws the grenade, which homes in on the airborne bomb and destroys it.

THRUSH

SATRAP UNIT

ASSUMED IDENTITY

What Evil Thing Have You Done Today?

WARNING

IF YOU SEE THIS THRUSH LOGO ANYWHERE, YOU ARE ADVISED TO USE EXTREME CAUTION AND IMMEDIATELY CONTACT U.N.C.L.E. VIA YOUR LOCAL TAILOR SHOP.

OPPOSITE, TOP:

Deadly Thrushette. The muzzle of his gun helps Napoleon Solo make a point with beautiful Thrush adversary Serena (Senta Berger).

ABOVE AND OPPOSITE, BOTTOM:

The Man from Thrush. Thrush uses as its insignia the image of an encircled thrush bird, in attack mode, which appears on its agents' uniforms, weapons, and documents. This identification card belonged to the man who created Thrush, writer-producer Sam Rolfe.

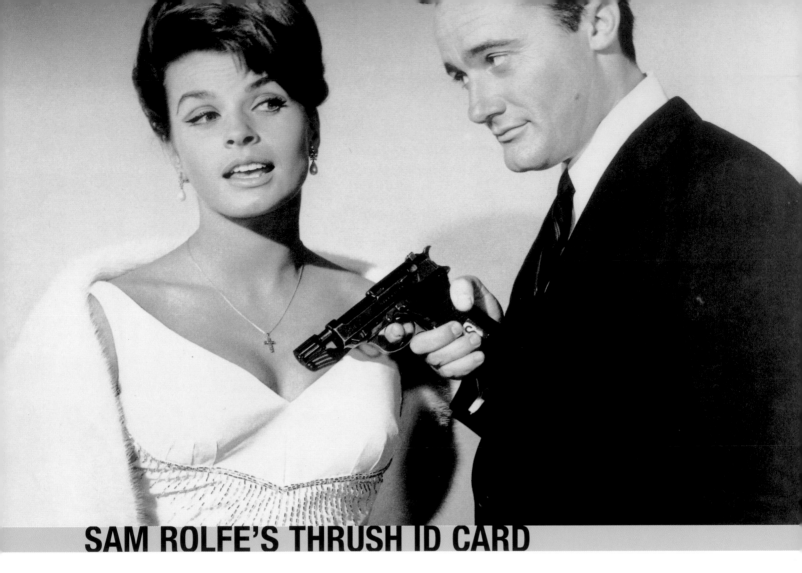

SAM ROLFE'S THRUSH ID CARD

"Thrush might be a man, or a woman, or a committee that heads a secret international organization—very powerful, very wealthy. Thrush has no allegiance to any country, or to any ideal. It would embark upon any undertaking it may decide is in its own interest. And where Thrush succeeds, many, many people pay a terrible price."

—*Napoleon Solo, "The Vulcan Affair"*

Thrush was invented by Sam Rolfe, who originally described it as "an unknown cipher . . . a darker convolution of U.N.C.L.E.," who is "the brain, the backbone, the support" of "an ingenious, well financed, highly scientific band of men and women," analogous to "Dr. Moriarty and his friends." Rolfe wrote that "the audience will sense . . . a shrill, piercing thrill . . . at the base of their spines when they first realize that Thrush is on the scene."

This prop Thrush ID card belonged to Sam Rolfe. Similar cards were mailed to fans who requested them. But when the studio ran short, they substituted an U.N.C.L.E. card, along with a letter that stated, "I note that you have applied for a Thrush card In the interest of law and order you should not even try to become a Thrush agent. An U.N.C.L.E. Identity Card is enclosed, which puts you on the side of Law and Enforcement in its fight against Thrush."

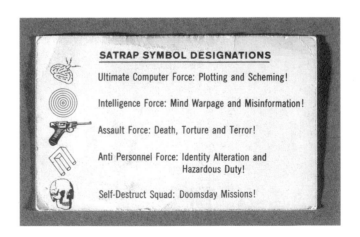

SATRAP SYMBOL DESIGNATIONS

Ultimate Computer Force: Plotting and Scheming!

Intelligence Force: Mind Warpage and Misinformation!

Assault Force: Death, Torture and Terror!

Anti Personnel Force: Identity Alteration and Hazardous Duty!

Self-Destruct Squad: Doomsday Missions!

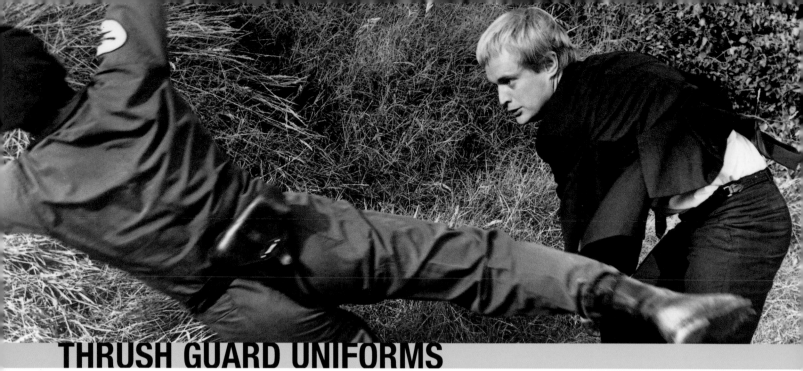

THRUSH GUARD UNIFORMS

Thrush cannot follow through with its plans for world domination without armed security forces at its disposal. All guards and officers wear special uniforms, each identified with the Thrush patch on its sleeve.

The first time I crossed paths with a Thrush guard was in February 1967, in Culver City, California. Smartly dressed in suit and tie, I made my way past a guard gate and proceeded west down a long street. I pulled a secret map from my jacket pocket and studied it. The turnoff was coming up quickly. When I reached the side road, I turned left. It was a short stretch and appeared to lead to a dead end.

Could this have been a setup? A trap? Just ahead of me, slightly off to my left, I caught sight of a figure dressed in what looked like Army fatigues. It was a man, and he was headed in my direction. I could now see that he was wearing an olive-green jumpsuit and a beret. The oval patch on the sleeve was unmistakable: Thrush!

I had heard of the dreaded Thrush security personnel and had seen actual footage of them in action. But this was the first time that I had been in the presence of a real,

live Thrush guard. We were only yards apart now. The pace of my stride slowed while the beat of my heart quickened. I saw that he was walking casually, looking to the ground, occasionally glancing up. He appeared to be in his forties, with a rugged type of face. *Yup,* I thought, *that's Thrush, all right. That's how they pick 'em. No doubt about it.* He took no notice of me, and we passed, just like two normal people.

Of course, that's exactly what we were. He was a movie extra, and I was a kid, thirty years his junior. This was MGM Studios, and the "Thrush guard" had just stepped off the *U.N.C.L.E.* set, where I was headed to watch them film.

Three years later, I returned to MGM to find the actor's Thrush uniform hanging on a rack inside a studio sound-stage. I bought it for all of $5. MGM needed cash and had launched Hollywood's first-ever movie studio auction. I don't know how much my $5 helped to bolster the struggling studio, but acquiring that Thrush uniform was a thrill for me—the first piece of on-screen movie memo-rabilia I had ever acquired.

ABOVE:
Wham! A Thrush guard goes flying after Illya throws a punch.

OPPOSITE, TOP LEFT:
Face-to-Face with Thrush. This is the classic uniform of the Thrush security forces. Although rarely seen in public, a Thrush guard wearing this uniform crossed paths with the author in February 1967.

OPPOSITE, TOP RIGHT:
THRUSH OFFICER UNIFORM

In Command. This two-piece uniform and silver cap were worn by a top Thrush officer. What evil commands did he issue to his operatives from his secret Thrush satrap?

OPPOSITE, MIDDLE RIGHT:
THRUSH HELMET

Memories of Battle. The helmet of a Thrush guard was left behind after a confrontation with U.N.C.L.E. agents. Remnants of the Thrush logo, bruised in battle, are visible.

OPPOSITE, BOTTOM:
On Guard. The camera rolls as Robert Vaughn and Judy Carne portray prisoners of Thrush. A Thrush guard can be seen in the upper-left part of the photo.

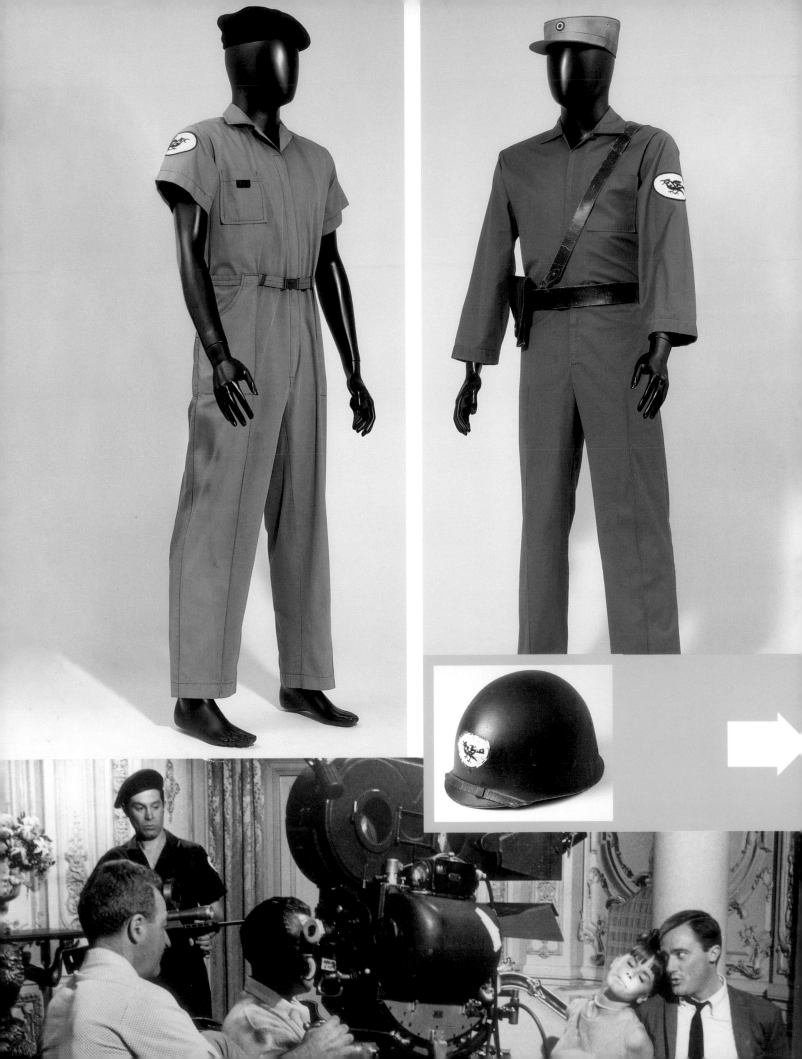

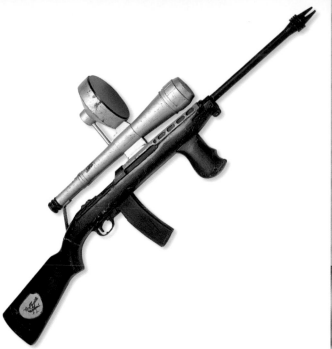

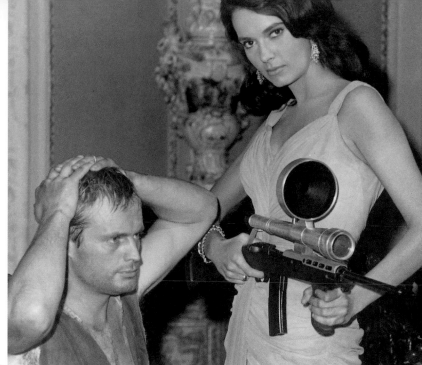

THE THRUSH CARBINE

Combing through a local Army surplus store on Colorado Boulevard, Arnold Goode dredged up a U.S. Army nightscope and M-1 carbine to create this wicked-looking weapon. A Thrush emblem affixed to the stock, the carbine sported a telescopic sight and glowing red scope that produced a foreboding, cricket-like "chirping" sound. This is the standard version of the carbine that Thrush security forces used during the entire run of the series. Dozens were built—some real, some made of resin, others out of rubber. This exotic prop also served as the model for a popular toy from Ideal, the Thrush Gun.

ABOVE, LEFT:
Exotic Weapon. Leave it to the evil genius of Thrush to devise something as intimidating as this. "I like to think of the Thrush gun as wearing a sneer," said Sam Rolfe.

ABOVE, RIGHT:
Time to Surrender. Illya becomes the prisoner of a pretty Thrushette brandishing the deadly Thrush carbine.

EARLY THRUSH RIFLE

Before the Thrush carbine was created, Thrush agents used this weapon in several early adventures. "The one thing I forgot [to put] in the U.N.C.L.E. guns," said Sam Rolfe,"I put on the Thrush gun—an infrared light so the Thrush people could shoot at night."

In the series' second episode, "The Iowa-Scuba Affair," Solo and an Iowa farm girl are hunted by a squad of Thrush assassins. The rifle chirps as the nightscope produces an X-ray-like image of its prey, prompting Solo to deduce that their pursuers are "using black-light emissions and special finders." In "The Yellow Scarf Affair," someone places an invisible Thrush-bird marker on the back of Solo's jacket, which later becomes an illuminated target when an assassin hones in on Solo through the Thrush nightscope.

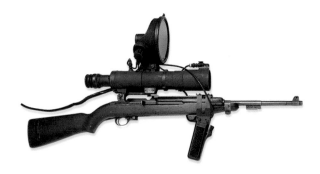

Targeting Mr. Solo. This 1964 model Thrush rifle liked to put Napoleon Solo in the crosshairs of its humming nightscope. Two years later, the weapon fell into better hands—those of professional bodyguard T.H.E. Cat (see page 146)—to save a policeman's daughter from being murdered by a mob hit man.

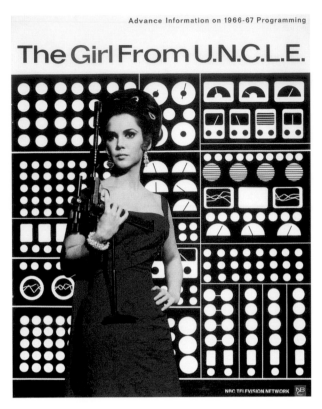

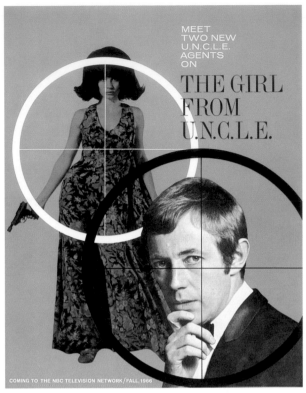

THE GIRL FROM U.N.C.L.E. NBC BOOKLETS

"April Dancer . . . is qualified uniquely for many special assignments—just because she is a girl. Despite her sex and her beauty . . . [she] soon comes to be known to Thrush . . . as five feet, five inches and 108 pounds of deadly danger."

—NBC Network Planning, 1966

It was only natural that the enormous success of *The Man from U.N.C.L.E.* would lead to the creation of a spin-off series, *The Girl from U.N.C.L.E.* After various approaches were considered, it was decided that an episode of *Man* would serve as the pilot. Broadcast on February 25, 1966, "The Moonglow Affair" featured former Miss America Mary Ann Mobley in the role of a twenty-four-year-old U.N.C.L.E. agent, April Dancer (a name invented by Ian Fleming for the *Solo* series). Norman Fell costarred as her partner, a cynical veteran operative, Mark Slate.

NBC put *Girl* on the air in fall 1966, but recast April Dancer's role with Stefanie Powers as a more mod, athletic April and Noel Harrison as a younger, hipper Slate. That season also saw the tone of both *U.N.C.L.E.* series take a sharp turn from tongue-in-cheek adventure to pure camp.

These booklets were created by NBC in early 1966 to drum up sponsor support for *The Girl from U.N.C.L.E.* before its fall debut. The first booklet was assembled when the pilot cast was in place. But once NBC gave the series a new approach and recast the leads, that booklet was scrapped and replaced with the revised version.

TOP, LEFT:

First of April. The original April Dancer, Mary Ann Mobley, got top billing in this early NBC booklet promoting the new *Girl from U.N.C.L.E.* series.

TOP, RIGHT:

Dancer and Slate, Take Two. NBC revised its *Girl from U.N.C.L.E.* promo booklet when the show was recast with Stefanie Powers and Noel Harrison.

ABOVE:

WOMEN'S WARDROBE SIGN

Lady Spies Only, Please. This production sign from MGM Studios directed actresses working on *U.N.C.L.E.* to the department designated for female wardrobe and makeup.

U.N.C.L.E. MERCHANDISE

The *U.N.C.L.E.* TV series had a merchandising program that proved to be a worldwide gold mine, marketing toys, books, records, comics, apparel, action figures, and board games. Given the popularity of the show's U.N.C.L.E. Special and Ideal's success with the Napoleon Solo Gun, the Marx toy company decided to develop its own U.N.C.L.E. "gun"—but with a gimmick. Rather than firing caps, this gun would project a reel of movie film, featuring scenes from actual *U.N.C.L.E.* adventures.

Marx designers created this presentation mock-up of the toy Projector Gun that never went into production. Whether the project was sabotaged by Thrush or was simply deemed too costly, we may never know.

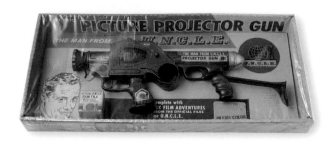

The Toy That Never Was. This prototype for a toy gun would project, on the wall of a child's bedroom, live-action scenes from *U.N.C.L.E.* TV episodes. The idea didn't make it past this single mock-up.

SUPERMAN COMIC BOOK

Superman Meets U.N.C.L.E. Open Channel S! The Man of Steel entered the age of espionage in 1965 when DC Comics devoted an issue of its Superman comic book, *Jimmy Olsen,* to the spy craze. The cover, which features Olsen showing off an array of spy gadgets, makes a prominent reference to *U.N.C.L.E.*

[*Superman's Pal Jimmy Olsen* #89 copyright 1965 DC Comics. All Rights Reserved. Used with permission.]

U.N.C.L.E. PAJAMAS

"The Forty Winks Affair." This child's pair of *U.N.C.L.E.* pajamas was worn by the author in 1965. Losing consciousness nightly due to a Thrush "sleep ray" or some other diabolical sleep-inducing device, young Biederman always had these pj's on standby.

FELTON MEMO ON THE FATE OF THRUSH AND U.N.C.L.E.

It was January 1968. NBC had just aired the two-hour finale of *The Man from U.N.C.L.E.*, in which Solo and Illya prevent Thrush from using a mind-control drug to subjugate the human race. The onetime TV phenomenon was now history, yet fans have long pondered what might have been.

A few years after the show's cancellation, Norman Felton wrote these notes to me, in which he revealed the fate of both U.N.C.L.E. and Thrush. True to the spirit of the series—which hinted that the secret world of U.N.C.L.E. might in fact be real—Felton claimed to be on the run from Thrush, and he painted a grim picture of U.N.C.L.E.'s current state of affairs:

"Danny . . . this is written in haste as Thrush is after me. . . . U.N.C.L.E. has had to go 'underground' to escape Thrush—and the U.N.C.L.E. headquarters were all destroyed. . . . "

Was Thrush real? Did it play a role in the demise of Felton's TV series, which for four years portrayed Thrush as losing against U.N.C.L.E.? Was that evil group now going after Felton himself?

"I shall have to go underground. . . . "

Although in hiding, Felton did manage to get out a hopeful message from U.N.C.L.E.'s survivors:

"You will be pleased to know that all members of U.N.C.L.E. were embarking on a policy of peace to all men . . . and decided, before they disbanded, to refrain from using guns except on missions of extreme danger."

—Norman Felton, #1 of Section One

BELOW, LEFT:
Secret Communiqué. U.N.C.L.E.'s executive producer sent these memos to the author after the show ended, informing him of U.N.C.L.E.'s fate.

BELOW, RIGHT:
END CREDITS PHOTOS

Channel D—Out. Every color episode of *U.N.C.L.E.* concludes with a sequence in which cast and crew credits appear over a select series of photographs of Napoleon, Illya, and Mr. Waverly. The photos used for this sequence, so familiar to the show's legions of fans, were rescued from imminent destruction at MGM.

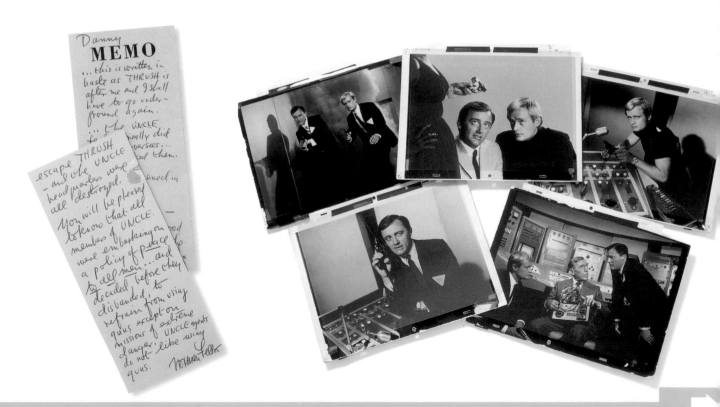

We wish to thank the United Network Command for Law and Enforcement, without whose assistance this chapter would not be possible.

THE WILD WILD WEST

3

CHAPTER 00:03

Frontier Agent. James West travels the country in his private railroad car in the TV show originally conceived as *James Bond of the West.*

"James Bond was so popular. Sean Connery was so popular. They said, 'Let's call it *James Bond of the West.*' It was the hottest property in Hollywood at the time."

—Robert Conrad

Westerns were the all-American staple of prime-time television during the early 1960s. The landscape was littered with such sagebrush sagas as *Bonanza, Gunsmoke, The Rifleman,* and *Have Gun—Will Travel.* But the popularity of James Bond and *The Man from U.N.C.L.E.* was bringing another genre to the forefront. By the end of 1964, it was clear that espionage thrillers were now coming into vogue, promising to unseat the Western as TV's hottest fad.

Producer Michael Garrison, with CBS-TV, decided to try blending the two popular adventure genres into a single entity. Written by Gilbert Ralston, a pilot was filmed, starring Robert Conrad (star of *Hawaiian Eye*) as U.S. Secret Service agent Major James T. West and Ross Martin (*Mr. Lucky*) as his partner, Artemus Gordon.

The format of Garrison's series—originally titled *Wild West*—follows the adventures of undercover agents West and Gordon as they travel the great nineteenth-century American frontier in West's private railroad car, battling larger-than-life villains who are out to subvert the nation for their own evil gain. The agents' assignments come directly from the president of the United States, Ulysses S. Grant.

Debuting on CBS's fall 1965 schedule as *The Wild Wild West*, the series was smart, refreshing, and fun. Conrad choreographed and performed all his own stunts for the show's many fight scenes, and the series became well known for these sequences. They were fascinating to watch, given the integration of martial arts and the Western motif. Martin was the perfect counterweight to Conrad, and his character was every actor's dream: Artemus Gordon was a master of disguise, allowing Martin—a master of dialects—great latitude to invent a wonderful repertoire of humorous and endearing characters.

In the vein of Bond and *U.N.C.L.E.*, *The Wild Wild West* also delivered beautiful women, an exciting musical score, and an array of clever spy gimmicks. The gadgets were particularly interesting because the writers provided the characters with things that hadn't yet been invented in the 1870s. For instance, Artemus—an inventor who frequently supplied West with his secret devices—built the first tear-gas grenade ("a kind of crying gas," observed West). Even the villains were credited with building the world's first torpedoes, tanks, and TV sets.

The Wild Wild West maintained a strong following for four years, finally succumbing to a political crusade targeting "TV violence." The series was made a scapegoat in the wake of the nation's political assassinations and social problems, although the show's "fight scenes" were escapist in tone—never of a realistic nature. In fact, *The Wild Wild West* portrayed characters and situations in a very *positive* light, promoting values such as friendship, loyalty, respect, the triumph of good over evil, and a healthy dose of humor.

"I'm proud of *The Wild Wild West*," said Robert Conrad. "More proud of it today than I was then, frankly, because of its longevity. It stood the test of time. It was the hippest, most fun show."

Decades after leaving the air, *The Wild Wild West* is still fondly remembered by a generation of baby boomers who—between the fall of '65 and summer of '69—wouldn't let a week pass without parking themselves in front of the tube to catch Jim and Artie's latest adventure.

ORIGINAL *WEST* LOGO DESIGN

One of the most memorable things about *The Wild Wild West* TV series is its main title sequence. The segment fades in on a static drawing of Jim West, standing in a tall, rectangular panel, surrounded by four larger panels. The character comes to life as the panel lights up. To the beat of Richard Markowitz's lively theme music, West interacts with animated characters in the outer panels as each one presents him with a dangerous situation. There is a bank robber, a card cheat, a gunslinger, and a maiden who kisses West and then tries to kill him with a knife. Following the entertaining cartoon story, West walks away and the show's title emerges, the names of the stars appearing on a drawing of the train.

During the series' original run on CBS, the midpoint commercial break in every episode displayed the animated Jim West title character leaning back inside the title panel, the name of the series in large print, adjacent to it. A brief rendition of the theme music accompanied the series logo.

This is the original pencil rendering of that well-known logo, featuring the familiar animated title character who, for four years, ushered us into the wonderful world of *The Wild Wild West*.

Character Sketch. This is the original preliminary artwork of *The Wild Wild West* title logo.

JIM WEST'S SUIT

Robert Conrad's finely tailored suits, featuring the smart-looking bolero jacket and colorful vest, were an important aspect of James West's character. The fact that President Grant recruited West to serve as his agent in the field meant maintaining a convincing cover. So the government set him up to be a fancy, high-living gentleman from the East, who traveled the country at his leisure in his private railroad car. West's classy attire went a long way toward establishing this image.

The jacket also served a practical function: Hidden behind the left lapel was a small pocket in which West kept a picklock, and at the back of the jacket was another pocket that held a throwing knife. This jacket, along with its hidden devices, was used throughout the series.

The tight-fitting pants that matched West's jackets posed a special problem on the series due to the extensive stunt work performed by Conrad. "My pants, which were designed by a woman, were always splitting because they were too tight," recalled Conrad. "They were always saying, 'Okay, how many pairs of pants is he going to go through today?'"

The seat of Conrad's trousers bears the scars of needle-work repairs—a fitting testament to the daily rough-and-tumble activities of the wild, wild West.

ABOVE:

Secret Pocket. Behind the left lapel of West's jacket is a small pocket where he kept his picklock.

LEFT:

Suited for Action. This green suit was worn by Robert Conrad as Secret Service Agent James T. West.

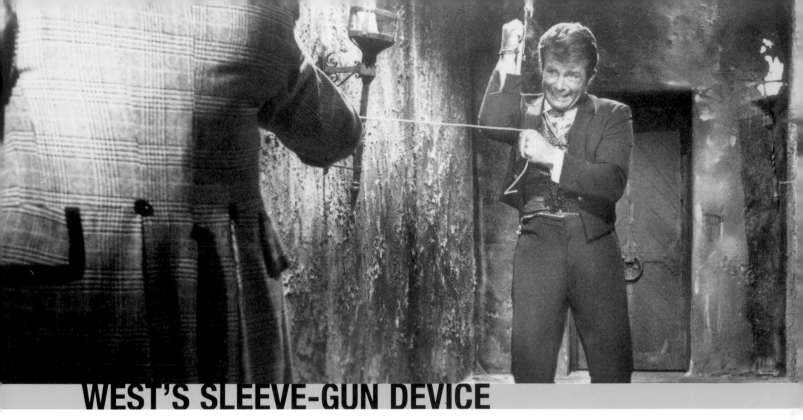

WEST'S SLEEVE-GUN DEVICE

The most popular gadget on *The Wild Wild West* was Jim West's sleeve-gun device. First used in the pilot episode, "The Night of the Inferno," the prop is a leather-and-metal rig that was secured to Robert Conrad's right forearm and hidden under the sleeve of his jacket. Attached to a spring-action rod on the rig was a Derringer. Whenever West was disarmed or needed a gun in an instant, he would trigger the device to release the rod, ejecting it about six inches forward, landing the Derringer in the palm of his hand.

Occasionally, the sleeve device would hold other gadgets, such as a knife or a tube of acid that he used, as a prisoner, to melt down the manacles on his wrists. In "The Night of the Bubbling Death" episode, West uses the gadget to travel over a boiling pit. In the scene, West ejects a contraption from his sleeve and attaches it to the taut line he's shot into the opposite wall. "I'd shoot the gun out," recalled Conrad, "and a wire would fire across. Then I'd slide over this pit of poison or fire." Tim Smyth, the show's special-effects master, was responsible for the setup. "Bobby would pop one of these devices out of his sleeve," he explained, "then hook the wheel over [the line] and go sliding across."

But it was the gadget's use as a sleeve gun that gained notoriety among the series' fans. "It's an awesome gadget," agreed Conrad. "Because here I am, in the surrender mode, or cowering, and I trigger it with my finger and . . . *boom!*—it comes out. And there's James West with that gun. I loved that. I probably should have taken it with me when the show was cancelled, but of course I didn't know how popular it would become."

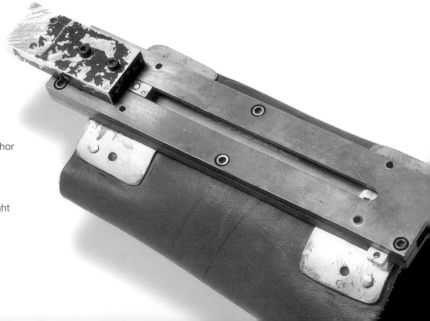

ABOVE:
Avoiding a Bubbling Death. West uses his sleeve rig to anchor himself on a rope and travel over a pit of acid.

RIGHT:
Something's Up His Sleeve. West's sleeve-gun device is a functional prop that was strapped onto Robert Conrad's right forearm. Hidden under his sleeve, the rig would eject a Derringer into his hand.

"The gadgets were so avant-garde, so far ahead of themselves. Kids liked them, adults were intrigued by them, I personally loved them. If you took the gadgets out, you might have lost audience."

—Robert Conrad

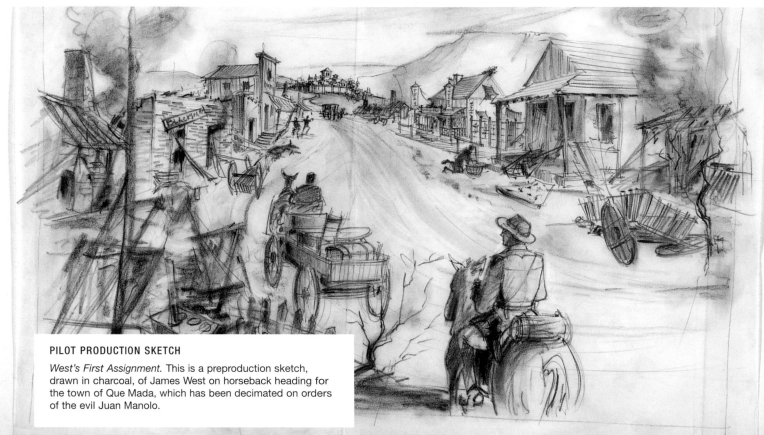

PILOT PRODUCTION SKETCH

West's First Assignment. This is a preproduction sketch, drawn in charcoal, of James West on horseback heading for the town of Que Mada, which has been decimated on orders of the evil Juan Manolo.

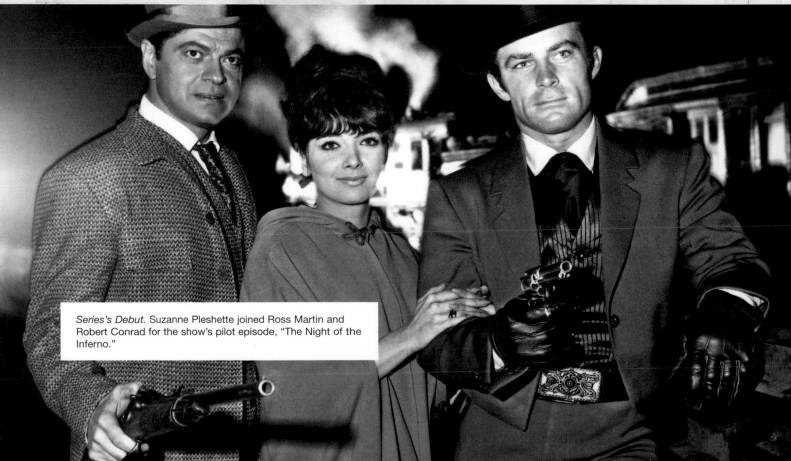

Series's Debut. Suzanne Pleshette joined Ross Martin and Robert Conrad for the show's pilot episode, "The Night of the Inferno."

CALL SHEET FOR DR. LOVELESS'S DEBUT

Every hero has a nemesis. For James West, it is Dr. Miguelito Loveless. Michael Dunn portrayed the diminutive villain, who became a popular recurring character in the series. A "brilliant, twisted little man" with a golden singing voice, Dr. Loveless is a scientist, sculptor, painter, and surgeon whose evil schemes belie his stated desire to make the world a better place for all its children. His assistant in many of those schemes is the quiet giant, Voltaire, portrayed by Richard Kiel (later to play "Jaws" in two 007 movies).

To Dr. Loveless, James West is a "meddler" who continually gets in the way of his plans. Eventually, Loveless plots against West, kidnapping him, replicating him, even trying to drive him mad.

ABOVE:
Jim West's Nemesis. Michael Dunn portrayed recurring villain Dr. Miguelito Loveless, and Phoebe Dorin was his associate, Antoinette, who joined him in singing beautiful songs.

RIGHT:
Calling Dr. Loveless. This is the original call sheet for the filming of Dr. Loveless's debut episode.

PROP HANDBILL FOR AN ARTEMUS GORDON PERFORMANCE

Artemus goes undercover as a traveling performer in order to infiltrate a villain's lair in "The Night of the Casual Killer." Appearing onstage to recite Shakespeare at the villain's compound takes Artie back to his roots. He is enthralled at the positive audience response to his performance—forgetting, momentarily, that the crowd is made up of criminals and gunslingers. As it was with Ross Martin in real life, acting is in Artie's blood. No wonder he is so effective at inventing and portraying such a variety of characters for his Secret Service missions.

Jim and Artie. Ross Martin regularly tried to fool cast and crew by showing up on the set garbed in one of Artemus Gordon's elaborate disguises. Robert Conrad frequently found ways to outwit him.

Artemus on Stage. This prop handbill used in a *Wild Wild West* production lists Artemus Gordon's "Shakespearean Readings" as one of the featured acts.

"Ross Martin was a lovely human being . . . a wonderful actor. He cared about his make-up, loved the acting, and was concerned about finding his inner character."

—*Robert Conrad*

ARTIE'S JEWELER'S CASE WITH SECRET COMPARTMENT

Intelligence operatives are known for having the most advanced communications equipment in existence. This is especially true of fictional agents, since the imagination of writers and prop designers knows no bounds.

In *The Wild Wild West,* set in the 1870s, agents West and Gordon are limited to the technology that existed at that time. Consequently, their communications with Washington and each other were accomplished via telegraph, courier, and carrier pigeon.

A compartment in West's train provided their pigeons— Henry, Henrietta, Anabella, and Arabella—with a means for discreet arrivals and departures. Communication from the field, however, required a creative solution, which

Artemus fashioned into a disguise. Working undercover as a jeweler, Artie carried a large sample case that held numerous drawers filled with fine gems. Unbeknownst to the common observer, the rear of the case was fitted with a camouflaged door leading to a secret compartment. Inside was a carrier pigeon, available at a moment's notice to deliver an urgent note to Jim, back at the train.

This jeweler's case is one of the few, if not the only, surviving props used by Artemus Gordon while in disguise during an assignment. The fact that it also functioned as a secret device makes it an even more significant piece of '60s-era spy history.

Diamonds Are for Cover. This prop jeweler's case was used to bolster Artemus Gordon's cover as a purveyor of fine gems.

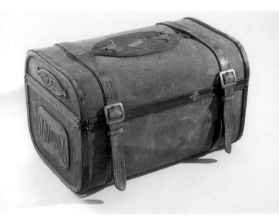

ARTEMUS GORDON'S LUGGAGE

Spy on the Move. One can only imagine the kinds of gadgets and disguises that Artemus packed inside his personal luggage.

SECRET PASSAGE DOOR FROM A VILLAIN'S LAIR

What is a spy thriller without a secret passage? How would the villain escape at the end of the story? And how would the villain's mistress betray her boss to the dashing hero she had just met if not by leading him to the secret passage?

Of course, you can't have a secret passage without a secret passage *door.* And certainly, what would a book filled with spy memorabilia be *without* such a door? Here, dear reader, is one authentic *secret passage door.* Very large and very heavy, this wooden item was used on the set of the 1967 *West* episode "The Night of the Tottering Tontine." Guarding a top government weapons scientist, West and Gordon become trapped in the villain's seaside manor, which is honeycombed with hidden rooms and unseen walkways. West finds the labyrinth after discovering that this exquisitely carved cartouche is actually a door leading to a secret passage.

Several years after the series had left the air, a friend of mine working at CBS Studio Center happened to be on the back lot when he spotted bulldozers rumbling down the studio's Western street. Like a scene out of a movie, they plowed through the saloons, barns, hotels, and other storefront façade that had once served as the backdrop to the fictional world of Jim West and Artemus Gordon. Unbeknownst to my friend, the studio had just approved the razing of its outdoor Western sets, along with the destruction of the famous lake used in *The Wild Wild West, Gilligan's Island,* and other shows.

As my friend watched this Old West town fall to the ground, he saw a smattering of colors emanate from beneath the rising clouds of dust. In the middle of the dirt road, he could see the Egyptian door, abandoned and forgotten. The bulldozers closed in, threatening to crush it into a thousand splinters. My friend dropped what he

ABOVE:

Original Plans. This is a preproduction drawing of the secret passage door. All production design for *The Wild Wild West* was done by the series' art director, Albert Heschong.

RIGHT:

Behind the Egyptian Door. This is an actual part of the set from a *Wild Wild West* adventure: the door that leads Jim West to a secret passage.

was doing and ran straight for the cartouche. Lifting it from one end, he began dragging the massive slab of wood down the Western street, away from the mechanical monsters.

Now a part of the Spy-Fi Archives, the Egyptian door was included as one of the items displayed in my exhibit at the CIA. Although it was a Hollywood prop, the mystical beauty of the piece sets it off as a work of art. And since it was designed to look like a historic artifact, I always wondered if the hieroglyphics on its face were authentic ancient characters or merely the musings of a Hollywood art director. The prop door did have a special appeal for one of my friends at the CIA, so I asked if there was a linguistics expert at the agency who could attempt a translation. My query was passed along and, before long, I heard that someone had taken on the challenge.

As the scenario unfolded, my imagination could not be restrained: A CIA analyst deciphers the ancient hieroglyphic script carved into the Egyptian door once used in a Hollywood production and, to his astonishment, discovers a secret that affects the fate of the world!

Days later, word came back to me that a translation had been completed. It seemed that the hieroglyphics were, in fact, an exact replica of the writings on the tomb of King Tut. While I had been hoping for a clue to the origin of the universe, or at least the formula to the fountain of youth, I must admit that I was fascinated to discover a connection between King Tut and *The Wild Wild West*.

Weeks later, a thought crossed my mind. If CIA analysts *had* uncovered a startling message engraved on the secret passage door, *what* would they have told me?

"FLAMING GHOST" MASK

This prop mask is part of a special fireproof suit worn by a diabolical madman who plans to use a flame-throwing supercannon to seize control of the Western cities of the United States. Wearing this outfit in the middle of a raging fire, he convinces his superstitious army of renegades that he is the living ghost of abolitionist John Brown, who was hanged for treason years earlier. After acquiring the fireproof mask and examining it aboard his train, West infiltrates the villain's compound and, disguising himself with the mask, destroys the superweapon.

Jack Wilson—a prop maker and stuntman on *The Wild Wild West*—had been asked to design and construct the mask that John Doucette was to wear as the villain. Wilson built a flesh-colored prototype, which the show's director decided was too modern looking. So Wilson made a second mask more fitting for the show's era. This one, which was metallic with protruding eye shields, was approved and used in the episode. When the time came to film the action scenes requiring the fireproof costume, Wilson was asked to don the mask and perform the stunt work himself.

A decade or so after "The Night of the Flaming Ghost" was produced, Mr. Wilson invited me to his home, where he shared his memories of shooting that *West* episode. Before I left, Mr. Wilson disappeared into his garage and emerged with both masks—the original prototype and the one actually used. He kindly gave me both props for my collection. These treasured artifacts represent some of the earliest work done on *The Wild Wild West* and are a rare glimpse into the creative process of designing a prop to fit the requirements of a period story.

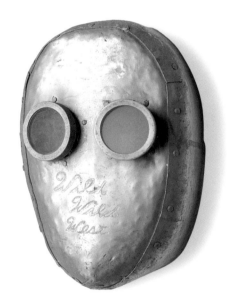

ABOVE, LEFT:
The Face of a Villain. This prop mask was part of an elaborate fireproof costume worn by one of Jim West's deadly adversaries.

ABOVE, RIGHT:
Out of Its Time. This prototype version of the villain's mask was rejected for looking too futuristic.

VILLAIN'S WORLD-TAKEOVER GLOBE

In many a spy thriller, the villain wants either to take over the world or to destroy it. The audience usually learns this after the hero has been captured and forced to listen to the madman's evil plans. The villain often looks forward to this speech so that he can gloat over his own diabolical genius. To impress the imprisoned secret agent, and to make the plot perfectly clear to the audience, the villain usually makes his presentation with numerous visual aids. These typically include scale models of buildings and cities, large wall maps, even special effects utilizing lights or small explosives.

In "The Night of the Brain," a *Wild Wild West* villain used this large model of Earth for just this purpose. Jim West is captured by the villainous Braine, who reveals his plans for replacing world leaders with exact doubles. Describing the world as "one massive case history of madness," he tells West that a surgeon is needed to "put it to rights." This globe floats down from the darkness above as Braine explains how, through his highly placed agents, he will foment international chaos. Seated in his motorized wheelchair, Braine suddenly points up to the globe and, in a fit of rage, hollers out his prediction of "a world gone mad, a world on fire!" The globe suddenly bursts into flames.

This prop from "The Night of the Brain" hung for many years in the rafters of a CBS warehouse. Before the studio released it to me, I noticed that its entire top—the Arctic Circle—was caked with an inch or two of dust. Beneath those layers of dust remained the burn marks from the flames that Braine had ignited in the presence of Jim West.

The World Is Hot Enough. This large prop globe was set on fire by a criminal mastermind as he told West of his evil plans.

COUNT MANZEPPI'S TOY CHICKEN

"Once again we have . . . brought forth another *Wild Wild West* I'm not quite sure what we did, but, by Jupiter, [we] did it."

—*Victor Buono, in a 1966 memo on his role as Count Manzeppi*

This toy chicken is something of a legend in the annals of *The Wild Wild West* TV series. The inner cavity of the innocent-looking toy houses the Philosopher's Stone, the mythical fourteenth-century rock with the power to change things into gold. No one knew this better than Count Carlos Manzeppi, self-proclaimed "poet, adventurer, and lover of all that is forbidden, corrupt, and blasphemous." He was also chief of the Eccentrics, a band of specialists in the art of murder.

"Just what is the big attraction of that little chicken?" West asks Manzeppi in "The Night of the Feathered Fury." Revealing the toy's secret, the Count admits that the tale of its discovery "would weave a tangled thread into the musty stench of ancient crypts, through the brooding bazaars of Damascus, up to the high wastes of Tibet—watered by a small ocean of blood. . . . " Once the stone finally comes into his possession, Manzeppi hires toy maker Heinrich Sharff to build the mechanical chicken as "a convenient cover from prying eyes."

When West witnesses the chicken's magical powers, he agrees that "there's never been a prize like that since the world began." Stolen by one of the Eccentrics (a "theft most fowl," says the Count), the chicken becomes the object of a hunt by Manzeppi, West, and Gordon. In the end, neither the Count nor the Secret Service winds up

with the elusive chicken. In fact, an Italian cook named Mama Angelina finds the toy and, not knowing its secret, innocently takes it with her.

Surviving into the twenty-first century, the priceless artifact is now in the possession of the Spy-Fi Archives, which, in 2001, acceded to a request that it be shipped to the top-secret Kirtland Air Force Base in Albuquerque, New Mexico, home of our nation's nuclear research labs. Along with other artifacts, the chicken was ushered into a security vault at the National Atomic Museum, prior to display. Could America's leading nuclear scientists have had an interest in the Philosopher's Stone? Was the chicken ever "borrowed," late at night, from its secure location at the atomic site? This we don't know.

One thing *is* certain, however. If you happen to see this toy chicken at an upcoming *Spy-Fi* Exhibit, please make sure that you are not standing close to it while under the glow of a full moon. In the fanciful world of *The Wild Wild West*, such conditions can cause even a *human* to be transformed into gold.

Midas Touch. For seven hundred years the world has been trying to track down the incredible treasure held inside this toy chicken. At last, the hunt is over. This prop, as seen in the show, is said to turn objects into gold.

THE VALENTINE-SHAPED GLASSES OF A DIABOLICAL WOMAN

"I shall reign as queen. I shall not like to rule forever. Just long enough to win total independence for women."

—*Emma Valentine*

Rarely do screenwriters make their main villain a woman. But certainly the "fairer sex" is just as capable as a man—if not more so, some might say—to scheme and be vicious. During the latter part of 1966, in an unusual twist for prime-time television, *The Wild Wild West* cast Agnes Moorehead as the title character in "The Night of the Vicious Valentine." Well known to '60s TV viewers as the meddling witch Endora, in *Bewitched,* Moorehead took a delightful turn as the deadly Emma Valentine, who plots both matrimony and murder to gain financial control of America's richest men. Moorehead's sparkling performance earned her an Emmy from the TV Academy as Best Supporting Actress that year.

Although the villainous Valentine had a heart of ice, she adored all things heart-shaped. The art director designed her home with nearly everything in the shape of a heart. Perhaps the most important item adapted to this design was Emma Valentine's eyeglasses. Custom-made for Moorehead's character, these specs sport heart-shaped lenses within a gold frame that, at the release of a button, fan outward from the red-velvet, heart-shaped pockets that hold and protect them.

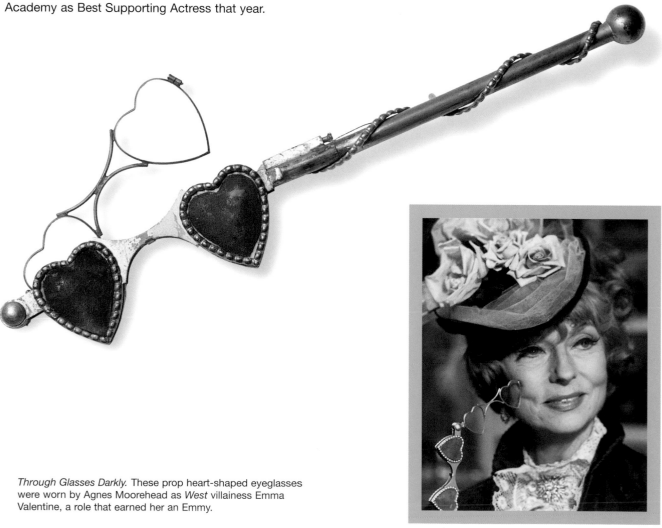

Through Glasses Darkly. These prop heart-shaped eyeglasses were worn by Agnes Moorehead as *West* villainess Emma Valentine, a role that earned her an Emmy.

DEADLY SPEARS SPECIAL-EFFECTS RIG

For James West, king-size beds were always a double-edged sword. He frequently found this type of furniture in a room with a beautiful young woman. It's a combination that certainly has potential, but more often than not, the lovely lady is a lure, and the bed is a trap.

In the series' second adventure, "The Night of the Deadly Bed," West is drugged by a beautiful señorita and ends up unconscious on a bed that nearly impales him with deadly blades. In other episodes, West's beds are blown up, crushed, and turned into Swiss cheese. Talk about rude awakenings!

How do West's enemies engineer these diabolical sleeping arrangements? This enormous contraption is a special-effects rig, utilizing two lengthy spears, that was secured high above the set and controlled off camera by effects man Tim Smyth. As West prepared for bed in "The Night of the Sedgewick Curse," these spears shot down into the mattress, just missing him.

"These were real metal spears," pointed out Smyth. "They were in a pipe to guide it, mounted up on the grids on the stage. I had pull pins in to let them drop. Bob Conrad was trusting enough where he would lay there until he saw them coming. On cue, I'd pull the pins and those spears came down. Bobby rolled out of the way. The mattress was made out of Styrofoam, so when they hit, they stuck. They would have gone right through him."

In "The Night of the Janus," this same device is used during West's visit to his old Secret Service training academy, where a seemingly harmless living room is made lethal by a traitor. Locked inside the room, Jim uses his gadgets to activate booby traps from a safe distance. When he loads a piton into his Derringer and fires it at a wooden coat rack, the impact triggers one of these spears to drop from the ceiling—a devious trap that otherwise would have killed him.

Whether he's in a living room or a bedroom, relaxing on the job is rarely in the cards for Jim West. Especially if it's at the invitation of a lady.

ABOVE:

Design for a Deadly Weapon. The spear blades were fashioned after this preproduction drawing.

BELOW:

Blades of Doom. This large special-effects rig, fitted with ornate spears, was utilized in several deadly traps set by villains intent on killing James West.

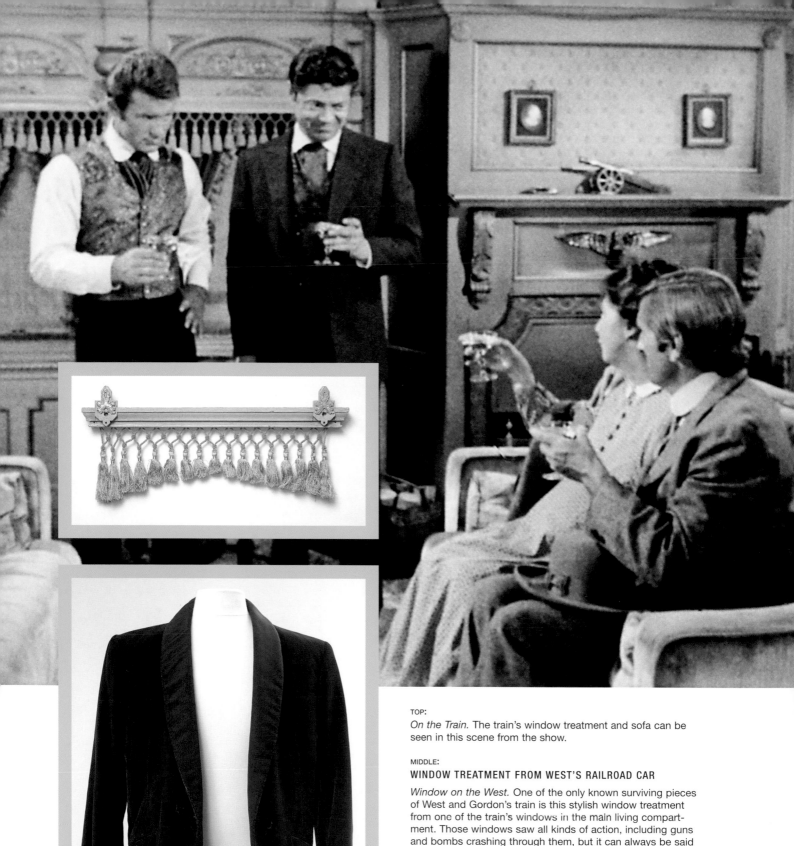

TOP:

On the Train. The train's window treatment and sofa can be seen in this scene from the show.

MIDDLE:

WINDOW TREATMENT FROM WEST'S RAILROAD CAR

Window on the West. One of the only known surviving pieces of West and Gordon's train is this stylish window treatment from one of the train's windows in the main living compartment. Those windows saw all kinds of action, including guns and bombs crashing through them, but it can always be said that, no matter what damage they sustained, they always looked good.

BOTTOM:

JAMES WEST'S SMOKING JACKET

Relaxing in Style. Robert Conrad wore this red-velvet smoking jacket in scenes when Jim West was relaxing aboard his train. As several villains have conceded, "Mr. West, you have considerable style."

THE GOLD SOFA FROM JIM WEST'S TRAIN

The private railroad car loaned to James West by the U.S. government should have had its own billing as the third star of the series. Built at a cost of $35,000, the train set appears in every episode. Serving as the agents' home, as well as their mobile base of operations, the train contains a lab, where Artemus creates his various gadgets and disguises, and the main living quarters—attractively furnished in golds and greens— where the men conduct business, as well as entertain.

This gold sofa was a key piece of furniture on that set. During the run of the series, its luxurious, golden cushions were enjoyed by such varied personalities as the president of the United States, members of royalty, and foreign dignitaries, as well as an assortment of criminal masterminds who invariably found their way onto West's private car.

Both Jim and Artie would probably agree, however, that the sofa had its most memorable use at the end of each assignment—at the tag of nearly every *Wild Wild West* episode—when two lovely ladies would curl up on this sofa in the arms of our heroes. The theme music would swell as the train chugged along the tracks into the distance, the two agents enjoying a well-earned rest from having, once more, saved our great nation from the forces of evil.

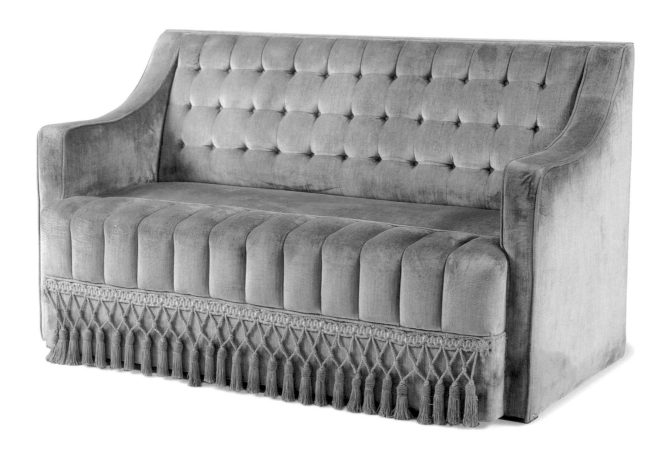

Have a Seat, Mr. President. One of the most recognizable set pieces on *The Wild Wild West* is this luxurious gold sofa, which can be seen front and center on the train-car set in nearly every episode.

MISSION: IMPOSSIBLE

CHAPTER 00:04

4

Art of Espionage. The essence of *Mission: Impossible* is portrayed in this original painting created in 1967 to promote the show. The artwork was never used.

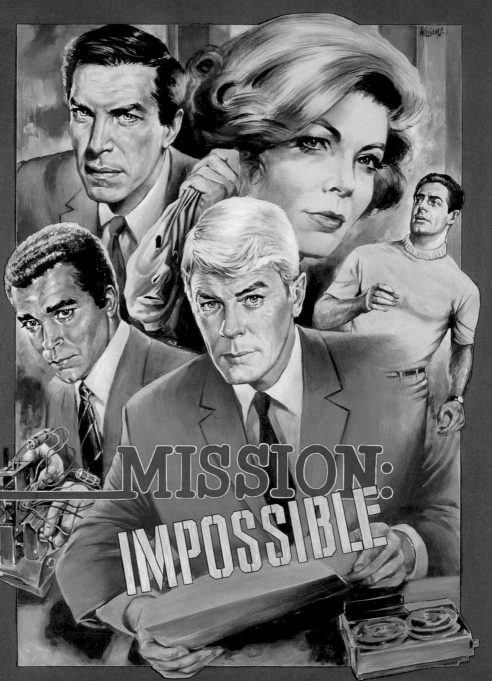

PETER
GRAVES

MARTIN
LANDAU

BARBARA
BAIN

GREG
RRIS

ETER
LUPUS

MISSION:
IMPOSSIBLE

Created by **BRUCE GELLER**

"Good morning, Mr. Phelps. . . . "

For more than three hundred weeks on national television, those four words set the wheels in motion for hundreds of incredible schemes and amazing plots that kept our country safe from evil dictators, unscrupulous drug lords, underworld mobsters, and foreign spies.

The brainchild of writer-producer Bruce Geller, *Mission: Impossible* took a new approach to espionage, offering a format unlike that of the dozens of other spy thrillers on the scene in 1966. This series features practically no fight scenes, no car chases, very little romance or sexual innuendo, and almost never a simple story. Instead, we are presented with intricate plots laced with suspense and illusion. The star of *Mission: Impossible* is the script, a complex maze of twists and turns that demanded, for one hour every week, the full attention of the viewer.

The concept revolves around a team of specialists who undertake missions deemed *impossible.* Each episode begins when the leader of the Impossible Missions Force, Jim Phelps (played by Peter Graves), shows up at an obscure, prearranged location to find a hidden tape recorder and information packet. He plays the tape, which always begins with a man's voice saying, "Good morning, Mr. Phelps." The recording briefly spells out a dire situation in the world, one that usually involves a pressing time element. "Your mission, should you decide to accept it," the voice always instructs, is for Phelps to accomplish such tasks as locating and destroying a biological weapon, stopping an ex-dictator from regaining power, or rescuing an imprisoned American agent. When the tape ends, Phelps is told, "This recording will self-destruct in five seconds. Good luck, Jim." The reel of tape then goes up in a billow of smoke.

At his apartment, Phelps goes through his IMF dossier and selects the specialists for the mission. During the series' first three seasons, the IMF team included Rollin Hand, an actor and master of disguise (played by Martin Landau); Cinnamon Carter, a femme fatale (Barbara Bain); electronics genius Barney Collier (Greg Morris); and strongman Willy Armitage (Peter Lupus). Phelps meets with his team for a rundown of the disguises and gadgets to be used on the mission; this is a cryptic scene, which adds to the fun of the story when we later discover how each element contributes to the enactment of Phelps's plan.

Each mission is executed like clockwork, with the best-laid plans of the IMF always about to go awry at the commercial break. The payoff arrives at the climax, when the villain realizes that he has been duped. By then, the team is packed up inside their disguised van, peeling off masks, catching their breath, exchanging smiles. The van zooms down the road, the camera flipping the image to freeze-frame and fade-out.

Geller originally conceived *Mission: Impossible* as a star vehicle for his friend, Martin Landau, whom he planned to cast as a Houdini-like magician named Martin Land. First titled *Briggs' Squad,* the concept was envisioned as a feature film or a TV miniseries before evolving into a weekly hour-long show for Desilu. Steven Hill starred as IMF leader Dan Briggs during the first year and was replaced by Peter Graves as Phelps in 1967. Joining the IMF team in later seasons were Lesley Ann Warren, Sam Elliott, Lynda Day George, and Leonard Nimoy, who became disguise expert Paris after his three-year stint as *Star Trek*'s Mr. Spock.

With clever scripts by William Read Woodfield, Allan Balter, Laurence Heath, and others, and Lalo Schifrin's remarkable (and soon-to-be-famous) theme music, this Paramount production turned heads when it debuted in the fall of '66. *The New York Times* wrote, "CBS may have found its *U.N.C.L.E.*" A winner of numerous Emmy Awards, *Mission: Impossible* ran for seven seasons on CBS, making it the longest-running spy series on American television. Its title became part of the American lexicon and has been used for decades to describe any task or goal considered difficult, if not impossible, to achieve. The self-destructing tape also caught on with the public, and has been parodied endlessly. The show was revived in 1988, airing for two seasons on ABC with Graves reprising his role as Phelps and Greg Morris's son, Phil, following in his dad's footsteps.

Mission: Impossible is remembered and respected as a classic, its prime seasons representing some of the highest-quality writing on American television.

BRIGGS' SQUAD OUTLINE

The origin of *Mission: Impossible* dates back to January 1964, when Bruce Geller began making notes for *Briggs' Squad.* The idea focused on six former military specialists whose hazardous duty in foreign lands was under the leadership of Lieutenant Colonel David Briggs of the U.S. Special Forces.

Since crime has become the natural outlet for their talents in civilian life, the specialists are recruited by Briggs to perform criminal acts that will serve the common good—"an endeavor undeniably illegal," noted Briggs in the outline, "but with overtones of meaning of which many . . . could approve." Briggs's team includes a wealthy thief, a ladies' man, a master magician, an engineer, a strong man, and a syndicate killer. "I have made

them unfit to live as normal human beings," said Briggs. "Each seems destined to end up in the electric chair . . . unless I can channel all this that I have made." Briggs himself is a behavioral analyst. "I am one of the world's greatest guessers," he said. "I can tell you . . . how man will respond to life."

The team that would one day evolve into the secret U.S. agents of the IMF was originally designed by Geller to function without governmental sanction. However, Geller anticipated a problem selling the networks on a concept for a show whose heroes were murderers and thieves. "To suit the Television Code," wrote Geller, "Briggs' Squad may have to be given a semi-official status . . . by which they are actually performing their services for the United States Government. If they are caught they will have to take the full rap as the government will not acknowledge any awareness of their existence."

On the last page of this outline, written in pencil by Geller, are additional words that foreshadow the hit TV series into which *Briggs' Squad* would soon evolve: "Briggs' Squad has always, and will again, operate as one man while . . . the relationship [among the villains] is one of mutual suspicion and distrust. It is this human factor that is the key to the impossible being accomplished."

LEFT:
Idea for a TV Show. Bruce Geller's original January 1964 outline for *Briggs' Squad* presented a concept that would evolve into *Mission: Impossible.*

BELOW:
Characters Come to Life. Two of Bruce Geller's original characters from *Briggs' Squad*—David Briggs and Willy Armitage—were given form on-screen by Steven Hill and Peter Lupus. The name David was changed to Dan.

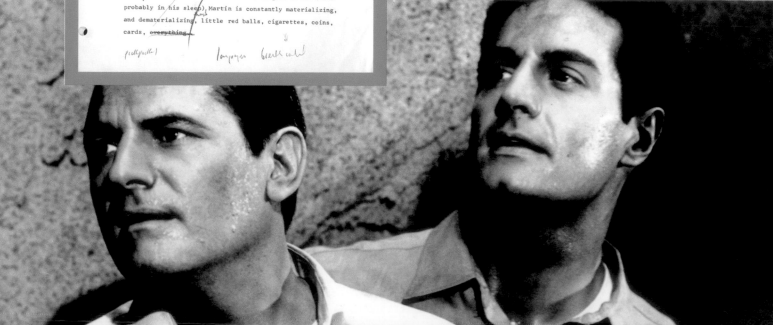

MARTIN LANDAU'S PILOT SCRIPT

"We have learned [of] two nuclear warheads furnished . . . by an enemy power . . . and their use is imminent. Your mission . . . will be to remove both nuclear devices. . . . "

Such is the very first "impossible" mission offered to Dan Briggs and his IM Force. Written by Bruce Geller in November 1965, the pilot script details a threat that is still frighteningly pertinent.

This copy of the script for the series' first episode was used during production by Martin Landau, who earned acclaim portraying the IMF's "man of a thousand faces." In this early draft, Landau's character is named Martin Hand. An insert memo dated December 8 notes that the name "should be changed to read Rollin Hand." The script also contains several handwritten notes Landau made on the set. They include addresses, phone numbers, and reminders of appointments he had at the Beverly Hills Hotel, 9:00, and with Carol Baker, Thursday, 8:30.

BELOW, LEFT:
First Mission. This is Martin Landau's personal copy of the pilot script for *Mission: Impossible.* Landau starred as disguise expert Rollin Hand for three seasons.

BELOW, RIGHT:
Behind the Scenes. Producer Bruce Geller (left) looks on as Martin Landau takes a break during filming.

BOTTOM, LEFT:
PARAMOUNT PRODUCTION SIGN

Sshhh . . . Spies at Work! This Paramount Studios production sign was used on the studio lot, and possibly on location, to alert people that filming was in progress.

BOTTOM, RIGHT:
Fantasy Meets Reality. The author stands at the majestic entrance of CIA headquarters with the sign used on *Mission: Impossible.* The agency revealed an interesting connection it had with the TV series.

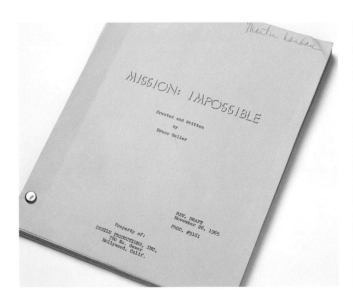

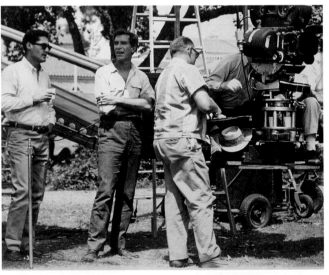

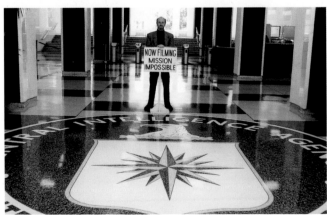

NETWORK SERIES PRESENTATION

"Dan Briggs is an undercover agent . . . highly trained in World War II clandestine activities . . . [and] on call at all times to a hush-hush agency of the United States government. . . . "

—*CBS Network Presentation, April 1966*

When CBS created this booklet to announce the debut of *Mission: Impossible*, it could not have imagined that its weekly series about an elite team of secret agents would become required viewing for the members of a *real* U.S. intelligence agency.

When the CIA flew me out to its headquarters in the spring of 2000 to make preparations for my exhibit, a longtime agency operative shared a fascinating story with me: During the 1960s, the CIA assigned some of its staff to watch *Mission: Impossible* on television and report their findings. This weekly analysis gave the agency ideas for real-world applications. It also caused alarm when the agency recognized what appeared to be its own classified technology and scenarios in the series' fictional scripts.

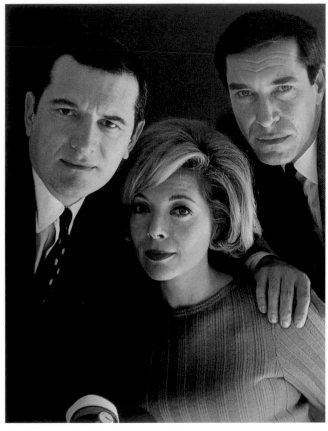

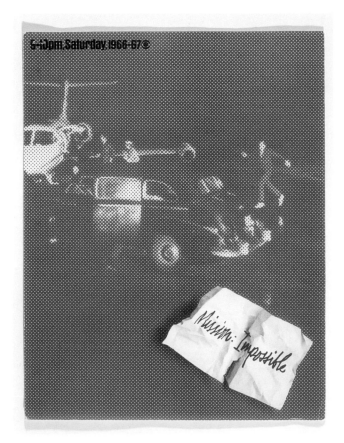

ABOVE:

TV GUIDE COVER PHOTO

First Team. Three of the original core agents of the IMF—Dan Briggs, Cinnamon Carter, and Rollin Hand—are featured in this original photo that was used for the February 11, 1967, cover of *TV Guide.*

LEFT:

Introducing the IMF. This network booklet alerted the TV industry to a new series that would catch the eye of critics, the public, and even the CIA. The six-page write-up says that "guest specialists" joining the IMF will include a human fly, a wild-animal trainer, a tank commander, and a glassblower. Curiously, those roles were never developed.

SELF-DESTRUCTING MISSION TAPE

Perhaps the most popular element of *Mission: Impossible* was the self-destructing tape. After proposing a mission, the mysterious recorded voice alerts Phelps, "This tape will self-destruct in five seconds." Smoke spews from the reel, destroying evidence of the assignment.

In the majority of those scenes, the tapes were never really destroyed. To create the illusion that they were, effects technicians piped smoke up through the bottom of the tape recorder. However, when the series began production, one or two mission tapes actually did self-destruct. "They put a chemical in the tape," explained Peter Lupus. "Then they blew air on it from off camera, causing the chemical to react. It made the tape crumble and turn to dust."

The producers decided it would be too expensive to make these self-destructing tapes for every episode, so the special smoke effects were devised instead.

This Tape Will Self-destruct in Five Seconds. This reel of recording tape was saved by one of the show's producers. The mysterious voice that gave Phelps his mission every week was that of Bob Johnson.

"MISSION BRIEFING" NEWS ARTICLES

"Good evening, Mr. Briggs. This is Carl Wilson, a special U.S. envoy [who has been] kidnapped . . . and replaced with an imposter. . . . "

When the IMF leader gets his taped mission, he also receives a briefing envelope that contains pertinent photos and newspaper clippings. The mysterious voice on the tape identifies the individuals pictured and explains their role in the crisis at hand. These news articles were part of the secret briefing packets provided to Jim Phelps and Dan Briggs by their anonymous government employer.

The IMF's secret missions are conducted behind the scenes of fictional world news. . . .

BELOW, LEFT:

Hijacked. Jack Cole hijacked a priceless Incan treasure belonging to a small, democratic nation, which had planned to sell it as a means of saving its weak economy. Mission: Retrieve the treasure.

BELOW, RIGHT:

Coup. Security Chief Gomalk plans to overthrow a pro-Western government by assassinating the nation's leader, President Rurich. Mission: Stop Gomalk.

FOLLOWING PAGE, TOP:

Imposter. A special U.S. envoy, Carl Wilson, is replaced with an exact double, an enemy agent whose plan is to sabotage an international treaty. Mission: Rescue Wilson.

FOLLOWING PAGE, BOTTOM:

Diplomat's Wife. Phelps recruits the wife of a top U.S. diplomat as bait for an enemy agent seeking to verify stolen documents that reveal U.S. missile-control locations. Mission: Discredit the data.

JACK COLE ARRESTED IN SANTALES

JACK COLE

The sole survivor, allegedly, of a hi-jacking gang, Cole is accused of master-minding the stealing of the priceless collection of Incan gold artifacts as it was being shipped to the British Museum.

The Government of Santales had expected the income from the sale of the collection to help them through their current economic trouble.

STEPHAN GOMALK and BEYRAN RURICH

Celebrate their moment of total victory at a secret camp in the mountains of Yurava.

Special Envoy Wilson

Special Envoy Wilson is on an extended tour covering fifteen different countries on behalf of the U. S. State Department to promote trade and good will.

have the defense that its purpose is to inform the public of matters which they may be entitled to know before the election.

The man in the middle is chief counsel for the committee. He argued against immediate hearings, when the party announced them, on the ground that several months were needed to complete his investigation. The members stood firmly behind him—at first.

Now it develops that this support from the majority will be determined entirely by the political considerations. He must wonder how much, when and if hearings are finally held, he will be expected—or permitted—to reveal.

To insure that the capital investment of farms goes in the first place to develop communal economy—for the building of farm buildings, stables, and sheds for the animals, for irrigation and other canals, for reservoirs, for the clearing of undergrowth from the land, for the planting of field-protecting forest belts, for the building of stations, and other constructions necessary for the successful development of the economy of the increase of the revenue of farms and farmers.

Just how serious the need may be is a subject of dispute itself. S. Gilbert, the loan guaranty officer of the administration here, said that ownership achieved from local lenders, the need was desperate and the surface had hardly been scratched.

Never in thirty years in the business, he said, has he seen such a "marvelous record of repayment of loans." Government losses to date through guaranteeing such mortgages, he added amount to one five-thousandth of one per cent.

In one move, the city planning board and zoning commission yesterday both tightened and loosened restrictions on subdivision plats offered for approval.

The commission approved the plat of Rincon terrace which includes lots having 8,000 square feet instead of 9,000, the previously minimum. The exception was made because of the location of the subdivision and the fact that the subdivider plans to build low-cost homes there.

The board feels that, where an area lends itself to housing developments and where there is a plan for putting up such dwellings, the minimum restriction should be removed to make the program possible. Exceptions will continue to be made on an individual basis.

A suggestion that public hearings on applications be limited to one every six months was taken under advisement by the commission.

The facts regarding the situation remain the same, state the authorities. Details concerning the action have been given a preliminary investigation but it is felt that only by a more detailed study will the true facts became known.

Many persons feel at this stage that some legal action is forthcoming but it now becomes common knowledge that there is pressure from the inside which will materially change the aspect of the case.

32-Hour Fight Lost by Bolivian Force

ASUNCION, Paraguay, March 12.—(AP)—The Paraguayan War Office, in a bulletin today, said the third Bolivian division had been overwhelmingly defeated after a thirty-two-hour battle with Paraguayan forces in the Gran Chaco, where the two nations have been in conflict several months.

The communique stated the Bolivians suffered more than 2000 casualties while fleeing from Paraguayan cavalry.

Thus at this conference all our governments found themselves in unanimous agreement regarding this undertaking. Arrangements for dealing with questions and disputes between the republics were further improved.

Of no less importance was the common recognition shown of the fact that any menace from without to the peace of our continents concerns all of us and therefore properly is a subject for consultation and cooperation. This was reflected in the instruments adopted by the conference.

Never in thirty years in the business, he said, has he seen such a "marvelous record of repayment of loans." Government losses to date through guaranteeing such mortgages, he added amount to one five-thousandth of one per cent.

... will be shed on the situation in the near future. Available facts seem vague but authorities feel that time will disclose some means of arriving at a solution.

U. S. Envoy Calls on Vice Premier

To make use of the expansion of the existing enterprises as a major reserve for increasing production with the least outlays.

To create in advance reserves in the construction of plants, power stations, and coal mines so as to insure the necessary development of these industries in subsequent years.

To insure an improvement in the geographic distribution of construction of industrial enterprises in the new plan, bringing industry still closer to the sources of raw material and fuel with the object of eliminating irrational and excessively long shipments.

To increase by two times the material and food reserves, which could insure the country against any eventuality.

Capacity is being increased because most businessmen are convinced that despite occasional fluctuations, sales will rise over the long haul. Intent on bettering their economic position, the majority of companies are proceeding on the theory that building extra facilities in a period of sales decline will pay off as soon as demand picks up.

The report might be compared to an unedited film of a congressional hearing. It is just as confusing and by no means as entertaining. But politicians will be mining this record for partisan nuggets.

Such nuggets are not lacking in the report. It is possible to draw some damaging new inferences and to reinforce some already made. It is possible to do so even after discounting the vastly different political climate of that last year of the war.

Thus at this conference all our governments found themselves in unanimous agreement regarding this undertaking. Arrangements for dealing with questions and disputes between the republics were further improved.

Of no less importance was the common recognition shown of the fact that any menace from without to the peace of our continents concerns all of us and therefore properly is a subject for consultation and cooperation. This was reflected in the instruments adopted by the conference.

In view of the situation, authorities assure all concerned that everything is being done to alleviate matters. Available facilities will be stressed to the utmost. Meanwhile, public interest is mounting and voices of immediate action will have to be heard.

Future plans will, of necessity, have great bearing on the situation as it now stands. Decisions will have to be made of the actual planning of the project will take considerable time but it is felt that these steps are very important.

mercury ions to travel at tremendous speed through a series of small tubes, the driving force being an electric field in each tube. The maximum energy thus far developed by the tubes is 2,850,000 electron-volts.

As pointed out in its recent annual survey of business' plans for new plant and equipment, this bullishness displayed by businessmen "is not a case of whistling in the dark. They frankly expect a decline in sales this year, but the minor dip we've experienced isn't halting large-scale additions to productive capacity."

Capacity is being increased because most businessmen are convinced that despite occasional fluctuations, sales will rise over the long haul. Intent on bettering their economic position, the majority of companies are proceeding on the theory that building extra facilities in a period of sales decline will pay off as soon as demand picks up.

The report might be compared to an unedited film of a congressional hearing. It is just as confusing and by no means as entertaining. But politicians will be mining this record for partisan nuggets.

Such nuggets are not lacking in the report. It is possible to draw some damaging new inferences and to reinforce some already made. It is possible to do so even after discounting the vastly different political climate of that last year of the war.

CONVICTS UNGUARDED ON KANSAS ISLAND

Fort Smith, Ark., 7.— —A timbered Missouri river island near Lansing is a "land of beginning again."

Upon 2,500 acres of its rich soil live 210 men, who, to all outward appearances, are laboring freemen. In reality, they are convicts, sentenced for the first time to the Kansas penitentiary at Lansing

Many of them never have seen the inside of the prison. Warden Kirk Prather, believing these first offenders are not criminals at heart but men human enough to err, has placed them on their honor.

PRESIDENTIAL ADVISOR RECALLED FROM EUROPE

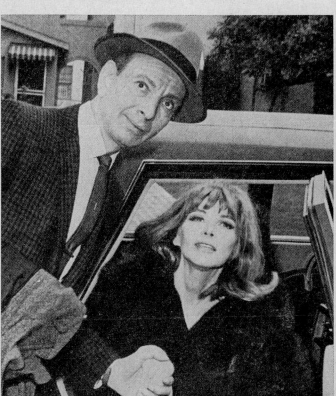

Capacity is being increased because most businessmen are convinced that despite occasional fluctuations, sales will rise over the long haul. Intent on bettering their economic position, the majority of companies are proceeding on the theory that building extra facilities in a period of sales decline will pay off as soon as demand picks up.

The report might be compared to an unedited film of a congressional hearing. It is just as confusing and by no means as entertaining. But politicians will be mining this record for partisan nuggets.

Such nuggets are not lacking in the report. It is possible to draw some damaging new inferences and to reinforce some already made. It is possible to do so even after discounting the vastly different political climate of that last year of the war.

At the coming election the public will have in its hands the power to relieve a pressing condition.

As you know, the problem of providing schools for our ever-increasing youth is becoming more and more serious. In the next five years, an average of 11,000 more children each year will be enrolled in public schools.

At the present time we do not have the facilities to give all of these children a full day's schooling.

Many things have to be considered before additional action can be taken and it remains for the reader to make a thorough study of the facts before a decision can be reached.

Furthermore, there will be a continuing need for the projects included in the program of the Board of Education for the relief of over-crowding and the replacement of antiquated buildings.

It was recommended that any additional needs for school accommodations created by the housing projects that cannot be met in existing school buildings.

American Mining Expert Asks British Citizenship

By The Associated Press.

LONDON, (Special) — Alfred Chester Beatty, mining expert.

BLUEPRINT OF DAN BRIGGS'S APARTMENT

Before executing each mission, the IMF leader assembles his team for a meeting at his apartment, where details of his plan are reviewed and rehearsed. The only permanent set on the series, Dan Briggs's (and later Jim Phelps's) apartment was designed and dressed in purely black-and-white decor. "There's nothing quite as arresting in color as black and white," observed Bruce Geller. "Then when you cut to something in color, the effect is startling."

The rule banning color from that set was so firm that production was abruptly halted when one of the stars decided to change his wardrobe without telling anyone. "I didn't like the tie that the wardrobe folks gave me," recalled Peter Lupus. "I had some ties of my own so I put one on. It was not black or white or gray; in fact, it had red in it. I kind of sneaked onto the set and they stopped shooting immediately. Bruce said *everything* on this set is black and white, even our wardrobe."

Top Engineer. Greg Morris portrays electronics expert Barney Collier, seen here working on a blueprint.

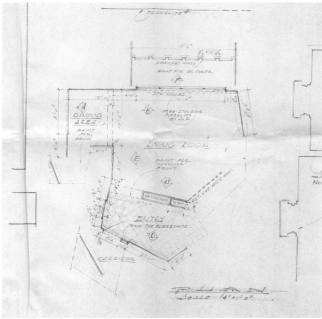

The Plot. This is a preproduction blueprint for Dan Briggs's apartment, where the IMF missions are planned. The series never revealed its location, but this schematic—drawn on December 2, 1965, for the pilot—states that it is in New York City.

COIN AND POSTAGE STAMPS FROM A FOREIGN DICTATORSHIP

How do you free a people from their dictator? It's a problem that the United States has faced for decades. Left unchecked, as with Adolf Hitler, the power of a tyrant to enslave and slaughter his people may be projected beyond that country's own borders and threaten the world. But efforts to stop the madman can lead to world war or, as in the case of Castro, a Bay of Pigs fiasco.

Will our intervention win the gratitude of a liberated populace or trigger the indignation of the world? Should the president of the United States publicly call for "regime change" and back up his demand with armed invasion? Or is it better to use subversive methods to achieve our goals? Whichever means we employ, are they legal, moral, and in keeping with our own democratic principles? The answers to these questions are difficult

because the world stage is often complex, with matters of good versus evil frequently not as black and white as we would like.

These moral ambiguities have been acknowledged in TV spy series like *Secret Agent, The Prisoner, I Spy,* and *Agency.* But in many other thrillers—particularly in the world of *Mission: Impossible*—there are no shades of gray. The heroes of this TV show are clearly in the right, and their enemies are, without a doubt, in the wrong.

For the first several seasons of *Mission: Impossible*, the IMF's assignments are primarily to remove an evil foreign ruler from power or to prevent his usurping power from a peace-loving leader. In these stories, the IM Force uses all manner of trickery to stop or destroy the enemy. While they usually don't engage in direct assassination, they will go to great lengths to frame the villain so that he will be executed by someone else.

With a dictator removed, the path is clear for a compassionate and moral leader (usually in the wings) to fill the vacuum. No one in the world is ever aware of this American action in the cause of freedom since it is performed by agents functioning under deep cover. The audience can root for the IMF because it so clearly and nonviolently pursues a course of action that makes for a better world.

Nations whose citizens have benefited from the IMF's secret operations include Valeria, Lombuanda, Svardia, Santales, Elkabar, Veyska, Surananka, and Povia. Although none of these countries exists in real life, the producers of *Mission: Impossible* worked hard to make the audience believe they did. Sometimes, in fact, the show succeeded a bit too well. "Although we always

locale in mythical countries," said Geller in 1967, "we get letters from viewers complaining, 'That's not the sea-coast of Hungary!'" Writer and story editor Paul Playdon recalled, "I wanted to use Albania once and couldn't. We were under strict orders to invent fake Eastern European countries."

Props were designed to give an added sense of reality to these fictional nations. For the non-existent San Cordova, the prop masters created this coin and sheet of postage stamps bearing the likeness of Riva Santel, the powerful widow of the nation's late president. In the episode "The Elixir," Santel plans to cancel the country's elections and take over as absolute dictator. Because the IMF succeeds in preventing Santel's coup, undoubtedly her image was subsequently removed from San Cordova's currency and other public documents, making these Santel stamps and coin the *only* surviving evidence of the would-be dictator's shadowy reign.

ABOVE:

Stamp of Authority. This prop coin and postage stamps bear the likeness of a would-be dictator, whose use of power the IMF must prevent.

LEFT:

Dictator-in-Waiting. This is Ruth Roman as Riva Santel, ruler of San Cordova.

IMF SIGNATURE-TRANSFER DEVICE

The IMF invented a way to copy someone's signature without forging it. Using this special device, a "ghost" of the signature is captured and transferred to another document, making it appear authentic.

Cinnamon Carter uses the gadget to replicate the signature of exiled dictator General Ernesto Neyron, who is planning a military coup to return him to power in his native country. Working undercover at the general's Miami estate, Cinnamon uses these materials to "lift" Neyron's signature off the glass table on which he signed a document. She then applies it to a faked contract, which is later used to frame him. The plastic sheet and yellow material are props that Barbara Bain used on-screen. The rubber stamp bearing Neyron's signature is a behind-the-scenes tool used to print the villain's name onto the screen-used props.

Gadgets such as this are in keeping with the series' rule to portray only technology that is existing or within the realm of possibility. "Our spy devices always have been fairly exotic," said Bruce Geller. "We've done a great deal of research. Some [real devices] are so fantastic that if we put it on the show, nobody would believe us."

ABOVE:

Identify Theft. This gadget was used by Barbara Bain, as Cinnamon, to perfectly duplicate the signature of an exiled dictator.

NEWS OF A SOVIET DEFECTOR

Did you ever imagine that the citizens of a small town in the United States might all be foreign agents, residing there for the sole purpose of using their town as a staging area for political assassinations? En route to a vacation getaway in 1968, Jim Phelps stops off at the little town of Woodfield and stumbles upon such a conspiracy. Their secret uncovered, the townspeople subdue and drug Phelps, marking him for death. In Sy Salkowitz's offbeat tale "The Town," the IM Force assembles to rescue Phelps and prevent two of the town's killers from carrying out an assassination plot. These news articles announce the Los Angeles speaking engagement of a top Soviet defector. Correctly deducing that he is the assassins' next target, the team saves both the defector and Phelps, and puts the town out of commission for good.

RIGHT:

Target for Assassins. Newspaper stories, which report a Soviet defector's public appearance, alert Phelps's team to the likely target of an assassination plot.

JIM PHELPS'S WARDROBE

Good luck, Jim. . . . This wardrobe was worn by Peter Graves in the role of IMF leader Jim Phelps.

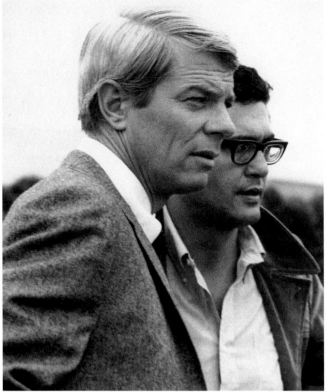

Mission *Masterminds.* Executive producer Bruce Geller and star Peter Graves confer on the set.

IMF COVER ID CARDS

No other fictional spies use cover identities as regularly as the agents of the IMF. Facilitating their deceptions are disguises, voice impersonations, and fabricated documents. The most obvious, yet effective, forgeries are identity cards. Flashing authentic-looking IDs before the eyes of a busy security guard always does the trick.

Phelps uses the IMF-created business card for the fictional Dr. Anton Lumin to help establish his alias as an amnesia specialist. Such an "expertise" allows Phelps to be recruited by the enemy to help unearth a memory lost in Paris's mind. Once extracted, the IMF-manufactured "memory" factors significantly into Phelps's plans. Other forged cards have identified Phelps as James Travis, an insurance investigator, and as Jan Golni, a state archives researcher hired by an aging dictator.

Who were the secret operatives working behind the scenes, supplying the IMF with these clever forgeries?

"Art director Art Wasson or I would design all those cards," recalled *Mission* prop master Bill Bates. "We would decide what it should look like, have it approved by the director and producers, then have the print shop make it for us."

As an inside joke at the beginning of the show, a picture of Bates was included in Phelps's dossier of specialists as he sorted through the photos to select his team. Bates was not among those chosen.

OPPOSITE:
The Game of the Name. Enemy agents will never know they've met an IMF agent because their business cards always give them fake identities. These prop ID cards were each used to establish an alias for one of our heroes.

WORLD INDEMNITY COMPANY

This certifies that:

Name **JAMES TRAVIS**

is a representative of this company. Any courtesy extended the
bearer in performance of duty will be appreciated.

253 _____

PRESIDENT

DR. ANTON LUMIN, M.D., Ph.D.

COMPUCORP

RAY HARPER, Systems Analyst

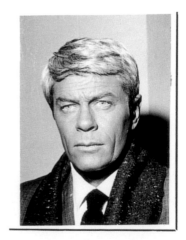

Name GOLNI, JAN

Born FEBRUARY 10, 1930

Place of Birth CENTRAL STATE
HOSPITAL, PROVINCE OF TALMA

Residence 83 MARA PROSPECT,
TALMAKAVO, PROVINCE OF TALMA

Education STATE INSTITUTE

Occupation RESEARCHER, STATE HISTORICAL
ARCHIVES, PROVINCE OF TALMA

TRANSPARENT PLAYING CARDS

Have you ever played a game of solitaire and discovered that you could "see through" the backs of the cards, enabling you to identify them? If so, then you have contracted a rare disease—Van Delberg's Syndrome—that allows you to see images of events that will occur in the future. That's if you believe the diagnosis of the Impossible Missions Force. No, they're not doctors . . . but Jim Phelps poses as a doctor when he makes a house call at the home of a deposed tyrant who is shaken by his sudden ability to predict the future.

Of course, the dictator doesn't know that the IMF substituted his playing cards earlier with these specially treated ones. Under preset lighting, the cards become transparent, allowing the villain to believe he can predict each card before turning it over. Convinced by Phelps that his disease is harmless and temporary, yet very real, the dictator is fed additional "visions" that help the IMF maneuver him through Phelps's carefully structured game plan.

If, while staring at the photo of these prop cards, you find you are able to see through them to the cover of this book, please make an appointment to see your doctor at once. Tell him the IMF sent you and that Van Delberg's Syndrome may have struck again. . . .

ABOVE:
Master of the Cards. While Cinnamon keeps the enemy (Nehemiah Persoff) off balance, Rollin breaks the bank with sleight of hand.

RIGHT:
IMF Card Trick. These specially designed playing cards are used to trick the villain into believing he can identify the cards while they are face down.

MEMORIES FROM "THE BUNKER"

"Progress on the missile continues. . . . The launching is tentatively scheduled for tomorrow."

—OBQ Centrale secret report

We've all read in the newspapers about that unscrupulous enemy intelligence apparatus, OBQ. Or have we? In fact, the organization is complete fiction. "I based OBQ on the fact that every year the KGB changed its name," explained writer Paul Playdon. "No one could keep up with its permutations. In intelligence work, this supposedly creates confusion on the other side. 'What is this organization? Is it new? Just hanging another name on the same one? Why did they change it?'"

This may be true in the real world, but on *Mission: Impossible* no acronym, not even OBQ, could confuse Jim Phelps and his team. Thanks to the Impossible Missions Force, a secret OBQ underground weapons lab is blown up, preventing the enemy from completing development of a powerful new long-range missile.

Miraculously, these items survived the explosion, providing us with a snapshot of the hidden danger and drama that existed in March 1969, when the IMF infiltrated the enemy missile base located one hundred meters beneath an abandoned cave. The artifacts include secret missile documents and an ID pass from OBQ Centrale, an IMF ID card of a nonexistent female OBQ official, and a snapshot of an assassin—Alexander Ventlos—that Phelps, under an alias, passed around as a warning to OBQ officials.

Pieces of an Urgent Mission. This assortment of props was used in the two-hour episode "The Bunker," in which the IMF must stop the enemy from completing work on a deadly new missile. Bruce Geller had tried to convince Paramount to release it theatrically in Europe under the title *Mission Impossible Beneath the Earth.*

BOWER HOTEL GUEST REGISTRATION AND LOGO

You're on a business trip and didn't have time to book a hotel in advance. You pass a nice-looking hotel on the corner of the block—the Bower Hotel. "Just drop me off here," you tell the cabby. You grab your luggage and head inside, finding the lobby to be unusually quiet, almost eerie. Yet everything seems normal. Perhaps too normal.

The hotel manager—a silver-haired man behind the registration desk—is registering a guest. He is a handsome-looking, brown-haired man in a suit. The manager gives him a green guest registration form to fill out. The man puts down his name as Lou Laurence. The manager hands him a key, and he heads for his room.

You approach the desk, but the manager is flustered. "I'm sorry," he says, "but we're out of rooms." Something feels funny; you sense he is lying, but you accept what he tells you and go to the phone booth. You pull out the directory, which sports a red "Bower Hotel" logo on it. You flip through, looking for another place to stay.

If you knew the truth about this hotel, you would be shocked. This is *not* the Bower Hotel. The silver-haired man is *not* the manager. And the hotel is *not* booked. In fact, every room is *vacant* . . . except for one. And that room was just registered to the hotel's only guest: Lou Laurence. Of course, his name isn't really Lou Laurence. It is Eddie Lorca, and he is a hired assassin.

Lorca has arrived in this city to fill a contract for a powerful underworld leader code-named Scorpio. Lorca has killed many people, but this time he will not succeed.

That is because the hotel manager is in fact Jim Phelps, and this building—disguised as the Bower Hotel—is controlled by the IMF. Phelps and his team will keep a close eye on Lorca and prevent him from making his hit. As a bonus, they will also nail his boss, Scorpio.

Now you understand why Phelps kindly turned you away. There are other hotels down the street. Any one of those would make more sense than walking into a web of danger and death by spending a night at the Bower.

Checking In. This is the guest-registration form and sticker of a hotel "manufactured" by Phelps and his team as a trap for a killer.

CAUGHT!

"As always, should you or any member of your IM Force be caught or killed, the secretary will disavow any knowledge of your actions. . . . "

—Voice on the tape recorder

Jim Phelps knows the rules of the game all too well; this proviso is repeated every time he is offered a mission. Unlike real life, the covert operations in *Mission: Impossible* are never compromised to the point that U.S. officials have to make public denials. However, on several occasions, members of the IM Force are caught. In each instance, the other team members formulate a rescue plan while still achieving their goal.

HEARTBEAT OF A LADY SPY

"She may not be the same Cinnamon we knew when they're finished with her. But they'll break her . . . and then they'll kill her."

—*Jim Phelps, "The Exchange"*

Cinnamon Carter is captured by the enemy on January 4, 1969, after completing an undercover assignment. She is interrogated but refuses to reveal anything. Secretly monitoring her pulse rate, Cinnamon's captors threaten her with disfigurement and then with death. There is no change in the pulse; she truly appears to have no fear of either.

But when her interrogator introduces the idea of locking her in a small space, Cinnamon's heart rate jumps. Monitoring the race of her pulse, the enemy discovers Cinnamon's weakness: claustrophobia. They place the

IMF agent in smaller and smaller rooms, until she is locked inside a tiny rectangular space that barely contains her. Enduring relentless questioning, Cinnamon nearly breaks, but she never reveals more than a single name—*Jim*.

These EKG printouts show Cinnamon Carter's heart rate at the time her captors threaten her with various forms of torture. The steep jumps indicate the moment that she hears her phobia verbalized. The printouts can be seen in the harrowing interrogation scene of writer Laurence Heath's standout episode, "The Exchange."

TOP:

Captured by the Enemy. Barbara Bain, as femme fatale Cinnamon Carter, undergoes psychological torture when she is captured by the opposition.

LEFT:

Fear Is the Key. The pulse rate of agent Cinnamon Carter is revealed on these monitor printouts. Interrogated by the enemy, Cinnamon's heart races when her secret phobia is mentioned.

THE CASE AGAINST A TRAITOR

Determining that the only way to rescue Cinnamon is through an exchange, Jim Phelps orchestrates the kidnapping of Rudolf Kurtz, an Eastern agent held prisoner by a third country. This legal brief—*Proceedings Against Colonel Josef Strom*—is instrumental in Phelps's plan to secure Kurtz. The brief is quickly fabricated by the IMF and presented to Kurtz as a trick to extract vital information. Kurtz reads through this brief, astonished to learn that his superior, Strom, has committed treason. Of course, it is all fiction created by Phelps, but it is effective. With the information Kurtz discloses in response, the IMF is able to conduct an exchange of spies: Kurtz is handed over to Strom, whom he now discovers was never a traitor. And Strom delivers, in exchange, Phelps's agent and friend—who *never* broke—Cinnamon Carter.

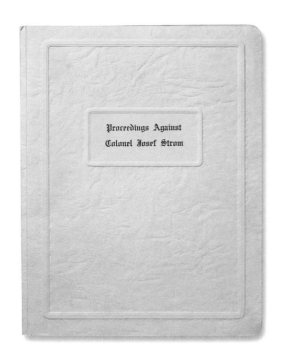

Clever Ploy. This prop legal document was created by the IMF to convince an enemy agent that his spy chief is a traitor.

CREDENTIALS OF A PRISON INSPECTOR

Many scenes have shown the IMF using advanced photo and printing techniques to fabricate documents, letters, and ID cards. Along with their elaborate disguises, such props are crucial to the team's ability to infiltrate various political, military, and private organizations.

The IMF created this data sheet to establish the bona fides of Cinnamon Carter, who undertook the alias of Christine Zensky, code name of Anna Nilas, the notorious chief of prisons in an unnamed Eastern Bloc country. Cinnamon took on the identity as part of Phelps's plan to rescue a peace-loving resistance leader from prison.

The phony document, which bears a photo of Cinnamon disguised as Nilas, notes that she is "endowed with a photographic memory" and is "extremely apt in procedures of confinement" (an irony, given Cinnamon's personal phobia). The ID sheet did its trick, effectively giving Cinnamon access to the prison.

Credentials for Cinnamon. The IM Force doctored these credentials for Cinnamon Carter to help convince the opposition that she was, in fact, the notorious chief of prisons.

The facts regarding the situation remain the same, state the authorities. Details concerning the action have been given a preliminary investigation but it is felt that only by a more detailed study will the true facts be known.

Top UCR Official To Visit U.S.

MILOS KURO
Director of Arts Theatre

TWO TICKETS TO A PLAY

"When one is with one's mistress, one loses all track of time."

—Premier of the UCR speaking to the president of the United States in Joan Vincent's play, At the Summit

You are given two tickets to a political play, *At the Summit*, at the Delphi Theatre. When you arrive, the theater doors are locked and there is a near riot out front. Cinnamon Carter (using the pseudonym of playwright Joan Vincent) is in an uproar, telling the media that *At the Summit* has been banned by the U.S. government as too controversial. You leave, disappointed. But someone else holding a ticket in his hand remains to speak to Cinnamon.

Visiting foreign minister Milos Kuro decides to invite Cinnamon to stage her play in his country, the UCR. Privately, he sees it as an ideal anti-American propaganda tool that will embarrass UCR's Premier Vados on the eve of signing a peace treaty with the United States, which Kuro opposes. Unbeknownst to Kuro, the IMF rewrites some of the dialogue and arranges for the premier to sit in on a rehearsal. Thanks to a sound umbrella rigged over the premier's head by IMF electronics whiz Barney Collier, Kuro is unable to hear the doctored dialogue being piped

into Vados's ears, which insinuates that the premier has a mistress and a Swiss bank account. Vados is outraged and has Kuro hauled off, inadvertently saving the treaty.

These prop tickets for *At the Summit* were given to Kuro by a "hospitable" State Department representative. Barney, posing as the rep, used the courtesy tickets as the hook to pull Kuro into the IMF's web. He told Kuro that he might enjoy spending his evening at the theater during his U.S. visit.

TOP, LEFT:

Creative License. These two tickets were to a controversial play written and performed by the IMF. Their last-minute rewrite would save an international peace treaty.

TOP, RIGHT:

Welcome to the U.S. This prop news article announces the visit of foreign minister Kuro, who has secret plans to sabotage an important agreement between his country and the United States.

FABRICATED TELEGRAM

Two Hours Late. On January 15, 1969, the IMF sent this telegram in the episode "The Vault" to Phillipe Pereda, finance minister of Costa Mateo, informing him that the expected auditor, Friedrich Vinder, would be arriving two hours late. Rollin, as Vinder, showed up as promised. Working from inside the finance ministry, he helped Phelps sabotage Pereda's diabolical plan to take over the peace-loving country.

A CHECK FOR $50,000

Try cashing this $50,000 cashier's check at your local bank. The money would be paid out of an account held at the 645 Post Avenue branch of City National Bank. As this was a legitimate check drafted by the IMF for one of its secret operations, the account must be a real one, utilized by Jim Phelps, the U.S. government, or, more likely, a front corporation far removed from both.

The check is made payable to Vitol Enzor, one of the top acting talents in the UCR. Rollin Hand, posing as Broad-way producer David Morgan, handed Enzor this check, along with a contract to star in *King Lear* in the United States. Using a disguise provided by Rollin, Enzor accepted his offer, escaping from behind the Iron Curtain to live a life of freedom.

ABOVE:
Just a Down Payment. This $50,000 check was paid by the IMF to a prominent Iron Curtain actor as part of a plan for disguise expert Rollin to step into the actor's shoes.

CODE SHEET AND FOREIGN AGENT PHOTOS

The IMF gets to the enemy's dead drop site first and replaces its all-important code sheet and "contact agent" photo with its own version. Master spy Stefan Miklos picks up the data and, not knowing it has been tampered with, uses it for an important operation. Now attached to the faked code sheet is a black-and-white snapshot of Rollin, which replaces the color shot of the real foreign agent, Simpson (played by Ed Asner). By the time Miklos gets to Simpson's office, Rollin has moved Simpson out and taken over his identity. Rollin's contact with Miklos sets the wheels in motion for an elaborate counterspy operation orchestrated by Jim Phelps.

Codes and Contacts. The IMF substitutes the color snapshot of enemy spy Simpson with that of Rollin, attaching it by paper clip to a different code sheet that served Phelps's own purposes.

NEWSMONTH PROP MAGAZINE

Take one cryogenics chamber, capable of freezing people so that they awaken decades into the future . . . and throw into the picture a famous '60s secret agent. Who comes to mind? Sorry, you're wrong. (You can find *that* guy on page 129.)

The correct answer is Jim Phelps. Yes, the leader of the IMF, in 1968, takes on the identity of a cryogenics specialist, Dr. Ward Kingsley, even landing himself on the cover of *Newsmonth* magazine. It is all done for the benefit of Albert Jenkins, an incarcerated criminal who's hidden $10 million in stolen cash. The IMF convinces Jenkins that he has a terminal disease, the cure to which might not be found until years after his death. The only hope for Jenkins is to be frozen in Kingsley's cryogenics chamber and thawed out far into the future: *1980!* Of course, it is all an IMF ploy to learn the whereabouts of Jenkins's haul.

The idea for this story, "The Freeze," came from an article on cryogenics that writer Playdon read in *Time* magazine. The cover story on the fictional *Newsmonth* was Playdon's nod to the real article. "We just lifted it,"

admitted Playdon. "We invented the name *Newsmonth* veiled for *Newsweek,* changing it just enough so everyone would understand."

In the episode, the duped crook is undoubtedly crushed to learn that the high-tech 1980 he's awakened into is only futuristic set dressing fashioned by the IMF. He should have guessed that it was all made up. After all, who would have believed a fantasy world in which anyone can pop a tiny cartridge into a machine and instantly watch a movie on a giant, flat TV screen. Really, now!

Where did that prediction come from? "Bruce Geller, himself, came up with a lot of the ideas for what the future would be," said Playdon. "Considering it was 1968, I'd say there was a little bit of Jules Verne in there."

Cover for a Spy. Jim Phelps appears on the cover of this prop magazine as Dr. Ward Kingsley, a cryogenics expert.

TELLTALE ASHES FROM CINNAMON'S FIREPLACE

"I wish I could meet the man that masterminded their operation. He was brilliant. I feel sorry for him. He played the game well, but he lost. And it'll destroy him."

—*Enemy agent Stefan Miklos, speaking about Jim Phelps*

Perhaps the most complex and ingenious episode of *Mission: Impossible* is "The Mind of Stefan Miklos," scripted by one of the show's top writers, Paul Playdon. Two intelligence masterminds are pitted against each other—American agent Jim Phelps and enemy operative Stefan Miklos. They never come face-to-face, yet do quiet battle in the shadows, like a chess game played in the dark.

Phelps's plan involves laying an elaborate but subtle network of clues, which he hopes will be detected and assembled like a puzzle in the mind of Miklos. Among the many puzzle pieces is an inch-long strip of paper containing the phone number of the New York Stock

Exchange. It is partially burned and placed in Cinnamon's fireplace, making it seem as if she had meant to destroy it. During a search of her apartment, Miklos discovers the telltale clue, which moves him to the next step in Phelps's carefully constructed maze. The IMF operation succeeds, leaving Miklos to believe that it is *he* who has outwitted his opposite number, the brilliant tactician he never met: Jim Phelps.

The tiny burned stock slip—*even its fallen ashes*—somehow survived after the filming of the fireplace scene in Cinnamon's apartment. This paper prop is the smallest artifact of the thousands of items preserved in the Spy-Fi Archives.

Burnt Offering. The IMF planted this little "clue"—a stock-exchange telephone number—among the ashes of Cinnamon's fireplace, hoping that master spy Miklos would discover it.

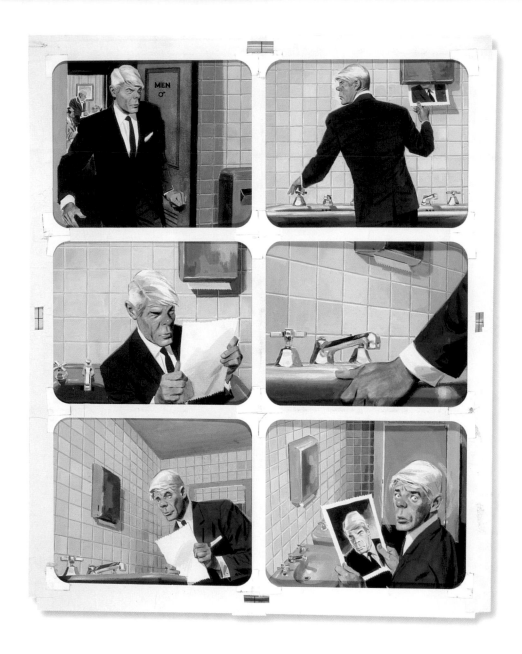

ABOVE:

Mad Mission. This is the original artwork for *MAD* magazine's comic send-up of *Mission: Impossible.* The cartoon was written by Chevy Chase.

[*MAD* #134 copyright 1970 E.C. Publications, Inc. All rights reserved. Used with permission.]

PRODUCTION GIFTS TO THE *MISSION* TEAM

RIGHT:

Thanks to the IMF. This serving tray and drinking glass—embossed with the series' logo and autographs of the stars—were given as gifts to the crew of *Mission: Impossible.*

SPY SPOOFS

CHAPTER 00:05

5

Comedic Spies. Rowan Atkinson as Johnny English and Don Adams as Maxwell Smart satirize the espionage genre.

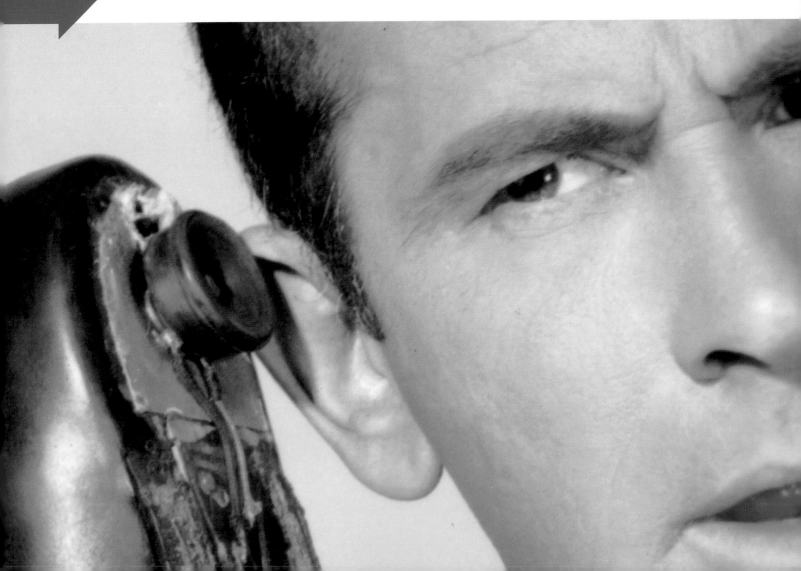

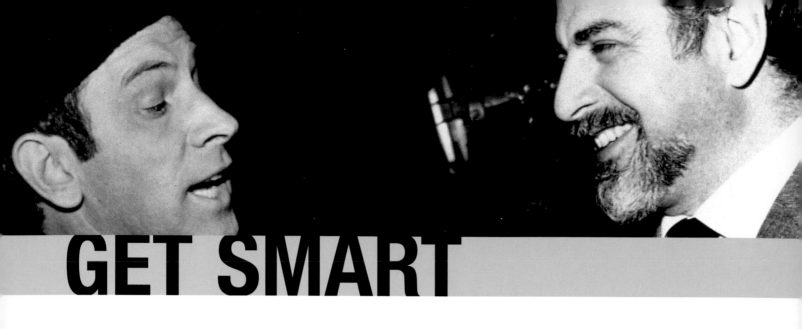

GET SMART

"The '60s was a decade when everything was happening—the sexual revolution, Vietnam, drugs, the Kennedy assassinations, the love child. A whole different world was coming in, and *Get Smart* was a part of it."

—Don Adams

James Bond *had* to be spoofed. The dashing spy with the cool car, the clever gadgets, and the devastatingly beautiful women could not carry on for long without someone in Hollywood scratching his head and thinking, **"Wait a minute! This could be *really funny!*"**

Two of the first heads to be scratched were those connected to the torsos of comedy writers Mel Brooks and Buck Henry. With executive producer Leonard Stern's Talent Associates and NBC, the comedic duo created the pilot for a half-hour spy parody, *Get Smart*.

Buck Henry said the whole idea originated with producer Dan Melnick. "Dan called Mel and me in one day and said, 'Look, there are two big hits out there. One is Bond, and the other is [Inspector Jacques] Clouseau.' That was the way it started."

The pilot script, "Mr. Big," was originally developed for ABC with Tom Poston in mind to play the starring role of an incompetent spy, Maxwell Smart. When ABC passed on the project, NBC stepped in, offering the role to a comedian it had under contract, Don Adams, who'd played house detective Byron Glick on *The Bill Dana Show*.

Adams took on the role of Agent 86, dedicated operative of Control, a top-secret counterspy agency located in Washington, D.C. "Maxwell Smart is every man," said Adams. "Max is your taxi driver, your garbage man, your accountant who is put in a position of James

Bond. He wouldn't be tall and handsome and have women falling down at his feet and saving the world, but he'd get the same result as Bond by bumbling his way through it."

Barbara Feldon, a former model who had played a "sensuous industrial agent" on TV's *Mr. Broadway,* won the role of Max's statuesque sidekick, Agent 99. "They had it in their minds that 99 had to be me, and I'm grateful," said Barbara Feldon. "Agent 99 was a certain percentage of who I am, so I dipped into that percentage of myself to create 99. She was a feminist without knowing it, and predicted where women were going at the time."

Max and 99 both worked for Control, reporting to the Chief, played by Ed Platt. "Ed was so right for the show because he grounded the Chief in his own reality," said Feldon. "He played it so straight, and his character was so beleaguered. Ed Platt was the kindest, dearest, loveliest man."

Get Smart was a brilliantly written and performed comedy that parodied spy thrillers to the hilt. Secret conversations took place in a "cone of silence" in which no one could

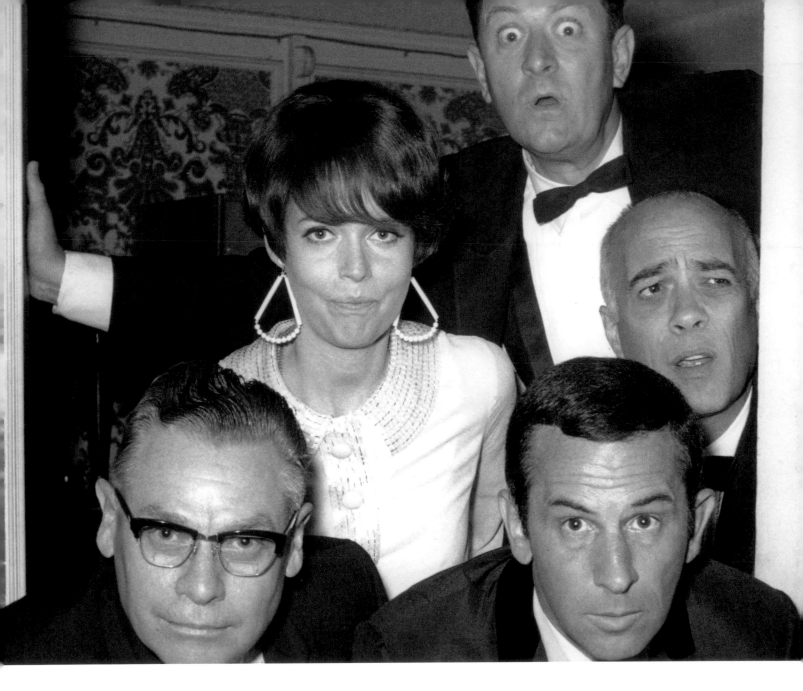

hear the other speak. Max's secret contact, Agent 13, was always hiding inside a fireplace, mailbox, or washer/dryer. His spy dog, Fang, was, as Adams described him, "the dumbest dog that ever lived on the face of the earth." Max drove a red Sunbeam Tiger convertible and, as far as the rest of the world knew, worked as a greeting-card salesman. In spite of all the threats from Kaos, the international organization of evil, Max fearlessly fought "the forces of rottenness" in order to make the world "safe for the forces of niceness."

The series became famous for its many catchphrases, which caught on like wildfire with the American public. Among them were "Sorry about that, Chief," "And loving it!," "Would you believe . . . ," and "Missed it by that much!"

Get Smart was an instant hit when it debuted in the fall of 1965 and won numerous Emmy Awards during its four years on NBC. When the show left the network in 1969, CBS picked it up for an additional season. The series continues to build new generations of fans through successful syndication and a cable afterlife.

OPPOSITE:

Star and Producer. Don Adams won the role of bumbling secret agent Maxwell Smart, while writer and executive producer Leonard Stern carried the classic comedy series through five hilarious seasons on network television.

ABOVE:

And Loving It! The stars (and unidentified friend) of *Get Smart* cram together for a fun-loving photo op: Barbara Feldon, Dave Ketchum, Ed Platt, and Don Adams.

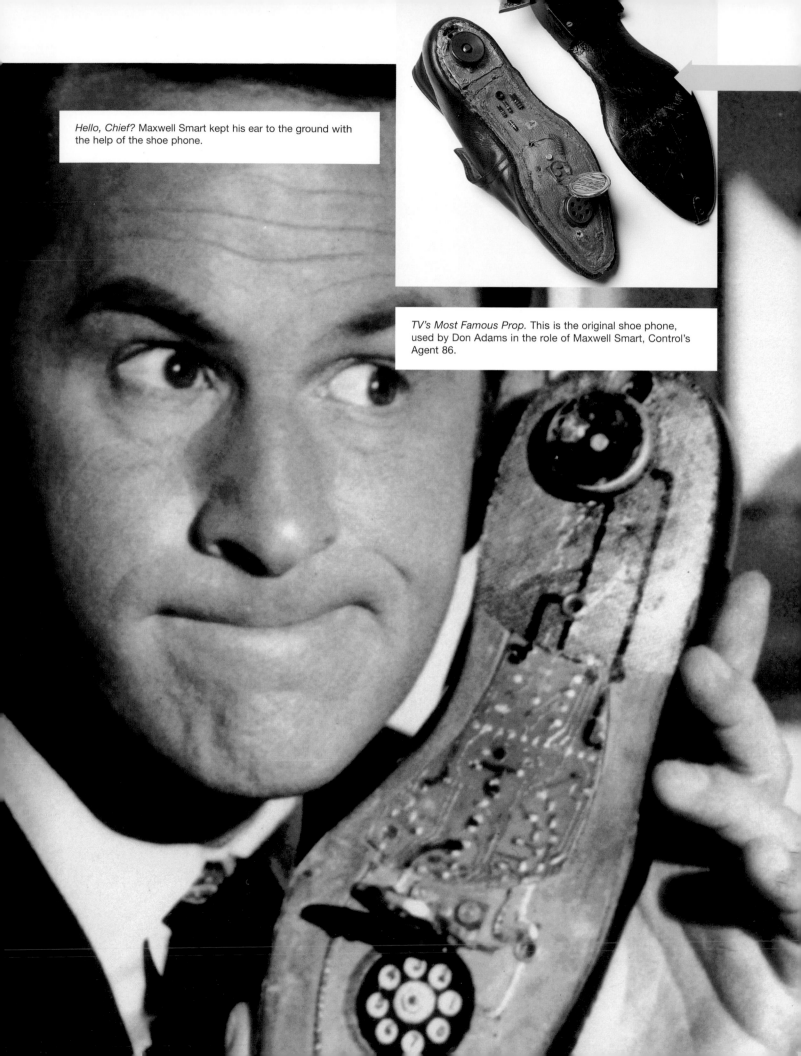

Hello, Chief? Maxwell Smart kept his ear to the ground with the help of the shoe phone.

TV's Most Famous Prop. This is the original shoe phone, used by Don Adams in the role of Maxwell Smart, Control's Agent 86.

THE SHOE PHONE

There may be no other prop in the history of television as famous as Maxwell Smart's shoe phone. A send-up of all those secret spy radios hidden in cigarette packs and watches, the shoe phone immediately became a permanent fixture on the show, with Max using it to contact the Chief in nearly every episode.

"I had the first cell phone," said Don Adams, "that was in a shoe. It was Mel Brooks's idea. He was in his office one day and all the phones were ringing and he didn't know which one to answer, so he finally picked up his shoe and started talking into it."

Leonard Stern said, "Neither Buck nor Mel ever claimed proprietary interest in the shoe phone. They did in some sandwiches and food, but that's a separate issue."

When the Chief called Max on his shoe, it would ring like a normal telephone. Max would then take off his shoe and turn the heel. This allowed him to unlock and remove the sole, beneath which was a built-in telephone, consisting of an earpiece, dial, flip-up mouthpiece, and an assortment of wires and cathodes.

A common question is, Did Adams actually wear the prop? "He didn't walk around in his shoe phone," confirmed Barbara Feldon. "They would stop shooting, bring it out, and Don would put it on his foot. They'd do a close-up of his taking the shoe phone off, opening it, and dialing."

Stern acknowledged that "the shoe phone was a hot item [that] piqued the imagination of the public." It still does, confirmed Don Adams: "To this day, as I'm driving along the freeway, people will drive up next to me, pick up their shoe, and hold it out and say, 'Here, it's for you!'"

99'S SECRET MISSION

Agent 99, top operative of the secret U.S. intelligence agency, Control, made an undercover visit to its sister agency, the CIA, in December 2000. Her mission: to check out the validity of reports that classified spy gear from Control had somehow made its way into the CIA. Using the alias of actress-author Barbara Feldon, 99 rendezvoused with me and a team of agency personnel inside the CIA. We escorted 99 to a special area of the building, where the truth was revealed to her: The CIA had indeed amassed an assortment of spy equipment used by both Kaos and Control, and it was now on display for members of the agency to study.

I gave Barbara a tour of my exhibit, which brought her face-to-face with the props from her *Get Smart* TV show. The shoe phone, which had become the star of the exhibit, was displayed in an exquisite case, perched atop crushed velvet. It was carefully removed and handed to Barbara for an impromptu photo session. Holding the famous prop in her hands, the actress confessed, "You know, this is the *first time* I've ever held the shoe phone!"

The normally leak-proof spy agency made an exception with such a delicious revelation. The next day, Barbara Feldon's admission had made it into the morning edition of the *Washington Post.* "I was fascinated by [Don's] shoe phone," Feldon later confessed, "but I never actually got an opportunity to use it or dial it. Maybe, subconsciously, I wished I had my own shoe phone. There was sort of 'shoe phone envy,' I think, coming out of there."

Intelligence . . . and Beauty. Barbara Feldon portrayed Control's intelligence agent 99.

THE OLD SHOE-PHONE-
IN-THE-BROKEN-DOWN-CAR TRICK

Maxwell Smart may have had more trouble fighting the phone company than he did battling the evil spies of Kaos. On numerous occasions, while trying to reach the Chief on his shoe phone as the fate of the Free World hung in the balance, Max found himself arguing with a belligerent telephone operator who wouldn't connect him to his party.

I understand Max's frustration. Following *Get Smart*'s cancellation in 1970, I set out on a quest to locate the world's most famous telephone—the original prop shoe phone used by Maxwell Smart. After several false leads—including a local garage sale and an out-of-state shoe store—I learned that the world's most famous loafer was locked in a vault somewhere in the middle of Hollywood. It was, I imagined, the perfect plot for a *Mission: Impossible* episode ("Your mission, Mr. Phelps, is to break into that vault and retrieve the shoe!").

After several years, I managed to acquire it. I was driving an old car that was on the verge of collapse and I gambled that it would get me to Hollywood and back home.

I made it to the vault site and, at long last, picked up the shoe phone. Like most film props, this cultural icon was completely nonfunctional; yet it sported all the gizmos—glued-on circuits, hinged microphone, spring lock—that, with the added sound effects on TV, had made it appear so real. Overjoyed, I got into my car and drove back onto the Hollywood Freeway, headed for home.

Suddenly, in the middle of Hollywood's summer heat and heavy traffic, my car died and would not start. I needed to phone the Auto Club or a friend for help, but this was before cell phones; I had perhaps ten cents in my pocket and there was no pay phone in sight.

I looked over at the shoe phone on the seat next to me. It had fielded calls across the country and around the world on *Get Smart*. But now, in the real world, it was totally useless. Somewhere off in the distance, echoing across the back lots of Hollywood where *Get Smart* had been filmed, I could almost hear Maxwell Smart's voice calling out, "Sorry about that. . . . "

TV GUIDE PHOTO COVER

Max and 99. This original dye-transfer print of the photo, featuring Don Adams and Barbara Feldon, was used for the cover of *TV Guide.*

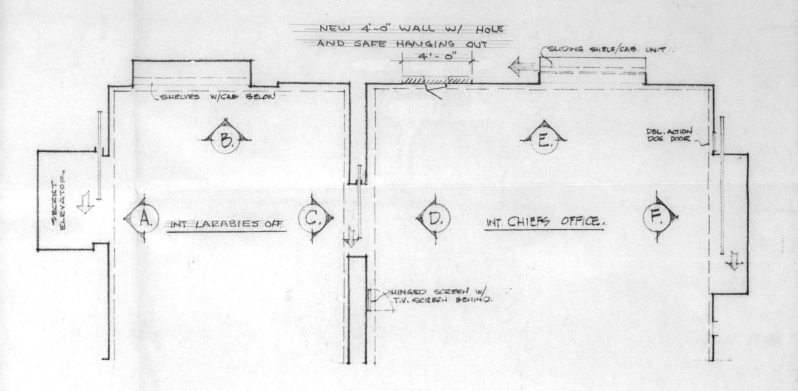

The blueprint shows labeled areas including: SECRET ELEVATOR, SHELVES W/CAB BELOW, NEW 4'-0" WALL W/ HOLE AND SAFE HANGING OUT, 4'-0", SLIDING SHELF/CAB. UNIT, DBL. ACTION DOG DOOR, B., E., A., INT. LARABEE'S OFF., C., D., INT. CHIEF'S OFFICE., F., HINGED SCREEN W/ T.V. SCREEN BEHIND.

CONTROL HEADQUARTERS BLUEPRINT

Control's secret headquarters is a subterranean complex located in Washington, D.C. The entrance is through an ordinary office building, where a descending flight of stairs leads to an elevator door, which opens to a long corridor secured by a series of steel doors. These doors automatically open for authorized personnel, who walk to the end of the corridor, where they find a solitary telephone booth. The person enters the booth, puts a coin in the slot, and dials a number. The floor of the booth opens, dropping the person to Control headquarters at the bottom. A door would then open, leading the person to the office of Larabee, assistant to the Chief.

"When we filmed the phone-booth bit, we were seriously considering digging down underneath it so that Don could drop effectively to the bottom," explained Leonard Stern. "Then Don said, 'Why don't I just fall down?' And it worked! It was so simple. We were just about to chop into the soundstage."

Directed by Stern, the opening title sequence of *Get Smart* follows Max through this labyrinth of hallways and sliding doors. It's a direct takeoff on the opening scenes in *The Man from U.N.C.L.E.,* in which we follow Solo and Illya into the tailor shop and through a maze of corridors and metallic sliding doors to get to Mr. Waverly's office.

"I figured out how many different ways doors can open, so that's how many doors we had," said Stern. "It was like growing up in a converted apartment in New York—doors leading into doors. I felt the credits would be perfect over this. I didn't think it would endure [through the life of the series], but no one ever suggested changing it."

The *U.N.C.L.E.* show appears to have had at least as much influence on *Get Smart* as did the Bond films. An eyewitness to this is none other than the man from *U.N.C.L.E.* himself, Robert Vaughn. "Buck Henry and Mel Brooks visited the *U.N.C.L.E.* set a number of times to watch what we were doing," revealed Vaughn. "It wasn't until I saw Don Adams on TV opening up his shoe that I understood what they were doing on our set. They were obviously creating *Get Smart*." Buck Henry didn't deny it: "There's no question—we had an eye on *Man from U.N.C.L.E.* We were also playing their game a little bit."

From Control's Secret Files. Yes, it's the blueprint of Control's secret headquarters! Would you believe a Kaos spy smuggled it out? How about it got stuck to the gum on the bottom of Max's shoe? Larabee borrowed it to show his wife where he worked?

HYMIE THE ROBOT'S GEAR BOX

"Nobody cares about a robot. Just wind him up, turn him loose, and grease him every thousand miles."

—Hymie the Robot

Seeing value in having an indestructable agent, Kaos purchased a robot named Hymie for $1 million from scientific genius Dr. Ratton. But once Control got hold of Hymie, Max reprogrammed him for niceness. Hymie joined Control and became Max's best friend.

Hymie's control center is this gear box, located in his chest. The front of Hymie's dress shirt would zip open to reveal the box. Opening its lid exposed the various gears and wiring that made Hymie work. "Dick Gautier was so convincing as Hymie," said Barbara Feldon. "He always showed up on the set with his gear-box mechanism. It was like acting with a robot."

Hymie was impervious to bullets, though being electrocuted could make him believe he'd just fallen in love. Another of Hymie's little quirks, which everyone at Control had to keep in mind when speaking to him, was that he took everything literally.

Once, Max discovered that a Kaos spy had tampered with the gear box in an effort to sabotage Hymie. "Aha!" said Max, peering inside the gear box. "There *is* a spy!" "Really?" said Hymie. "He must be very small."

The Chief's niece, Phoebe, arrived in town and was told that Hymie was Max's cousin, an electronics genius. "Oh, are you in electronics?" she asked him. "No," replied Hymie matter of factly, "electronics are in me."

TOP:
Robot Spy. Dick Gautier, as Control's Cybernaut Agent Hymie, prepares to have his gear box examined in a scene from *Get Smart*.

ABOVE:
His Father's Name Was Hymie. This prop gear box was worn by Dick Gautier as Hymie the Robot, the cybernaut who became Max's best friend.

Max: "Hymie is a robot. He's nothing but a machine, a bunch of bolts and wires strung together in a metal body."

Hymie: "Nobody's perfect."

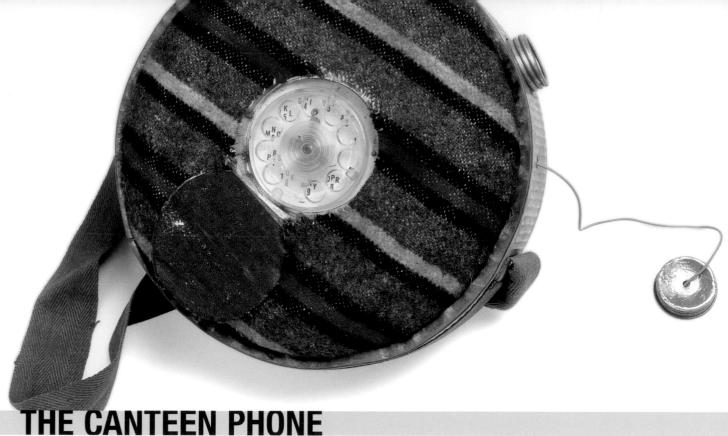

THE CANTEEN PHONE

"There wasn't a show we had where there wasn't something else used as a phone. Everything was a phone but a phone."

—*Leonard Stern*

When the Chief sends Agent 86 on a mission to the desert town of Mira Lodo, Mexico, Max disguises himself as a prospector, complete with mule and canteen. Of course, the canteen is actually a telephone. When Max needs to call the Chief, he opens a camouflaged flap on the side, revealing a phone dial. Unscrewing the canteen top exposes a retractable phone cord, providing both earphone and mouthpiece.

ABOVE:
Just Don't Get Thirsty. Since all that desert dust can damage his shoe phone, Max used this canteen phone during a rugged outdoor assignment in Mexico.

PRODUCTION SKETCH OF MAX'S APARTMENT

No Place Like Home. This is the original pencil rendering of Maxwell Smart's apartment. Although it looks quite ordinary, the phone receiver fires a bullet, the fireplace functions as a supervacuum, an invisible wall lowers from the ceiling, and a handheld remote can, with the push of a button, destroy every furnishing in the room. Max has a hard time maintaining housekeepers.

KAOS INSIGNIA ART

"We don't *shush* here!"

—Kaos leader Siegfried, explaining a Kaos rule to Max

Founded in 1957, Kaos's goal is "to foment unrest and revolution throughout the world." Its top agent is Siegfried, who, with second-in-command Shtarker, is the sharpest thorn in Max's side. Agent 86 describes Siegfried as "rotten, vicious, cruel, cunning, [and] maniacal." Although Siegfried pursues his evil aims with incredible verve and enthusiasm, he has been known to reflect on, and even to question, his own motives. "Twenty years I have been with [Kaos]," he once acknowledged. "Stealing, robbing, lying, killing, murdering. . . . And what did I get out of it? Nothing. Just a lot of fun."

When Siegfried holds a meeting with his associates, the Kaos insignia is always on the wall behind him. It is an image of a vulture, with its claws grasping an egg-shaped drawing of Earth, and is used in *Get Smart* on all Kaos props and wardrobe.

RIGHT::

Bad-Guy Logo. This is the original artwork for the official insignia of Kaos, the organization that sends shivers down Max's spine. Would you believe *up* his spine? How about across his shoulder blades, making a U-turn at his collar bone?

KAOS BOARD GAME

Out of the Kaos Toy Closet. What do Kaos agents do when they are taking a break from their nine-to-five job of taking over the world? They break out their very own Kaos board game and *play* at taking over the world. This prop game was created and used in such a scene at Kaos headquarters, probably during a Kaos lunch break.

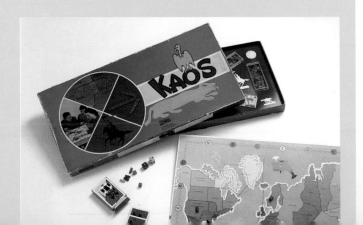

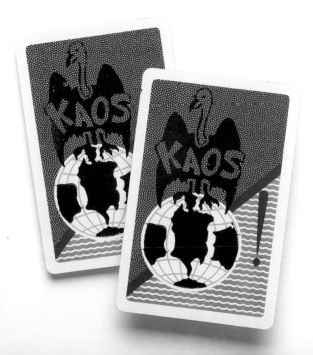

THE STEREOPHONIC GUN

One of the world's great mysteries was the sudden increase in the sale of electric toasters in early 1969. Identified in retail outlets as "item #949," these boxed toasters just flew out the door. For instance, at Knight's Redemption Center in Washington, D.C., dozens of people at a time lined up at the counter, requesting item 949.

Why the sudden demand for toasters? It turns out that Kaos came up with a way to distribute an insidious new weapon to its network of agents across the land. Hidden inside each "949" toaster box was the deadly new Stereophonic Gun, a double-barreled revolver operated

by a single trigger. Unfortunately for Kaos, the invention backfired. When they put through their order for a "stereophonic gun," the manufacturer interpreted that as meaning it should *play* stereo. Needless to say, that was music to the ears of everyone at Control!

The Old Kaos-Gun-in-the-Toaster-Box Trick. The Stereophonic Gun was designed to get Smart and a lot of other Control agents with a single shot. As it turned out, Kaos should have stuck with the toaster.

KAOS DISINFORMATION MACHINE

While trying to prevent New York City from being destroyed by the Kaos Sonic Boom Machine, Max and 99 are taken prisoner by Kaos. Held in its secret headquarters underneath a car wash, the agents are blindfolded and told they are being transported to Argentina.

Kaos used this tape recorder to play a variety of sound effects designed to create an illusion of ground and air travel, thereby throwing Max, 99, and Control off the trail. Yup, it was the old Kaos-Tape-Recorder-Used-to-Confuse-Control-Agents trick. That was the second time Max had fallen for it that month!

How to Confuse Max Without Really Trying. Picked up at a recent Kaos garage sale, this insidious disinformation machine was used by Kaos to make Max and 99 believe they had been taken to Argentina.

"What makes *Get Smart* endure is that it was an excellent synthesis of so many elements that could only take place then. It says something about our culture, our sensibility, and what was going on in the world at that time."

—*Barbara Feldon*

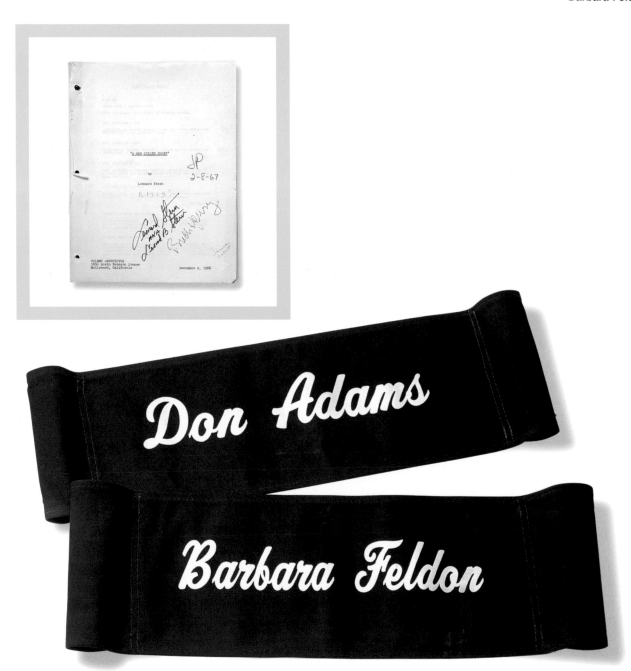

TOP:

SCRIPT FOR THE *GET SMART* MOVIE THAT NEVER MADE IT INTO THEATERS

A Man Called Smart. Leonard Stern's feature-length screenplay for a *Get Smart* motion picture was filmed but ultimately not released into theaters as planned. Instead, it was broadcast on the TV series in 1967 as a three-part episode.

ABOVE:

DON'S AND BARBARA'S DIRECTOR CHAIR BACKS

86 and 99 Take Five. These directors' chair backs were used by the two *Get Smart* stars during breaks on the set.

RIGHT:

Mad About 99. This prop book was "written by" Barbara Feldon's *Spy Girl* character on the NBC sitcom, *Mad About You.*

BOTTOM:

GET SMARTY SHOE PHONE AND SALT SHAKER

More Mad. Mad TV aired a 1996 comedy sketch, *Get Smarty,* that parodied both *Get Smart* and the movie *Get Shorty.* These props—a shoe phone and a spy gadget disguised as a salt shaker—were used in the spoof.

PROP *SPY GIRL* BOOK
SIGNED BY 99'S ALTER EGO

A tall, attractive actress writes a book about her life as the star of a popular 1960s TV spy series. It must be Barbara Feldon, right? Well, not exactly. The actress is Diane Caldwell, and the name of her '60s TV show is *Spy Girl.* If you don't recognize her name, or the title of the show, that's because they never existed. The fictitious actress and made-up TV series appeared in a 1993 episode of NBC's *Mad About You.* Caldwell—who autographed copies of her memoir, *Spy Girl Uncovered,* in a book-signing scene on the show—was played by . . . Barbara Feldon.

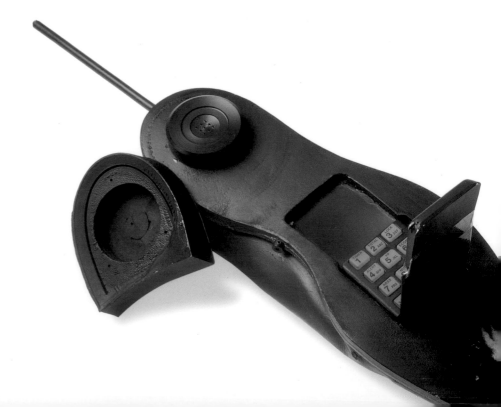

OUR MAN FLINT

"Our man must be ingenious . . . fearless . . . an opportunist . . . coldly calculating . . . master of himself . . . inventive . . . highly intelligent . . . Derek Flint."

—Our Man Flint *by Hal Fimberg and Ben Starr*

One of the first—and arguably *the best*—of the big-screen James Bond spoofs was *Our Man Flint.* Released in 1966 by 20th Century Fox, *Flint* starred James Coburn as a former U.S. operative and jack-of-all-trades who is recruited by intelligence chief Lloyd Cramden (Lee J. Cobb) to stop the Galaxy organization from taking over the world with a weather-control machine. *Flint* was a witty, sophisticated, and sexy send-up that mixed real spy thrills with its clever humor.

"It was great fun writing *Flint,***"** said Ben Starr, who coscripted it with Hal Fimberg. "It was an attempt to do an American 007 and it worked." The Saul David production was directed by Daniel Mann and featured a terrific score by Jerry Goldsmith.

Flint is a very independent bachelor who keeps an expensive high-rise apartment and a bevy of four luscious ladies who meet his every need, from giving a shave to taking a letter, from keeping his calendar to going out dancing. Scientist, author, skydiver, and judo expert, Flint seems to have an encyclopedic knowledge yet is the first to confess that there are "a great many things" he doesn't know.

Offered a case full of high-tech spy gear by Cramden, Flint rejects it all as "crude," preferring instead to use his pocket lighter, which sports "eighty-two different functions . . . eighty-three if you light a cigar." Flint relaxes before every mission by stopping his heart for hours on end; the beat resumes when his preprogrammed watch sends out a tiny metal arm to tap his pulse back to life.

"I came up with the wristwatch that did everything," recalled Starr, "because my plan was to get Flint into as much trouble as I could, and then get him out of it temporarily. The watch let me do whatever I needed at the particular moment. I had a blast making up stuff like that."

The box-office success of *Our Man Flint* resulted in a worthy 1967 sequel, *In Like Flint.* Plans for a third movie—*F Is*

for *Flint*—unfortunately never materialized. Considering the high quality of the productions, this spy spoof character had a remarkably short life. Although the style of its humor was markedly different from *Get Smart*, it ranks with it as one of the best spy parodies ever created.

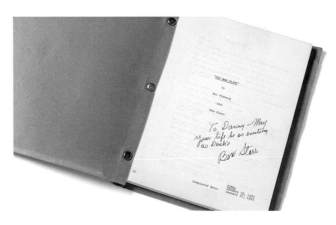

BEN STARR'S ORIGINAL SCRIPT

How It All Began. This is screenwriter Ben Starr's personal copy of the script for *Our Man Flint*, which he coauthored with Hal Fimberg. "My biggest kick in writing *Flint,*" said Starr, "was the scene where he revives the dead soldier by sticking Cramden's finger in the electric socket. I'd always wanted to write, 'I've got a beat!' like they say in hospital movies."

OPPOSITE:
BELGIAN MOVIE POSTER

Flint Travels the Globe. This is a Belgian movie poster for *Our Man Flint.*

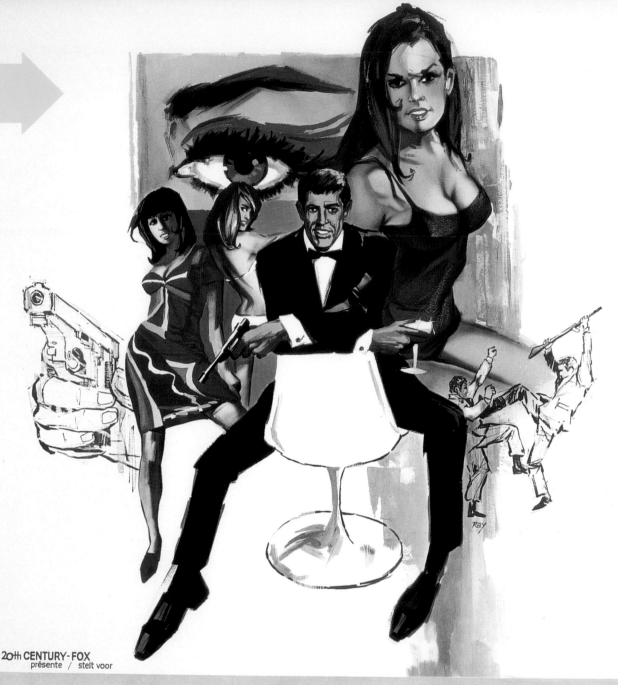

20th CENTURY-FOX
présente / stelt voor

DEREK FLINT CONTRE GALAXY
CONTRE TEGEN
(OUR MAN FLINT)

JAMES COBURN / **LEE J. COBB** / **GILA GOLAN** / **EDWARD MULHARE**

PROD. **SAUL DAVID** / REGIE **DANIEL MANN** / SCENARIO **HAL FIMBERG & BEN STARR** / **CINEMASCOPE** / COULEURS KLEUREN **DE LUXE**

IMPR. J. LICHTERT & FILS - BRUXELLES

Z.O.W.I.E. UNIFORM PATCH

Z.O.W.I.E. (Zonal Organization World Intelligence Espionage) is the U.S. intelligence agency that recruited Derek Flint from outside its ranks to investigate the mysterious assassinations of its field agents. It is run by Lloyd Cramden but is ultimately under the jurisdiction of the president of the United States. The official insignia of Z.O.W.I.E. is emblazoned on this patch, which is worn on all Z.O.W.I.E. personnel uniforms.

A small footnote: Z.O.W.I.E. is one of the only counter-spy outfits in history that has had the honor of having its name used in the title of a song. "Your Zowie Face" can be heard during the end credits of the 1967 movie, *In Like Flint*.

Z Is for Z.O.W.I.E. This wardrobe patch bears the insignia of the secret organization that asked Flint to help save the world.

DEREK FLINT'S GALAXY JACKET

"How very smart you look in your Galaxy uniform, Mr. Flint."

—*Galaxy agent Malcolm Rodney*

A trace of bouillabaisse found on a poison dart fired at Cramden sends Derek Flint from Washington, D.C., to Marseilles and then, by submarine, to the Mountain Island—headquarters of Galaxy. Galaxy is run by three scientists who create the means to control the weather. Threatening to trigger volcanic eruptions and other natural disasters, they demand the capitulation of the world's leaders so that they can take over, promising to make "a perfect world."

Flint infiltrates the island, first disguising himself in a technician's jumpsuit and then donning this Galaxy jacket, which allows him to blend in with the similarly garbed Galaxy security forces. Eventually Flint destroys the complex and blows up the island, which, as Flint put it, sends "Galaxy into orbit."

OPPOSITE, TOP LEFT:
Dressed to Spy. This Galaxy jacket was worn by James Coburn as Derek Flint, so that he could move about unnoticed on Galaxy Island. It was a temporary solution, as Flint, an American in the midst of foreigners, was spotted and attacked by an "anti-American eagle." Flint called the concept "diabolical."

OPPOSITE, TOP RIGHT:
Guest of Galaxy. Derek Flint is allowed a coffee break before his scheduled liquidation at Galaxy headquarters.

OPPOSITE, BOTTOM:
I Am Not a Pleasure Unit. Former enemy agent Gila (Gila Golan) asks Flint to brand her as a Galaxy "pleasure unit" as part of their plan to defeat Galaxy.

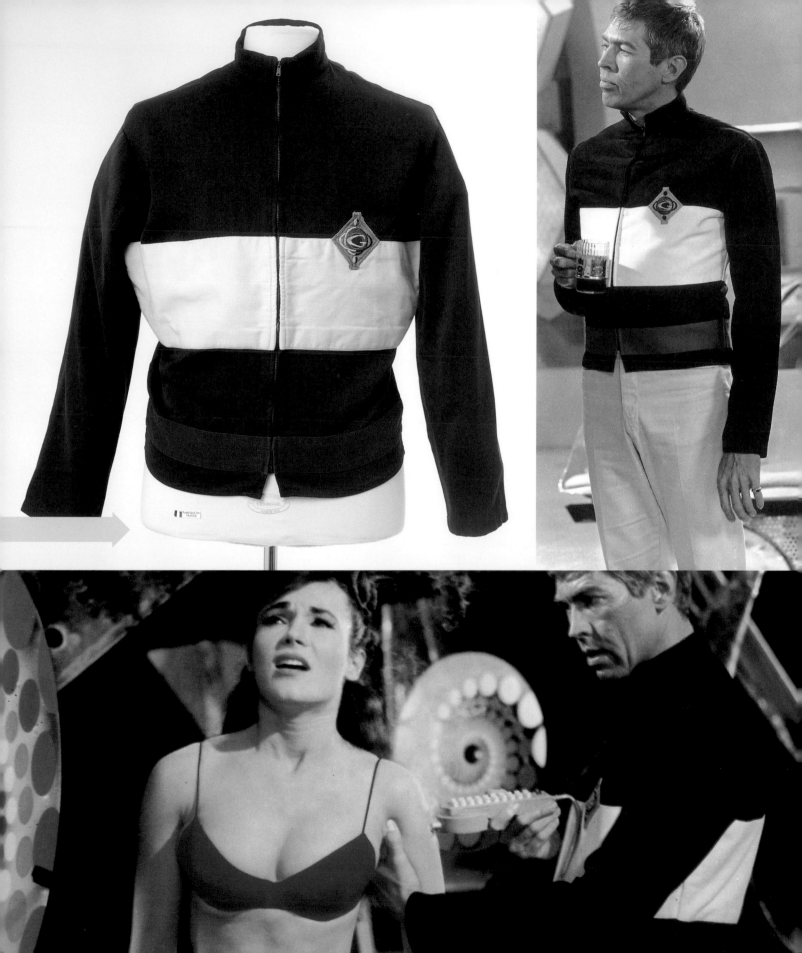

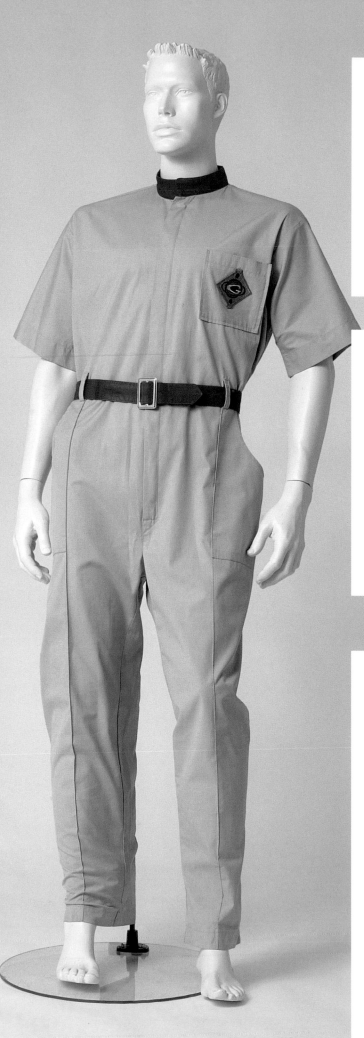

ABOVE:

ELECTRONICS PANEL FROM DEREK FLINT'S STUDY

Mysterious Machine. As Flint sits at his desk in his study, surrounded by his lovely ladies and chatting with Lloyd Cramden, this electronics panel can be seen on the wall behind him—an interesting piece of set dressing whose function was never revealed.

LEFT:

GALAXY TECHNICIAN'S UNIFORM

Momentary Disguise. Flint wore this Galaxy technician's jumpsuit when he first infiltrated the Galaxy complex.

BELOW:

Bound for the Galaxies. James Coburn wore this prop oxygen tank as part of a space suit when he launched into the stratosphere to prevent the arming of a space station by a renegade general.

FABULOUS FACE PURSE

"Brain- and hair-washing at the same time!"

—Derek Flint, commenting on an insidious Fabulous Face beauty treatment, in In Like Flint

"To really know a woman, first get to know the contents of her purse."

Shakespeare? Socrates? Tony Blair? No matter. The mystery of a lady's purse has plagued the male mind for an eternity. However, various documented sightings into the inner sanctum of every female's most valued accessory have provided us with a few clues. . . . Hairbrush. Car keys. Makeup. Driver's license. Credit cards. Breath mints. These are just *some* of the contents of an ordinary lady's handbag.

The purse pictured here, however, is by no means ordinary. The double *F* logo on the front of the purse is the official insignia of Fabulous Face, a Virgin Islands–based health-and-beauty resort for women only. This purse belonged to one of the founding members of Fabulous Face. It is placed on a large table directly in front of its owner as she participates in an important board meeting of Fabulous Face executives. To the ladies' surprise, Derek Flint is brought into the room, having just been caught spying on the grounds. Observing this "summit conference of brains and beauty," Flint learns that Fabulous Face is in fact a front for a master plan, launched by these international female CEOs, for women to take over the world.

As for the Fabulous Face purse, one can only guess at its secrets. What type of items would be carried around by a woman who plans to rule the world? Some sort of a doomsday device? In all likelihood, one would probably find a hairbrush, car keys, makeup, driver's license. . . .

Her World in a Handbag. The purse with the telltale insignia belonged to a Fabulous Face executive whose plans for world domination Flint viewed with amusement.

FLINT'S OXYGEN PACK

The president of the United States has been replaced by an exact double! Flint, Cramden, and the real commander-in-chief look on as a bevy of gorgeous, bikini-clad women unleash Operation Smooch, an aggressive kissing campaign that distracts and literally disarms the troops protecting the phony U.S. president. In an effort to stop the conspiracy from placing a nuclear weapon in outer space, Flint dons this oxygen pack and enters the villain's rocket just as it lifts off with the deadly cargo.

Worn by James Coburn, this prop never really held any oxygen. But sporting a few dials and gauges, and spray-painted silver, it gave the climactic scene of *In Like Flint* an added aura of authenticity.

Saving the world once again, Flint hitches a ride with a couple of pretty lady cosmonauts in their Russian space station and disappears into space . . . a fitting exit for James Coburn's final appearance as our man, Flint.

THE SILENCERS

Espionage satires aren't always sophisticated, witty, and clever. Sometimes they are just silly. The Matt Helm films, loosely adapted from the Donald Hamilton novels, were an attempt by Columbia Pictures to cash in on the spy craze. In 1966, producer Irving Allen produced *The Silencers*, starring movie star–crooner Dean Martin as Matt Helm, secret agent for ICE (Intelligence Counter Espionage). He worked for a man named MacDonald and had a private secretary named Lovey Kravezit, who would bathe with him while taking dictation and business calls. The film featured the usual spy elements—karate, guns, gadgets, bizarre villains, and lots of scantily clad women—but with the addition of Dean daydreaming his way through the story, to the accompaniment of his own repertoire of songs. While it signaled the onslaught of a wave of mediocre spy send-ups, the presence of Dean Martin, Victor Buono, Stella Stevens, and Dahlia Lavi made this film a harmless bit of fun and certainly a must-see for those of us hooked on spy spoofs, witty *or* inane.

The Helm series churned out three more Dean Martin spy spoofs—*Murderers' Row, The Ambushers,* and *The Wrecking Crew.* If nothing else, they proved to be guilty pleasures, offering bouncy title songs and even bouncier female starlets, including Elke Sommer, Beverly Adams, Ann-Margret, Senta Berger, Camilla Sparv, Sharon Tate, Cyd Charisse, and Tina Louise.

MATT HELM'S DAGGER-FIRING CAMERA

ICE agent Matt Helm's cover is that of a fashion photographer, specializing in magazine portraits of beautiful models in all manner of dress . . . and undress. Given these two careers—spy and photographer—it's only natural that the tools of his trades serve a dual purpose.

Helm's camera shoots not only photos, but also deadly daggers. Dean Martin used this special-effects prop camera to perform such double duty in his first Matt Helm adventure, *The Silencers*.

BIG O UNIFORM PATCH

Big O is the villain of the Matt Helm film series. In *The Silencers*, Victor Buono plays the leader of Big O, whose evil scheme—"Operation Fallout"—will result in the explosion of an atomic bomb over New Mexico, triggering World War III. Sexual innuendos abound in the Helm films, with the name Big O (the sexual/polar opposite of ICE) being one of the movies' larger "inside" jokes.

OPPOSITE, TOP LEFT:
He Got the Picture. Matt Helm takes aim with his dagger-firing camera and shoots.

OPPOSITE, TOP RIGHT:
Photo Shoot. This prop camera was rigged to fire daggers in *The Silencers*.

OPPOSITE, BOTTOM LEFT:
Look Out, Here Comes Big O! This is a uniform patch featuring the insignia of Big O, the evil conspiracy that Matt Helm finds himself up against.

OPPOSITE, BOTTOM RIGHT:
DEAN MARTIN'S MATT HELM CAP

Hats Off! As production commenced on the first Matt Helm movie, *The Silencers*, Dean Martin was presented with a congratulatory gift from the film's producer, Irving Allen. It was this cap, bearing the name of the spy character that Martin was about to bring to life on the screen.

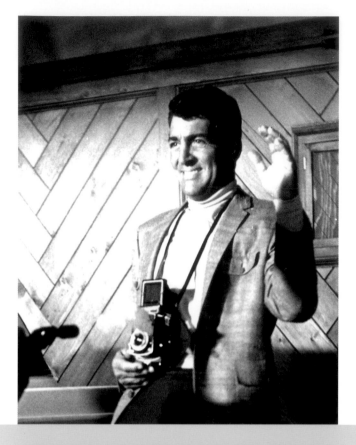

SPY CRAZY!

There may be no other genre that has been spoofed as extensively, both in the United States and around the world, as espionage. There's just something about all those razor-sharp derbies, gold-painted women, missile-firing cars, and hollow-heeled shoes that scream out for parody.

One of the better 007 send-ups was the 1965 British motion picture, *The Second Best Secret Agent in the Whole Wide World* (a.k.a. *Licensed to Kill).* Tom Adams plays Charles Vine, a blatantly deadly and womanizing British agent. As Sammy Davis Jr. sings in the title song, "He's every bit as good as what's-his-name." In fact, a luscious blonde lying in bed with Vine tells him, "It's funny. I met someone like you in Florida. James . . . James something."

The Italian film industry produced a series of Bond spoofs featuring a character named James Tont, secret agent

007½. The best of these was *Operation Goldsinger* (1966), a direct takeoff on *Goldfinger,* which includes a send-up of the famous scene in which Sean Connery is bound to a gold table while a laser beam threatens to dissect him. In the Tont version, the villainous Eric Goldsinger (owner of Goldsinger Record Enterprises) ties Tont to a giant turntable, which spins as a deadly record needle spirals inward toward his body, slicing off the heel of his shoe.

Vincent Price starred in *Dr. Goldfoot and the Bikini Machine,* which led to a sequel, *Dr. Goldfoot and the Girl Bombs.* Even James Bond himself spoofed James Bond: Fleming's first 007 novel, *Casino Royale,* was turned into an overproduced Bond send-up by Columbia Pictures. Starring David Niven, Peter Sellers, Jacqueline Bisset, Ursula Andress, Woody Allen, and Orson Welles, and helmed by multiple directors, the spirited mishmash tried hard to be the ultimate Bond parody. And even the Beatles poked fun at 007 in *Help!*

Comedians Marty Allen and Steve Rossi headlined one of the lesser spy spoofs, *The Last of the Secret Agents?,*

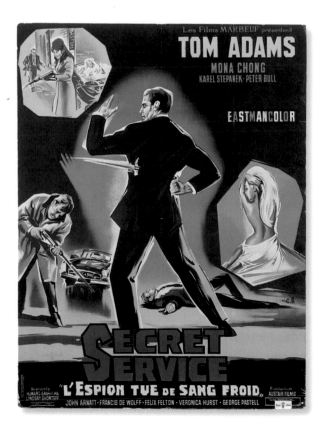

LEFT:

The Spy Who Tried Harder. This is the French poster for *L'Espion Tue de Sang Froid,* released in the United States as *The Second Best Secret Agent in the Whole Wide World.*

OPPOSITE, LEFT:

Dr. Goldfoot. Thirty years before *Austin Powers*'s "fembots" were the "girl bombs," sexy killer robots manufactured by the Bikini Machine. Dr. Goldfoot's diabolical invention pumped out young, bikini-clad models like an oversexed Xerox machine. Vincent Price played the evil genius, while Frankie Avalon was the secret agent out to stop him.

OPPOSITE, RIGHT:

The Spy in the Lace Panties. Wholesome Doris Day in a movie with a title like that? There's the British for you: They slapped their own title onto this family-oriented 1965 American-made spy spoof, *The Glass Bottom Boat.*

with a title song that Nancy Sinatra performed on the heels of singing *You Only Live Twice* for the Bond folks. Following *I Spy,* Bill Cosby starred in a disastrous spy spoof, *Leonard Part 6.* And Doris Day took her turn at a spy comedy in MGM's *The Glass Bottom Boat,* an enjoyable family film notable for Robert Vaughn's cameo as Napoleon Solo. Woody Allen dubbed a foreign spy flick with comic dialogue for *What's Up, Tiger Lily?* And *A Man Called Flintstone* was a spy musical for kids. The French delivered Jean-Paul Belmondo and Jacqueline Bisset in *Le Magnifique,* and the hit spy movie *The Tall Blond Man with One Black Shoe,* a marvelously funny and clever satire of the intelligence game.

Attempting to rectify its mistake of having turned down *Get Smart,* ABC gave the green light to *The Double Life of Henry Phyfe,* a sitcom starring Red Buttons as an accountant who happens to look identical to enemy agent U-31, recently deceased. He is recruited by U.S. agents to impersonate U-31 for secret missions that serve only to complicate his life with his girlfriend, Judy, and her nagging mother.

Spy parodies were written into almost every '60s TV series, including *The Dick Van Dyke Show, F Troop,*

Gilligan's Island, I Dream of Jeannie, The Beverly Hillbillies, The Monkees, My Favorite Martian, Hullabaloo, and *Please Don't Eat the Daisies* (which recruited Robert Vaughn and David McCallum for cameos in a clever *U.N.C.L.E.* tribute). Animated spy spoofs hit the Saturday morning lineup, including *Secret Squirrel, Cool McCool,* and *Tom of T.H.U.M.B.* Then came *James Hound* and *Undercover Elephant. The Roadrunner* and *Laurel & Hardy* cartoons churned out their own spy stories. And *Tom & Jerry* delivered *The Mouse from H.U.N.G.E.R.,* a direct *U.N.C.L.E.* spoof that had been bandied about as a possible MGM pilot. Even talking apes got in the act on the live-action *Lancelot Link, Secret Chimp.*

One amusing TV pilot that didn't sell was a full-fledged spoof of *Mission: Impossible,* called *Inside O.U.T.,* featuring then-unknown Farrah Fawcett. Years later, Leslie Nielsen starred as a secret agent in a disappointing big-screen parody, *Spy Hard,* redeemed only by Weird Al Yankovic's send-up of 007 title sequences. The '90s put youthful spies to work when the *Spy Kids* and *Agent Cody Banks* movies made their splash. And, as we would soon discover, the fun had only just begun. . . .

RIGHT:

Secret Weapon. This is a production model of the "nose cone," a deadly missile used by Andy Griffith's villainous character in the big-screen spoof, *Spy Hard.*

BELOW:

Leonard Part 6. This case of espionage gear, including several aptly named "waffle grenades," is supplied to former secret agent Leonard Parker (Bill Cosby), a restaurateur and loving father who is called back to spy duty.

BOTTOM, LEFT:

Tont, James Tont. This is the lobby card for the screen adventures of Italian superspy James Tont, a name that strikes fear into the hearts of master criminals like Eric Goldsinger.

BOTTOM, RIGHT:

The Double Life of Henry Phyfe. This is an original 1965 teleplay for the ABC-TV spy sitcom starring Red Buttons as Henry Wadsworth Phyfe, a timid accountant blessed with the same face as the late master spy, cigar-smoking U-31. His boss, Mr. Hannahan (Fred Clark), gives Henry his missions: "Remember, Henry—U-31 was a great gourmet. When you get to the restaurant, don't order a hamburger."

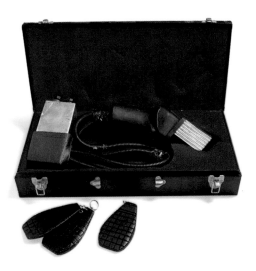

AUSTIN POWERS

"The ultimate gentleman spy. Irresistible to women, deadly to his enemies, legend in his own time."

—*Basil Exposition, Ministry of Defense, describing Austin Powers*

James Bond, Derek Flint, and Matt Helm were honored in a clever 1997 film parody of the entire '60s spy scene, *Austin Powers–International Man of Mystery*. Mike Myers wrote and stars in the tale of a famous British agent who, in 1967, voluntarily freezes himself in a secret government cryogenic chamber in order to awaken in the 1990s so that he can face off with his also-preserved nemesis, Dr. Evil.

The charm of the original movie is in its focus on Austin, who finds that his '60s values—particularly his sexist, womanizing ways—are not accepted in the "enlightened" '90s. As a spy parody thirty years removed from the genre's '60s heyday, it is able to spoof the spoofs, rather than be a straight parody of serious espionage thrillers. Myers, who plays both Austin and Dr. Evil, does this exceedingly well.

Having built a cult following in its video afterlife, the movie spawned several sequels. Although they were box-office hits, *The Spy Who Shagged Me* and *Goldmember* had lost Austin's mojo, allowing '90s-style low-brow "gags" to replace the heart and class that had made *Man of Mystery* shine.

An innocent, egotistical, quirky character, Austin "Danger" Powers is a joy to watch in all of these films. Myers's talent in creating the character produced a cultural icon for the 1990s, a comical spy who is perhaps every bit as recognizable now, if not as endearing, as Maxwell Smart in the 1960s. As Max's "Sorry about that" and "Would you believe . . . " lines caught on in 1965, Austin's own catchphrases became part of the common lingo decades later. Who isn't familiar with "Oh, behave!," "Very shagadelic," and "Yeah, baby, yeah!"

FAB! MAGAZINE

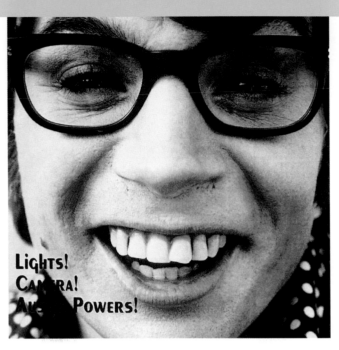

Secret agent Austin Powers wasn't so secret. A fashion photographer to boot, he was clearly a pop idol of the '60s, chased down London streets by mobs of teenage fans and the star of every mod happening. Of course, Austin made the cover—just barely—of *FAB!* magazine. Splashed across the front of its July 1967 issue, Austin was the rave of London that year.

In a parody of the opening titles of the Beatles' first movie, *A Hard Day's Night,* Austin is seated on a street bench hiding his face behind this magazine while screaming girls look for him. It's an important prop that helps set the tone, the setting and the character of Austin Powers and his wacky world.

Cultural Icon. This prop *FAB!* magazine dated 1967 sports the grinning face of London's favorite mod hero, Austin Powers.

AUSTIN POWERS'S GLASSES

"I'm telling you, baby. That's not mine."

—*Austin Powers, speaking about several embarrassing items he owned in the '60s, being returned to him in the '90s*

One of the only items Austin didn't dispute ownership of, as he awakened in the '90s, was his pair of black-rimmed eyeglasses. The only thing that he was wearing during his thirty-year cryogenic sleep, the glasses were frozen in place, crooked, on the bridge of his nose. And of all the physical characteristics that make up Austin Powers—his full head of '60s-styled hair, crooked teeth, velvety suits, male-symbol neck chain—it is his eyeglasses that are most identifiable.

For His Eyes Only. This prop pair of glasses was worn by Mike Myers in the role of Austin Powers in the original 1997 *Man of Mystery* movie. *Very groovy, baby, yeah!*

AUSTIN'S CRYOGENIC CHAMBER

"Powers volunteered to have himself frozen in case Dr. Evil should ever return."

—*Basil Exposition*

Somewhere deep in the secret recesses of London's Ministry of Defense is the Cryogenic Storage Facility. No one in the British government has ever admitted to its existence. However, evidence has surfaced that suggests otherwise. This mammoth facility is filled with ten-foot-tall "cryogenic chambers," each holding a living person in suspended animation. One special area in the facility is the "Celebrity Vault," which contains famous people like rapper Ice T, actor Gary Coleman . . . and top-secret agent Austin Powers.

This is the cryogenic chamber in which Austin Powers was preserved, in a frozen state, since 1967. In 1997 he was thawed out on the orders of the Ministry so that he could continue his fight against Dr. Evil. MOD's Basil

Exposition oversaw the five-stage thawing process, which consisted of cutting open the chamber with laser beams, a "warm liquid goo phase," reanimation, cleansing, and evacuation of bodily fluids.

Following this procedure, Austin began talking loudly and verbalizing his thoughts, which Basil assured officials was perfectly normal. Moments later, the famous spy realized why he had been defrosted. "Dr. Evil," he said knowingly, "where is he . . . ?"

Austin Van Winkle. This is the ten-foot-tall cryogenic chamber that held Austin Powers in deep freeze for thirty years. If you look carefully, you can see Austin inside. *Cool, baby. Very, very cool.*

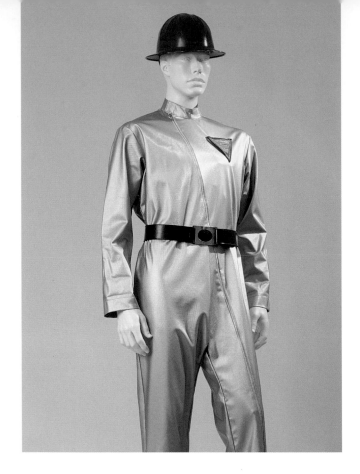

LEFT:

DR. EVIL GUARD UNIFORM

Volcano Chores. This uniform was worn by Dr. Evil's security guards, whose duties included keeping their boss safe from nosey British agents, deep down in Dr. Evil's hollowed-out volcano lair.

BELOW, LEFT:

Pinky of Evil. This is the original prop ring worn by Mike Myers as Dr. Evil, archnemesis of Austin Powers. The metallic silver ring, ever present on Dr. Evil's finger, bears the official logo of his billion-dollar criminal empire.

BELOW, RIGHT:

NUMBER TWO'S ID BRACELET

Power Behind the Throne. While Dr. Evil was in hibernation for three decades, his Evil empire was run by his second-in-command. "Finally, we come to my No. 2 man," said Dr. Evil to his staff. "His name . . . Number Two." This ID bracelet—engraved with the name "Number Two"—was worn by Robert Wagner in the role.

DR EVIL'S RING

"My mother was a fifteen-year-old prostitute named Chloe, with webbed feet. My father . . . would make outrageous claims, like he invented the question mark. Sometimes he would accuse chestnuts of being lazy. . . . "

—*Dr. Evil*

Such was Dr. Evil's background, which may go a long way in explaining why he so embraces being evil. Mike Myers's portrayal of Dr. Evil was, in large part, inspired by Donald Pleasence's portrayal of Blofeld in the James Bond movie *You Only Live Twice*. The bald head, prominent facial scar, tan Nehru jacket, and ever-present cat—all characteristics of Blofeld circa 1967—were adopted for Dr. Evil, as was Blofeld's all-important SPECTRE ring. Dr. Evil's ring is seen every time he places his pinky to his mouth and laughs uncontrollably at his own evil genius. Could this ring be worth . . . *one million dollars?? Hwa-ha-ha-ha . . . hwa-ha-ha-ha . . .!*

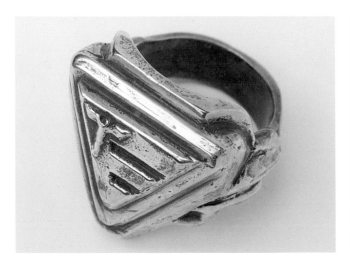

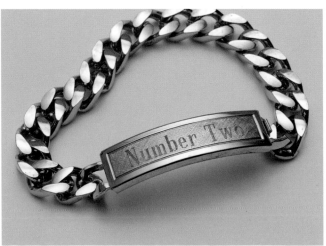

JOHNNY ENGLISH

One of the biggest box-office hits in England in 2003 was *Johnny English,* a spy spoof starring Rowan Atkinson as a junior MI7 agent who suddenly finds himself thrust into the position of being Britain's top intelligence operative.

A mixture of Maxwell Smart and Inspector Jacques Clouseau (Peter Sellers's character in the *Pink Panther* film series), English is a bumbling spy who, in spite of himself, manages to save the throne of England, along with the crown jewels, from villainous French entrepreneur Pascal Sauvage. Sauvage's scheme is to become king of England and turn Britain into a prison island, charging enormous fees to other nations for exporting their criminals. "His actions shocked many in polite society," noted *The Times.*

The movie was inspired by a series of popular TV commercials that aired on British television featuring Atkinson as an incompetent James Bond type. Curiously, twenty years before *Johnny English* was

released, Atkinson portrayed a similar character in the James Bond movie *Never Say Never Again.* As Nigel Small-Fawcet, Atkinson played opposite the real 007—Sean Connery.

INSET:

ENGLISH'S TOP-SECRET MI7 IDENTITY CARD

Authority to Terminate. Like James Bond's "license to kill," MI7 gave Johnny English "authority to terminate." This is his identity card granting him such license.

BOTTOM:

THE LONDON TIMES

Saving England. The London *Times* reported that Johnny English saved the nation from a villainous plot to steal the throne and turn England into one giant penal colony.

THE TIMES

No. 67495 TUESDAY APRIL 14 2003 4M www.timesonline.co.uk

40P
NEWSPAPER
OF THE

Knighthood for hero English

By Mike Saiz,

JOHNNY ENGLISH, the renowned MI7 agent has been awarded with a knighthood. English received the award from the Her Maje[st]y Queen at Buckingham yesterday afternoon.

The award was recent actions thwar amazing but chilling by the French entra Pascal Sauvage, to King of England. Sauv bullied the Queen and ily into abdication i that saw himself as t legitimate success England's throne.

English who has wo MI7 for twentyfive yea who give birth natu take more than a year ceive again — a measure of reduced fe according to the minis while the wait may no to a woman in her ear ties, it could be most i to the growing nun other criminals.

The alarming fac been reported as reco bers of criminals impl Sauvage in his busir often when there is no comper ment medical need — and will increase fears that too many of the operations are being carried out for social reasons.

Sauvage had risen in the public eye as an astute busi-

nessman over the past 30 years, and last year they accounted for more than one in five births in England and Wales. Some of the increase can be put down to the rising this mission very effective" He added. "This may be underestimating the true magnitude of the association. It is possible that some agents will choose not to have a further missions-

They need to be aware that if they are planning to have two children in quick succession, there may be a delay of one to three years as a result of their dedication to the service."

amazing but chilling attempt by the French entrapaneur, Pascal Sauvage, to become King of England. Sauvage had bullied the Queen and her family into abdication in a plot that saw himself as the only legitamate successor to England's throne.

English who has worked for MI7 for twentyfive years those who give birth naturally to take more than a year to conceive again — a standard measure of reduced fertility —

according to the ministry. And while the wait may not matter to a woman in her early twenties, it could be most important to the growing number of other criminals.

English who has worked for MI7 for twentyfive years those who give birth naturally to take more than a year to conceive again — a standard measure of reduced fertility — according to the ministry. And while the wait may not matter to a woman in her early twen-

ties, it could be most important to the growing number of other criminals.

The alarming facts have been reported as record numbers of criminals imployed by Sauvage in his businesses— often when there is no compelling medical need — and will increase fears that too many of the operations are being carried out for social reasons. The ministry of Special Security was established sixty years ago with the

aim to reduce incidents of this nature iin England.

The Government has been criticesed recently for lapses in security.The agent has been awarded with a knighthood. is is possible that some agents will choose not to have a further missions to achieve any further episode following the Sauvage coronation attempt. English said he now plans to enjoy his prestigious award with a very close friend on a much needed holiday.

and tobacco and alcohol uses and the full findings will be released to the press

Sir Pegasus said of his agents's bravery "He is a remarkable agent in many ways, his method's are unorthodox but as shown by

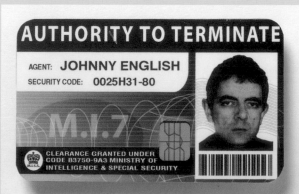

AUTHORITY TO TERMINATE

AGENT: **JOHNNY ENGLISH**

SECURITY CODE: **0025H31-80**

M.I.7

CLEARANCE GRANTED UNDER CODE B3750-9A3 MINISTRY OF INTELLIGENCE & SPECIAL SECURITY

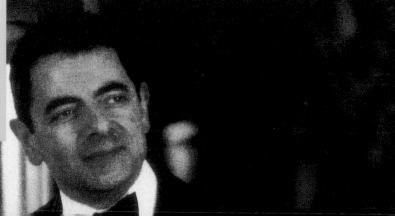

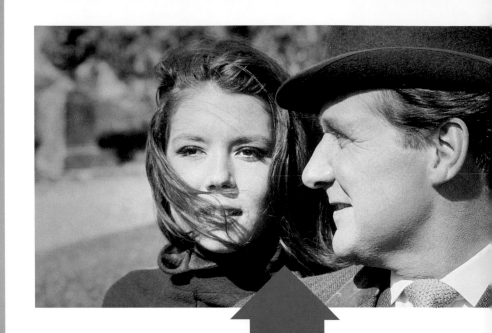

MORE SPIES

CHAPTER 00:06

6

"Everybody in Hollywood was rightfully aware of the great, wonderful aspect of doing spy shows. The trend was quite clear . . . and the bottom line, as always, was money."

—*Robert Vaughn*

British Agents. Diana Rigg and Patrick Macnee brought class and charm to the espionage game in *The Avengers.*

I SPY

"Like their real-life counterparts . . . Kelly and Scott are grassroots Americans. Cold war or hot war, they know that America is engaged in a deadly global struggle, and they are determined to have a hand in making sure that this struggle is won."

—*NBC-TV, 1965*

I Spy made television history when it debuted in the fall of 1965. The series was a milestone in the annals of American entertainment due to its innovation in TV casting and production. Robert Culp and Bill Cosby starred as, respectively, Kelly Robinson and Alexander Scott, two globe-trotting spies whose covers were that of a tennis player and his trainer.

"*I Spy* will neither attempt to out-Bond James Bond nor to out-Uncle *The Man from U.N.C.L.E.*," announced NBC, promising to "reflect life as it actually is—often stranger and more exciting than the fictional world of contemporary espionage." Indeed, *I Spy* featured no secret organizations, no exotic gadgets or disguises, no over-the-top villains. The agents received their assignments from the Pentagon and traveled the world from Mexico and Hong Kong to Spain, Tokyo, and Greece. The mission was usually to protect a diplomat, liquidate a traitor, rescue a scientist, retrieve some microfilm, or investigate a threat to the United States.

Loyal to their country and to each other, Kelly and Scott always saw the mission through, braving kidnapping, brainwashing, and torture. Romance also played a part in their lives, as each had his share of falling for beautiful women who, more often than not, proved to be a traitor or enemy agent.

Perhaps the most appealing element of the show was the relationship between Kelly and Scott. Their friendship was marked by a wonderful camaraderie, most notably displayed in their spirited dialogue, which was filled with good-natured ribbing. Characterized by Culp as "a groove . . . a new and unique language," it was performed with a rhythm that made their individual speeches seemingly interchangeable. (This was parodied in the *Get Smart* episode, "Die, Spy," in which Don Adams and guest star Stu Gilliam mimicked the Cosby-Culp banter as globe-trotting ping-pong players. Robert Culp appeared in a cameo as a tipsy waiter.)

The origin of *I Spy* can be traced back to a fateful meeting between Robert Culp and executive producer Sheldon Leonard. "I had written a spy show pilot, so Sheldon and I met and talked," recalled Culp. The script was a James Bond–type series, potentially for himself as the lead. Culp gave a copy to Carl Reiner, who passed it on to Leonard. The producer read it, liked it, but insisted that he had a better idea: "A show about two spies, and one of them is black." Leonard was right, said Culp. "His idea was better than mine."

A young Rob Reiner told his father, Carl, that he'd seen stand-up comedian Bill Cosby on TV and felt he would make a good choice to guest-star on a series being produced by Reiner and Leonard, *The Dick Van Dyke Show.* The twenty-six-year-old Cosby showed up for an audition but apparently lost the gig to Greg Morris when Leonard snagged Cosby for *I Spy.*

Casting Culp as Kelly had been a foregone conclusion for Leonard, and now the role of Kelly's African American partner would go to Cosby—a groundbreaking move. Against the backdrop of the mid-'60s social upheavals, from civil rights marches and antiwar protests to the assassinations of Robert F. Kennedy and Martin Luther King Jr., Leonard's bold casting decision broke down another door of discrimination and helped pave the way for more roles in the media for African Americans and other minorities.

I Spy was also innovative in that it was the first TV series to shoot on location around the world. Under the masterful

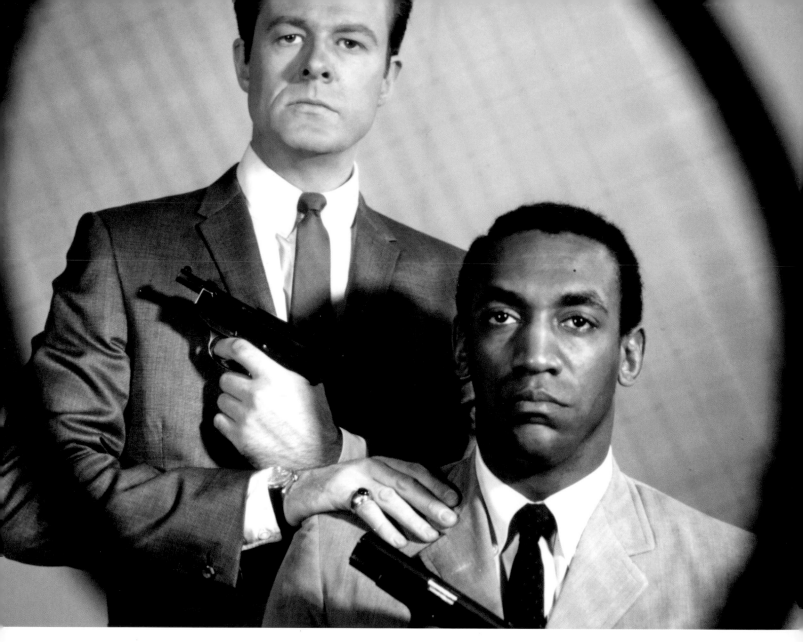

work of young Egyptian cinematographer Fouad Said—
who designed his own transportable production unit, the
Cinemobile—*I Spy* placed its stories of international
intrigue in the actual settings, for the first time sending
such global imagery in a prime-time series into the homes
of Americans. A quality production through and through,
I Spy earned numerous awards during its three-year run
on NBC.

ABOVE:

Kelly and Scott. Robert Culp and Bill Cosby are U.S. intelli-
gence agents Kelly Robinson and Alexander Scott, whose
covers are that of a tennis pro and his trainer.

RIGHT:

NBC PRESENTATION BOOKLET

Presenting I Spy. This is an in-house booklet designed by
NBC in 1965 that discusses the format, cast, and creators of
the network's new series.

KELLY ROBINSON'S TENNIS RACKET

> "[Sheldon] never stopped ragging me about my tennis, because I was supposed to learn to play it. . . .
> I didn't [really] learn the game until after the show."
>
> —*Robert Culp*

Tennis bum. Such is the term given to a man like Kelly Robinson who, with his trainer Alex Scott, travels the world playing tennis and rubbing shoulders with diplomats, politicians, the wealthy, and the jet set.

Kelly majored in international law at an Ivy League college, where he also placed on two Davis Cup teams. That is where his life changed course. On August 12, 1964, Kelly became an undercover operative for the U.S. government. His tennis activity was seen as the perfect cover for a globe-trotting spy, his notoriety on the tennis circuit being an ideal means of making social inroads into an underworld where espionage, international criminal operations, and political or military maneuverings might take root.

Tennis Anyone? This prop tennis racket was used during the filming of *I Spy* in Hollywood, 1965–1968.

I SPY TITLE SEQUENCE STORYBOARD

> "My hair was jelled completely with shaving cream. . . . White makeup on my legs, white on my
> face, white socks, white shoes, white-white everything!"
>
> —*Robert Culp, recalling the day he filmed the* I Spy *titles*

Living a double life is part of the job of being a spy. Maintaining a cover identity can mean shifting, at a moment's notice, from public persona to true self, shedding the trappings of one's alias long enough to carry out a hidden objective.

The dual lives of Kelly Robinson—tennis player/intelligence agent—are cleverly depicted in the show's famous title sequence when Kelly transforms, seamlessly, from tennis player into spy. This title segment appears at the start of every hour-long episode following a short, kickoff teaser. When that teaser ends, the screen suddenly turns stark white. A silhouette of a tennis player—Kelly—appears against a white backdrop, serves a ball, and begins to play tennis, swinging his racket while moving across the screen, as if engaged in a game.

Earle Hagen's thrilling theme music mimics Kelly's strides with sounds that echo the visual sensation of the serve, the swings, the strings of the net and racket. Behind the player move large, colorful graphics, the names of cities of the world—Tokyo, Paris, Hong Kong—creating a sense of global travel. Suddenly, Kelly's final swing turns his racket into a gun, the tennis outfit to a suit, the breezy stance into a cautious crouch, the free-flowing tennis movements into careful, deliberate steps. Spinning in place, he fires the gun, producing the giant letters "I SPY." Kelly escapes through a doorway formed by the letter *I*. Finally, the letters dissolve to black-and-white footage of Kelly lighting and throwing a bomb, which leads to a split screen of his eyes looking down on scenes of that evening's episode.

Title designer Herbert Klynn was the man behind that very innovative opening sequence. This nine-foot-long storyboard (page 138) was Klynn's visualization of his plan. Drawn in his own hand, the colorful inked frames show the evolution of the tennis sequence, which was the blueprint for shooting the scene.

"I got there, looked at the set, and it was very bizarre," recalled Culp. "It was like a clamshell, but all black. I asked, 'What are we going to do here?' He said, 'We're going to make you all up in white,' which they did—everything except my eyes."

"We shot it on a fifty-foot black cyclorama backdrop . . . to create a running matte," explained Klynn. "I had wanted to get a dancer who would double for Mr. Culp, but Sheldon said no. To this day I am so thankful that Robert Culp did it."

"They shot me against the black, doing all those moves with the tennis racket," said Culp. "I came around, the racket became a gun and so forth. At that time there was no CGI [computer-generated imagery], so they achieved me in silhouette, not lit from behind, but by reversing the negative."

Klynn spent two weeks performing tedious frame-by-frame optical work to combine the live action with the animation portion. When it was completed, Klynn was nervous. "I slept very little that night. The next morning everyone was present in the screening room. When the titles ended, applause broke out . . . much to my relief."

Much of the title's effectiveness, insisted Klynn, is due to the *I Spy* theme music that accompanies it. "I give recognition to Earle Hagen for his wonderful, 'driving' score," he said. Robert Culp concluded that the whole experience "worked just fine. It was very simple . . . *except* for how long it took me to get the damn makeup off!"

I SPY

TOP:

Historic Title Design. This is the nine-foot-long *I Spy* storyboard that laid out the vision for what would become one of television's most innovative main title sequences.

ABOVE:

TITLE ANIMATION CEL

Shooting Titles. This original animation cel was photographed for the show's opening titles. When Kelly, in silhouette, turns and shoots, these letters appear as if shot out of his gun.

BILL COSBY'S EMMY PLAQUE

"The wonderfulness of yourself!"

—Alexander Scott to Kelly Robinson . . .and vice versa

What better hero could one hope for than an American secret agent who regularly writes home to his mother? Even when he's in the middle of the most dangerous assignments half a world away, Alexander Scott maintains a loving correspondence with his mom. Just ask Kelly. He is often in the midst of getting a massage, packing his tennis racket, tying down his shoulder holster, or decoding a secret message when Scotty asks him if he's got a P.S. to tag on to his letter. Usually Kelly insists that Mrs. Scott be told that her son is not eating his greens.

The letter is mailed to Scott's mother back in Philadelphia, where Alexander was born, raised, and attended Temple University on a basketball scholarship. Scott took up languages at school and went to Oxford as a Rhodes Scholar, where he was recruited by American intelligence. He first met Kelly Robinson during training and officially became an agent on May 15, 1964.

Bill Cosby had proved himself as a remarkably talented comedian by the time he was approached by Sheldon Leonard to costar in *I Spy*. However, he'd had little experience as an actor. The first filmed episode written by producers David Friedkin and Morton Fine, "Affair in T'Sien Cha," left some people concerned about Cosby's ability to carry the role, but Sheldon Leonard stood by Cosby. Robert Culp, an established actor who'd starred in TV's *Trackdown* and numerous dramatic series and features, helped train Cosby, on the job, in the acting department.

Both Culp and Cosby were three times nominated by the National Academy of Television Arts & Sciences for their leading performances in *I Spy*. Cosby was awarded the

Emmy each time. This Emmy nomination plaque is the first honor that Bill Cosby received for his performance as Alexander Scott on *I Spy,* presented to him for the series' first year on the air—1965–1966. (No doubt Kelly wrote a congratulatory P.S. to Scott's mom back in Philly.)

Cosby Wins. Of the four Emmy nominations that *I Spy* earned for its first season on the air, Bill Cosby was the single winner for his portrayal of government agent Alexander Scott. This Emmy plaque was presented to Cosby in honor of his nomination.

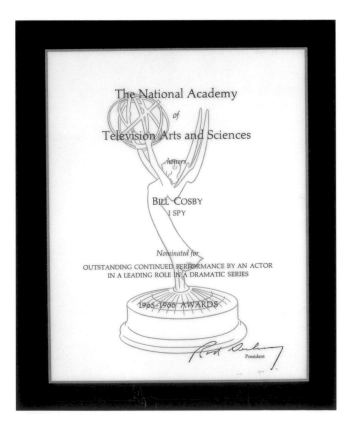

ROBERT CULP'S SCRIPT OF HIS FAVORITE *I SPY* EPISODE

> "Your deer rifle was there for me when I was tall enough to reach it and take it down by myself. And I would have made it next summer because I was tall and skinny . . . but that winter my mom died and next summer never came. Now I've come and I wish I hadn't. I'm sorry."
>
> —*Kelly Robinson to his Uncle Harry, "Home to Judgement," 1967*

You're an American agent. You and your partner have just escaped captivity, and you're on the run—"someplace in America . . . most probably Southern Idaho." You are badly wounded, bleeding and feverish, hungry, clothes tattered. The enemy is in close pursuit—unseen faces, armed men in business suits who have *"got* to kill [you] just because [you] know who they are." Racing across the open prairie, you come upon a small farm. You and your partner take refuge, hiding out in the loft of the barn. Soon you realize where you are—at the home of the uncle and aunt who raised you, a place you haven't seen in twenty-seven years. And you realize that you have, in your effort to survive, just brought a nightmare into the lives of the two people you care about the most.

"Home to Judgement" was the final script that Robert Culp wrote for *I Spy* during the series' last season on the air. An unusual story for the show, it incorporated personal reminiscences from Culp's own life.

Some of *I Spy's* best episodes were written by Culp, such as "Magic Mirror," "The Tiger," and the first *I Spy* episode broadcast by NBC, "So Long, Patrick Henry." Culp's scripts typically are powerful character-driven dramas with an edge.

It has been said that "Home to Judgement" is the personal favorite of both Robert Culp and Bill Cosby. This copy of the script, dated and signed by its author, is a studio original used during the making of the episode.

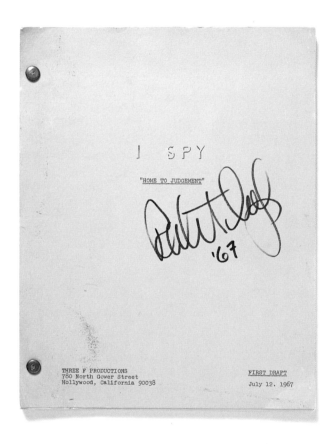

A Spy Comes Home. This is the original 1967 script of Robert's Culp's classic *I Spy* episode, "Home to Judgement."

THE AVENGERS

" Extraordinary crimes against the people and the state have to be avenged by agents extraordinary. Two such people are John Steed, top professional . . . and his partner, Emma Peel, talented amateur . . . otherwise known as The Avengers."

—The Avengers *teaser introduction for American broadcast*

England proved to be the source, in the 1960s, for many of America's most treasured pop-culture icons. James Bond hit our screens in 1962. The Beatles invaded our shores in 1964. And on television, in 1966, *The Avengers* arrived.

This hour-long ABC-TV adventure series was sophisticated, charming, and witty. Patrick Macnee stars as gentleman spy John Steed—very proper, very British, and the absolute model of grace under pressure. Always smartly dressed, Steed goes nowhere without his bowler hat and umbrella. And whenever he leaves his elegantly styled London flat, it is in his classic Bentley automobile.

Macnee recalled traveling to the United States with Diana Rigg to help sell the series to the networks. "We came over here and literally said, 'This is a show about a man in a bowler hat and a woman who throws men over her shoulder.' 'Oh, really?' they said. 'Oooh!' And to our astonishment, they put it on. It was the first network show to appear from England, so we're very proud of it."

The Avengers originated as a sort of spin-off of a 1960s adventure series, *Police Surgeon,* starring Ian Hendry, who, the following season, would become Steed's partner in the debut of *The Avengers.* Over the years, Steed— as an agent for the Ministry of Defence—was assigned to work with a number of agents. The one that American audiences first saw—and instantly fell in love with—is Mrs. Emma Peel, played by Shakespearean actress Diana Rigg. The wife of a missing test pilot, Mrs. Peel joined Steed as an amateur agent. "I was an eighteenth-century man, and she was a twenty-first-century woman," said Macnee of the two characters. "We transcended time."

The Avengers' assignments invariably involve preventing criminal masterminds from carrying out their diabolical plots against England. Missions involve locating missing scientists, stopping insidious brainwashing and blackmail plots, foiling murder-for-hire outfits, battling high-voltage assassins, defeating foreign spies, and tracking down killer robots.

During their investigations, Steed and Mrs. Peel happen upon the most eccentric characters imaginable, from an aroma expert who goes to extremes in babying his valuable nostrils . . . to a railway specialist whose home is a railroad shrine built from train paraphernalia. "We looked at life and we slightly tilted it," reflected Macnee. "That's the way I look at life, anyway."

A huge success in the United States and around the world, *Avengers* episodes continued to be exported from England, including later adventures in which Steed worked with Tara King (Linda Thorson) and early ones with Cathy Gale (Honor Blackman, who left the show to play Pussy Galore in *Goldfinger*). In 1978, CBS aired *The New Avengers,* in which Macnee returned as Steed with two younger agents, Purdey (Joanna Lumley) and Mike Gambit (Gareth Hunt).

No spy series has ever matched the stylish sophistication of *The Avengers.* Of its legions of fans in the 1960s, few will forget the sparkling images of Mrs. Peel placing a red rose in Steed's lapel or shooting the cork off a champagne bottle in Steed's hands before he pours her a glass. From the opening frames of the agents finding a well-dressed corpse lying across a giant chessboard to the closing scenes of Steed and Mrs. Peel driving into the distance in every imaginable mode of transportation, *The Avengers* may be the spy show that is remembered most affectionately.

JOHN STEED'S BOWLER HAT

"Always keep your bowler on in times of stress, and a watchful eye open for diabolical masterminds."

—*Emma Peel to John Steed, "The Forget-Me-Knot," 1968*

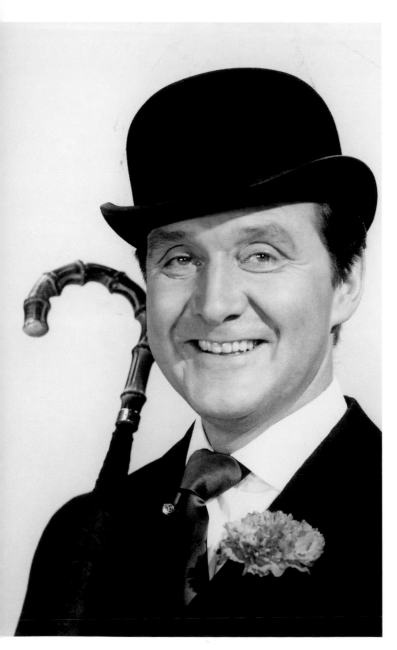

"I invented the character," said Patrick Macnee of the man in the bowler hat, John Steed. "It was just a name. Nobody told me what Steed was supposed to be, other than sort of elusive and strange. You can have several people playing Eliot Ness or James Bond or the Saint, but nobody had ever played John Steed."

The essence of Steed, explained Macnee, "is that he was cool way before it was hip to be cool. In other words, if you were cool in the early '50s or late '40s, just after the war as well as during war, to be cool really implied that you also stayed alive. It's an attitude that I maintain to this very day—from earthquakes to holocausts to explosions to sudden death to being mugged. If you're not cool, you're dead. That is the serious basis of John Steed's character."

Steed's fashionable suits, which Macnee designed himself, were always matched with a bowler hat. In some of the stories, the bowler is shown to be lined with a metal plate, which Steed uses, as needed, to knock the bad guys unconscious.

TOP:

A '60s Icon. This is the renowned bowler hat worn by Patrick Macnee as John Steed in the 1966 British spy series *The Avengers*.

LEFT:

A Man and His Bowler. Patrick Macnee, as John Steed, wears his bowler hat.

MRS. PEEL'S LEATHER PANTS

"With Diana Rigg I had a total unity of humor and of expression and of communication. She's a very considerable lady on all sorts of levels."

—Patrick Macnee

In the United States, they came to be known as the *Emmapeelers.* The sexy outfits worn by Diana Rigg as Emma Peel took the nation by storm. *TV Guide* magazine published a full photo spread on the apparel of this new female spy.

Beneath Diana's clothing, underlying the fashion statement being made, was a character who grabbed the attention of male and female viewers alike. The name "Emma Peel" is a play on "M Appeal," short for "Man Appeal," which is what the producers wanted this character to exude. With Diana Rigg in the role, they succeeded. Men found her attractive, sexy, and smart; women discovered a lady who was intelligent, feminine, and assertive.

Garbed in one of her colorful jumpsuits or in a pair of her trademark leather pants, Mrs. Peel was a judo expert who could toss a man across the room . . . which is exactly what she did in nearly every episode.

Mrs. Peel . . . you're needed. This is the pair of trousers that affected an entire generation of young boys in the mid-1960s—Diana Rigg's black leather pants. Rigg wore them as the athletic and alluring amateur spy, Emma Peel, in *The Avengers.*

LEATHER PANTS IN THE HANDS OF A WIDOW

"English people keep their distance in every respect. . . . Underneath everything, there is an absolutely surging, boiling cauldron of sex, but it's controlled. It's also made kinky and perverse by the use of leather and all those things."

—*Patrick Macnee, commenting on the sexual undertones in* The Avengers

I had just presented a lecture in conjunction with my *Spy-Fi* Exhibit at a museum in New Mexico. Giving a personal tour of the collection, I explained how some of the prop spy gadgets functioned, such as the pen that converts into a transmitter, the shoe that emits smoke, and the cigarette lighter that takes photographs. As we moved to the display of Mrs. Peel's leather pants, someone asked me, "They don't do anything, do they?" I replied, "Actually, I know some people that they would do a lot for."

I never guessed that Mrs. Peel's leather pants would prove to be the most talked-about artifact in my entire spy exhibit—second only to the *Get Smart* shoe phone. I was even interviewed about the pants on national radio by CBS News. Barbara Feldon paused to admire them as she toured my exhibit at the CIA, reflecting on the high quality and sophistication of *The Avengers* series. I have noticed that when women first see Diana's pants, they immediately ask what size they are. Men never ask—they just look.

However, one amusing query I regularly get is, How does one acquire a pair of leather pants worn by the sexy female star of a hit '60s spy show? The answer is perhaps even more amusing. . . .

Years after *The Avengers* had finished its original run on network TV, one of the show's directors, sadly, died. His widow, eventually gathering the courage to go through her husband's things, came upon Diana Rigg's pants, which her late husband had stashed away. I don't exactly know what the wife's reaction was to this find, but I do know that she didn't want to keep them. Through various means, Mrs. Peel's leather pants made their way out of the widow's house and across the ocean to California, where they received a warm reception at the Los Angeles headquarters of the Spy-Fi Archives.

Touring the country on exhibit, and like the memorable characters they represent, Mrs. Peel's pants and John Steed's bowler have simply been inseparable.

"Mrs. Peel . . . we're needed."

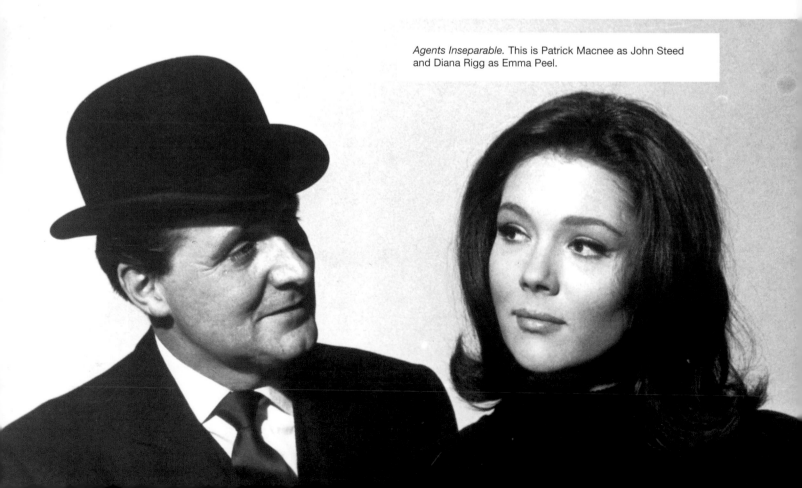

Agents Inseparable. This is Patrick Macnee as John Steed and Diana Rigg as Emma Peel.

IT TAKES A THIEF

MAIN TITLE STORYBOARD

"Now let me get this straight . . . you *want* me to steal?"

—*Master thief Al Mundy to spy agency chief Noah Bain*

Recruiting field operatives from outside agency ranks is standard practice in the world of spy-fi. Z.O.W.I.E. nabbed Flint, MI6 persuaded the Saint, and the IMF recruited its many specialists. In early 1968, Noah Bain of the U.S. government's SIA—Secret Intelligence Agency— extracted one of the world's greatest thieves, Alexander Mundy, from the San Jobel Prison and offered him a job. Would he be willing to steal for Uncle Sam? Mundy couldn't believe his ears, but when Bain told him his cover would be that of an international playboy—living on a posh estate with three gorgeous female "assistants"—Mundy had only one response: "Beautiful!"

Mundy's missions—which entailed stealing everything from microdots and secret formulas to jewels and people—frequently took place in Europe, courtesy of the Universal Studios back lot. Eventually the series switched to overseas location filming, introduced a new boss, Wallie Powers, and added to its cast Fred Astaire, who portrays master thief Alister Mundy, Alexander's father.

Of course, the SIA had to keep close tabs on Al to make sure he never got carried away with his thievery *or* the very beautiful women with whom he constantly became entangled. Forever hanging over his head was the threat of returning to prison.

Starring Robert Wagner as the ever-so-stylish burglar, con artist, pickpocket, and disguise expert Al Mundy, *It Takes a Thief* proved to be a spirited, refreshing take on the tongue-in-cheek TV spy show. The series ran for three seasons on ABC and featured a creative title sequence in which Al is seen plying his trade: romancing pretty ladies and punching out the bad guys—all in separate split-screen boxes.

As Al Mundy would say, "That's beautiful!"

Split Screen. This is the storyboard layout for Herbert Klynn's dazzling split-screen opening titles of the 1968 ABC-TV espionage caper series *It Takes a Thief.*

T.H.E. CAT

"Out of the night comes a man who saves lives at the risk of his own. . . . A professional bodyguard . . . primitive . . . savage . . . in love with danger . . . *The Cat!*"

—*Teaser intro to* T.H.E Cat

Need a bodyguard? We can direct you to the best one around. His name is Cat, and he can be found at a local jazz club, Casa del Gato. The incandescent glow of the cat-shaped neon sign will be your beacon.

Inside the restaurant, you will be greeted by the host, a warm and personable Spanish gypsy named Pepe. Tell him you are looking for Mr. Cat. In all likelihood, he will lead you through the smoke-filled dining room filled with customers listening to the music of a live jazz ensemble. Pepe brings you to the outdoor balcony, where Cat is alone with an attractive woman. "Thomas," says Pepe, "someone is here to see you."

One of the coolest, yet most obscure, TV series ever is *T.H.E. Cat*. Created by Harry Julian Fink and produced by Boris Sagal, *Cat* stars Robert Loggia as professional bodyguard Thomas Hewitt Edward Cat, who is hired by those in trouble, on the run, or targeted for assassination.

T.H.E. Cat is not a spy show per se but, created at the pinnacle of the '60s secret-agent frenzy, bore all the earmarks of one. Like Illya, Bond, Al Mundy, and other '60s spies, Cat wears a business suit by day and dons all black for nighttime sleuthing. His signature gadget comes from the James West school of survival—a hidden, spring-action device that he wears on his forearm under his sleeve. The rig stays loaded with a dagger, which he can eject into the palm of his hand at any moment.

Played with class and style by Loggia, Cat is a former circus aerialist and reformed cat burglar. In the role, Loggia indeed moves like a feline, darting down dark alleys with rope and grappling hook, scaling the sides of buildings, and walking tightrope between them—swiftly, quietly, effortlessly. The fight scenes, which Loggia performs with the grace of a dancer, are smartly choreographed and skillfully edited.

The intensely cool theme music is by Lalo Schifrin, responsible for the famous *Mission: Impossible* theme. *Cat*'s stylized title sequence, set within a nighttime urban motif, is completely animated and features a black cat that leaps into a transformation of a man.

NETWORK PRESENTATION BOOKLET

Cool Cat. One of the coolest, most offbeat TV series—which few people have heard of or remember—is *T.H.E. Cat*. The adventures of a bodyguard, set within the motif of the '60s spy scene, debuted in the fall of '66 on NBC. The concept was presented to industry insiders earlier that year in this network presentation booklet.

Having *The Man from U.N.C.L.E.* as its Friday night lead-in, the half-hour adventure drama debuted on NBC in the fall of 1966. Weak ratings suggested to some that viewers may have been put off by the show's bizarre villains, stylized dialogue, nebulous setting, and offbeat hero. *T.H.E. Cat* was cancelled after only one season.

Cat once described himself as a man "born out of his time." The same could be said of the series. Few people today claim to have ever heard of *T.H.E. Cat*. But those who remember it do so with a passion.

RIGHT:
Cat on the Move. This is the original artwork for a page from Dell's *T.H.E. Cat,* a 1966 comic book adapted from the TV show.

BELOW:
In the Thick of Danger. Robert Loggia stars as T.H.E. Cat in a scene with Janine Gray.

HONEY WEST

MAIN TITLE ELEMENTS

Private eyes are not spies. They are detectives and usually in business for themselves. Their domain tends to be swindling, kidnapping, blackmail, and murder. Rarely, if ever, does an investigator take on foreign agents and criminal masterminds. So when spies became *the* hot commodity in the '60s, many of TV's detective and police heroes had to bend with the wind: Captain Amos Burke *(Burke's Law)* was turned into a secret agent, and *Hawaii Five-O*'s Detective Steve McGarrett did battle with Red Chinese agent Wo Fat.

Honey West, whose pilot debut was actually an episode of *Burke's Law*, aired as a half-hour series on ABC during the 1965–1966 season. Although she was a private eye, the scripts and network promotion played her up as a female James Bond. A woman as TV "action hero," let alone spy, was practically nonexistent in those days, and Honey—an expert in firearms and judo—beat Emma Peel and April Dancer to the punch by a full year.

Portrayed by Anne Francis, Honey and her partner, Sam Bolt (John Ericson), used a TV repair service—H.W. Bolt

& Co.—as a cover. Their service van was a mobile spy unit, filled with surveillance equipment. Honey used a wide array of Bond-type spy gadgets in her work: Her earrings were smoke grenades, her garter was a gas mask, and her purse was a bag of spy tricks disguised as cosmetics.

The show's main title sequence features black-and-white photographs of Sam and Honey—even her pet ocelot, Bruce—edited to the theme music in dramatic, staccato fashion. A beehive-style collage of Honey's face segues to Bruce, whose eyes dissolve into those of Honey's.

INSET:
Taste of Honey. These are the original graphic elements used to create the opening title sequence of *Honey West*, a 1965 female detective show that liked to tinker in the realm of 007.

BELOW:
Private Eyeful. This is the storyboard for filming the *Honey West* titles.

SERIOUSLY SPY CRAZY!

Like love stories, Westerns, and horror films, spy thrillers are here to stay. The introduction of James Bond to the cinema in the early '60s spawned hundreds of secret-agent adventures, only a fraction of which have made it into this book. A number of additional titles deserves mention. . . .

The British TV series *Secret Agent* (1965–1966) was one of the highest-quality spy shows ever produced. Starring Patrick McGoohan as British intelligence operative John Drake, the hour-long *Secret Agent* episodes were well written, well acted, and totally captivating. Titled *Danger Man* in England, the series was a follow-up to an earlier half-hour series, under the same title, in which Drake works as an agent of NATO.

The Drake character evolved into a highly acclaimed follow-up series, *The Prisoner* (1968), in which McGoohan's British operative resigns from his job, is kidnapped and held prisoner in the mysterious Village. As "No. 6," he is subjected to all manner of psychological trickery by his mysterious overseers to learn why he resigned.

Sixties TV brought us a number of World War II spies: *Jericho, Blue Light,* and *The Man Who Never Was.* Over the course of four decades we have seen *Coronet Blue, Man in a Suitcase, The Baron, The Champions, Call to Danger, The Adventurer, The Persuaders, The Protectors, Department "S", The Professionals, The Delphi Bureau, Search, Masquerade, Spies, A Man Called Sloane, Cover Up, Gavilan, Fortune Hunter, Mr. and Mrs. Smith, Secret Agent Man, 24,* and many more.

Feature spy thrillers would fill several books. A few memorable titles include *Alphaville, Deadlier Than the Male, That Man in Istanbul, The Quiller Memorandum, Remo Williams, Come Spy with Me, Modesty Blaise, Arabesque, The Dirty Game, La Femme Nikita,* and the *O.S.S. 117* series.

THE SAINT CAST AND CREW POSTER

Before he became James Bond, Roger Moore was *The Saint*. Based on a series of best-selling novels by Leslie Charteris, the exploits of Simon Templar were dramatized on radio and in the movies before being made into a television series in England in 1962. The U.S. network premiere of *The Saint* was on NBC in 1967, starring Moore as Templar, the mischievous, well-to-do adventurer and do-gooder.

Rescuing damsels in distress, Templar usually found himself knee-deep in some insidious plot, frequently involving master criminals and foreign agents. His talent at righting wrongs came to the attention of British intelligence, which occasionally asked him to perform tasks such as rescuing a kidnapped scientist or retrieving stolen documents from behind the Iron Curtain.

A decade after its three-season run on NBC, *The Return of the Saint*—starring Ian Ogilvy as Templar—aired on CBS. In 1997, Paramount released a theatrical movie, *The Saint*, a surprisingly well-made espionage thriller starring Val Kilmer.

This poster of the famous *Saint* insignia was signed, in England, by the many actors, writers, and producers who had contributed to the making of the most popular version of *The Saint*, the '60s TV series starring Roger Moore.

Man with a Halo. This poster was signed by the cast and crew of the British adventure series *The Saint,* starring Roger Moore.

WASHINGTON WEATHER

Cloudy tonight; low, 40. Cloudy, windy and warmer tomorrow with some occasional rain; clearing and colder at night.

Temperatures Today

Midnight 45	8 a.m....37	2 p.m...49
4 a.m... 38	10 a.m....40	3 p.m...47
6 a.m....37	Noon....43	4 p.m...47

The Evening Star

WITH SUNDAY MORNING EDITION

Night Final SPORTS

106th Year. No. 329. Phone ST. 3-5000 WASHINGTON, D. C., TUESDAY, NOVEMBER 25, 1958—44 PAGES Home Delivered: Daily and Sunday, Per Month $1.95 / Night Final and Sunday, $2.00 **5 CENTS**

DIPLOMAT SLAIN AT U. N.

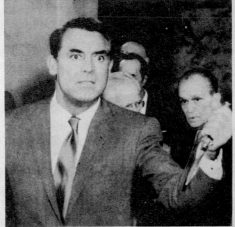

Assassin Eludes Police Efforts

BULLETIN

A photograph in the slaying of a diplomat at the U. N. today was tentatively identified as that of Roger Thornhill, a Manhattan advertising executive.

This indicates the name "George Kaplan," given by the slayer to an attendant in the General Assembly Building, was false.

A possible motive for the killing was suggested when it became known that earlier today Thornhill appeared in the Glen Cove (Long Island) Police Court on a charge of drunken driving with a stolen police car. In his defense, Thornhill charged that the murder victim, Mr. Townsend, had attempted to kill him the night before.

KEY PHOTOGRAPH—This picture was tentatively identified today as that of Roger Thornhill, a Manhattan advertising executive, in connection with the slaying of a diplomat at the U. N.

NORTH BY NORTHWEST PROP NEWS ARTICLE

Dateline—*Washington, D.C., November 15, 1958.* A startling photo and news story makes the front page of the *Evening Star* newspaper: "Diplomat Slain at U.N." The man in the photo, advertising executive Roger Thornhill, is holding the murder weapon. The chief of U.S. intelligence reads the story along with his closest advisers. Are they alarmed? Will they send a team of agents to the United Nations to investigate? Not at all. This fits right into their plans.

U.S. intelligence invented a fictional American agent, George Kaplan, as a decoy to confuse the opposition. Thornhill, by accident, fell into Kaplan's fictional life. The enemy now thinks he's U.S. operative Kaplan, which throws Thornhill's life into complete turmoil. He is kidnapped, nearly killed, and pursues his mysterious assailants to the United Nations, where he ends up framed for murder. A photo of him holding the real killer's knife makes the headlines.

This prop newspaper article can be seen in Alfred Hitchcock's classic 1959 spy thriller, *North by Northwest.* Viewed in close-up, the article is revealed to be in the

hands of "the Professor," the U.S. intelligence chief played by Leo G. Carroll.

In many ways, *North by Northwest* set the tone for the cinematic portrayal of espionage in the '60s. Its visually stunning set pieces—Cary Grant as Thornhill in peril from an attacking crop duster and stalked by villains on Mt. Rushmore—are precursors to such exotic dangers in the Bond films. Screenwriter Ernest Lehman's use of an innocent person swept into a world of international intrigue was later adapted as an important element in the *U.N.C.L.E.* series, not to mention the presence, in both productions, of Carroll as the adroit, pipe-smoking intelligence chief.

This news article—which, amazingly, has survived nearly half a century—is proof positive that, in the world of espionage, nothing is quite what it appears to be.

ABOVE:

Hitchcock Plot. This prop 1958 news article was seen prominently in Alfred Hitchcock's spy thriller, *North by Northwest.*

IPCRESS FILE POSTER

One of the coolest espionage films to have appeared on the '60s spy scene is *The Ipcress File*, starring Michael Caine as Harry Palmer, an insubordinate British sergeant who, in the wake of a serious indiscretion, is offered a position with British intelligence as an alternative to the brig. Shuffling between two spy chiefs while dallying with sexy operative Jean, Palmer becomes embroiled in the hunt for those behind a brain-drain plot.

James Bond coproducer Harry Saltzman brought Len Deighton's novel to the screen in 1965, serving up a secret agent markedly different from 007. Although he shares Bond's appetite for attractive women, the bespectacled Palmer enjoys books, cooking, and classical music.

The Ipcress File is laced with intrigue, atmosphere, and a wonderful John Barry score, all presented through Sidney J. Furie's stylish direction. Two Palmer sequels followed—*Funeral in Berlin* and *Billion Dollar Brain*—though neither recaptured the magic of the original. Caine returned as Palmer in two 1990s movies for Showtime.

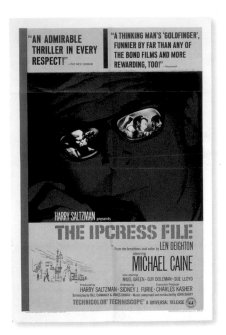

"Now Listen to Me . . . " These words trigger obedience from a brainwashed British agent in the first Harry Palmer spy thriller, *The Ipcress File*. Pictured is a poster for the movie.

MAX LONDON'S E.C.H.O. GUN FROM *SPY GAME*

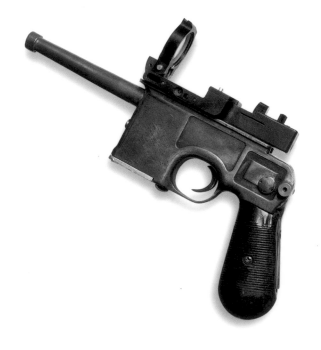

Attempting to recapture the spirit of the '60s spy scene, ABC launched *Spy Game* in 1997. In an atmosphere of intelligence downsizing, the president of the United States calls upon E.C.H.O. (Emergency Counter Hostilities Organization), which comprises former U.S. agents such as ex-CIA operative Lorne Cash and his partner, Max London.

This is the gimmicky prop gun used in *Spy Game* by Allison Smith in the role of Max. Along with various electronic sounds, the sight could pop up and the barrel could extend or retract at the push of a button. The weapon fired all manner of projectiles, include transmitters, homers, and bullets.

Wanna Play? Such was ABC's promo line for its 1997 adventure series, *Spy Game.* Unfortunately, no one did want to play because the show lasted only one season. Nonetheless, spy girl Max used this cool handgun, whose barrel she enjoyed extending and retracting with a touch of her finger.

ARNOLD SCHWARZENEGGER'S PROP ID CARD FROM *TRUE LIES*

RENQUIST CONSULTING
1461 Geary Street
San Francisco, CA 94108

HARRY RENQUIST 415-555-9020

Getting Harry. Housewife Helen Tasker (Jamie Lee Curtis) believes her husband, Harry, leads the ho-hum life of a computer salesman. In fact, Harry Tasker (Arnold Schwarzenegger) is a top-secret agent for the Washington, D.C., intelligence agency, Omega Sector. When on missions, Tasker uses the cover identity of Harry Renquist. This is the Renquist business card he uses in the 1994 spy film *True Lies.*

SCARECROW & MRS. KING SPY HEADQUARTERS BADGES

What divorced woman, living with two sons and her mother, wouldn't want to take a weekly break from PTA meetings and carpooling to go on secret spy missions with a handsome, debonair secret agent? That's exactly what Amanda King did for four years on the CBS television series, *Scarecrow & Mrs. King.* Debuting in fall 1983, the light, family-oriented adventure series stars Kate Jackson (one of TV's original Charlie's Angels) as Mrs. King, a suburban mom who accidentally crosses paths with a government agent known as "Scarecrow." The operative, Lee Stetson (Bruce Boxleitner), decides to seek Amanda's help on future assignments, eventually recruiting her to become a member of The Agency, his secret employer. Located in Washington, D.C., The Agency is hidden behind the façade of a documentary production company. Its secret entrance is through a coat closet.

These prop badges were worn by Lee and Amanda inside The Agency headquarters.

Security Measure. These prop security badges were used by the two stars of *Scarecrow & Mrs. King.* As operatives of The Agency, Lee and Amanda had to wear these ID badges throughout headquarters.

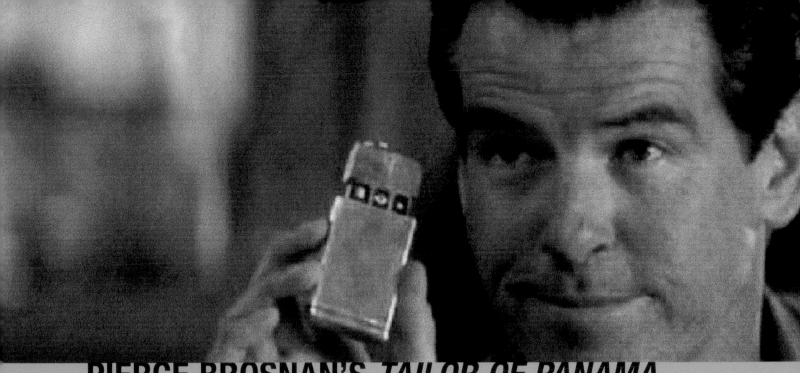

PIERCE BROSNAN'S *TAILOR OF PANAMA* LIGHTER/CAMERA

Lighter, Camera, Action! A cigarette lighter that's really a secret spy camera is used by Pierce Brosnan as a British intelligence agent in *The Tailor of Panama* (2001). Andy Osnard (Brosnan) persuades tailor Harry Pendel (Geoffrey Rush) to do some spying for him and provides him with this special lighter. In fact, two prop lighters were used during shooting—one that converts to a camera and another that reveals a secret compartment for film. On-screen, they correctly appeared to be the same gadget.

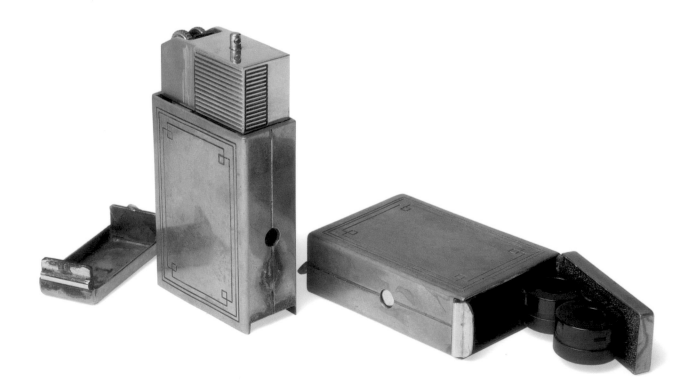

ALIAS

Can you imagine discovering that your father is really a CIA agent trying to save the world from an evil conspiracy? And that your mother, who died in a car accident when you were a child, was actually a foreign spy . . . and is alive? Welcome to the world of Sydney Bristow. Not since the spy genre's heyday in the 1960s has there been a TV series that even came close to the high quality of those espionage thrillers. Until *Alias* in 2001.

Sydney Bristow (Jennifer Garner) is recruited from college to become a covert agent for SD-6, a secret division of the CIA, hidden inside the Credit Dauphine building in Los Angeles. After revealing her secret life to Danny, her fiancé, Sydney finds him murdered. A series of shocking revelations turn her life upside down. She discovers that the murder was ordered by her SD-6 boss, Arvin Sloane (Ron Rifkin), and that SD-6 actually has no affiliation with the CIA. In fact, SD-6 is part of the Alliance, a global conspiracy that threatens the Free World.

Sydney agrees to secretly work for the CIA while continuing as an agent for SD-6, in order to destroy the Alliance from within. Joining her in this effort is her agency handler, Michael Vaughn (Michael Vartan). Sydney learns that her father, Jack (Victor Garber), is also a CIA operative trying to bring down SD-6 and that her mother (Lena Olin), long thought to be dead, is in fact alive. It also seems possible that Sydney's mom has been an enemy agent for decades.

The creation of writer-producer J.J. Abrams, *Alias* premiered on ABC in September 2001. Although the show's format shifted drastically in January 2003, the weekly, hour-long stories of Sydney's efforts against SD-6 are riveting drama—complex stories with fascinating characters, amazing plot twists, tightly directed action, plenty of suspense, and a subtle, masterfully nuanced sense of humor.

Agents of Intrigue. The cast of *Alias* strikes a serious pose.

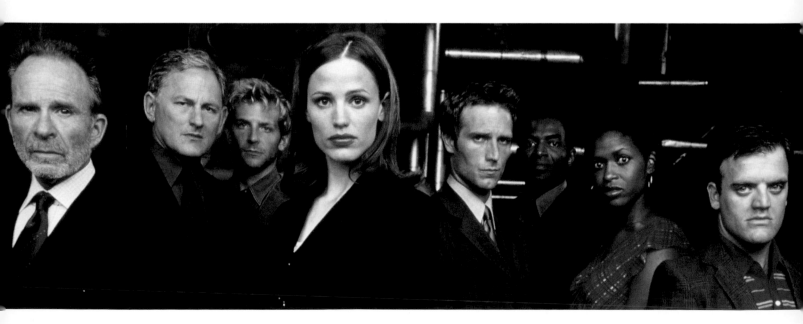

CIA DOSSIER ON AGENT VAUGHN

"Agent Jack Bristow is currently employed by both the SD-6 and the CIA as a double agent. . . .
Sydney Bristow is also [with] SD-6 and currently unaware of her father's involvement. . . . "

—*Vaughn's report to the CIA on infiltration into SD-6*

This prop from *Alias* is the CIA's classified dossier on its agent, Michael Vaughn. It contains a full history of Vaughn, including vital statistics, voice pattern ID, photo, mission documents with satellite photo and map, plus Vaughn's status report on the CIA's undercover operations against SD-6.

ABOVE:

Classified. The prop masters on *Alias* went to great lengths to manufacture this fictional dossier detailing the undercover activities of its operative, Michael Vaughn.

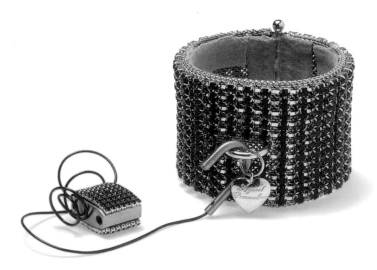

SYDNEY'S BRACELET WITH HIDDEN GAROTTE

Fashionable. This attractive piece of jewelry was worn by CIA agent Sydney Bristow on *Alias*. Of course, the ornate bracelet has a secondary function—a hidden garotte wire can be pulled out, used to strangle an enemy, then be retracted. Undoubtedly, this was a little gift to Sydney from the technical whiz at SD-6 (and later CIA), Marshall Flinkman.

DIXON'S MONEY CLIP WITH SECRET VIAL

Handy Device. This money clip was used by Sydney's partner, agent Dixon. The clip separates into two, revealing a secret vial for hiding liquids.

MISSED IT BY THAT

"It would be cruder if it were done today. We're in an age of cynicism now. I don't know if I'd be as comfortable doing it. It only works if it's kind, and not mean-spirited."

—*Producer Leonard Stern, on the idea of remaking* Get Smart

Insidious plots are afoot. People keep resurrecting the classic TV spy shows of the 1960s, but they are missing the point. The 1997 *Mission: Impossible* movie with Tom Cruise offended fans of the show when it turned a cultural icon, Jim Phelps, into a traitor and killed him. Unlike the film's sequel *MI2,* the basis of TV's original *Mission* was clever use of illusion and psychology, *not* mind-numbing violence. Fans of TV's *The Wild Wild West* discovered that the 1999 movie remake, starring Will Smith as Jim West, took a mean-spirited approach and undermined the foundation of the original series, which was the genuine friendship between Jim and Artemus. Then the 2002 *I Spy* with Eddie Murphy abandoned nearly everything from the TV show except the heroes' names, which they took the trouble to flip-flop. And the 1992 *Avengers* movie remembered the bowler and jumpsuits but left the charm at home.

Still, even though these remakes misfired, Hollywood prop makers remain in top form, as can be seen with these well-constructed movie spy gadgets.

LEFT:

MISSION: IMPOSSIBLE (1997)

TV Monitor Watch. This was worn by Tom Cruise as Ethan Hunt to communicate with his team members.

BOTTOM:

Exploding Chewing Gum. This Two-in-One gum stick used by Cruise as Agent Hunt created an explosion when its two halves were mashed together.

OPPOSITE, TOP LEFT:

I SPY (2002)

Cigar Gadget. Eddie Murphy as boxer Kelly Robinson marvels at agent Alex Scott's special gear. One of the devices is this ordinary-looking cigar, which pulls apart to expose an elaborate spy device.

OPPOSITE, BOTTOM LEFT:

WILD WILD WEST (1999)

Exploding Pool Ball. Will Smith as James West used this pool ball, which became a bomb when the number was pressed.

OPPOSITE, RIGHT:

THE NUDE BOMB (1980) (THE RETURN OF MAXWELL SMART)

Fashion Designer. This is the wardrobe worn by Italian star Vittorio Gassman as Kaos chief Nino Sebastiani, a fashion designer who threatens to make everyone in the world naked with his "nude bomb."

MUCH!

INDEX